SUSPECT

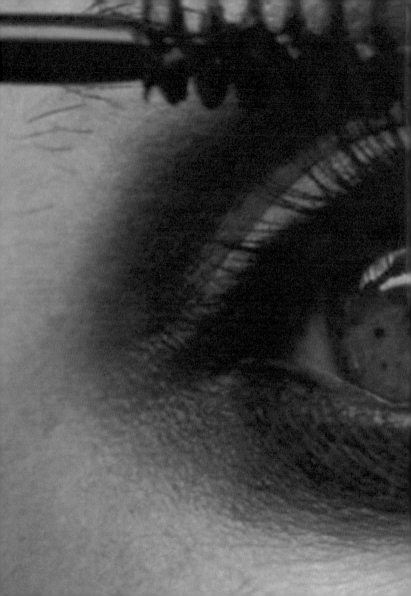

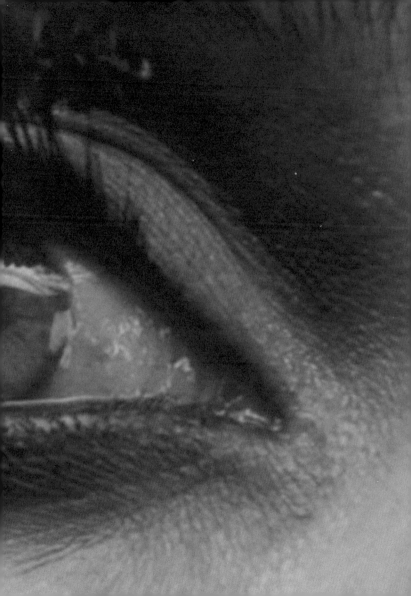

13269

ALPHABET CITY

10

SUSPECT

EDITED BY JOHN KNECHTEL

an ALPHABET CITY MEDIA book
THE MIT PRESS Cambridge, Massachusetts London, England

MIT Press books may be purchased at special quantity discounts
for business or sales promotional use. For information, please email
special_sales@mitpress.mit.edu or write to Special Sales Department,
The MIT Press, 55 Hayward Street, Cambridge, MA 02142.

This book was printed and bound in China.

ISBN: 0-262-11290-6
ISSN: 1183-8086

10 9 8 7 6 5 4 3 2 1

ALPHABET CITY MAGAZINE

EDITOR
John Knechtel

ART DIRECTION + DESIGN
The Office of Gilbert Li

MANAGING EDITOR
Jennifer Harris

COMMISSIONING EDITORS
Stephen Andrews
S. D. Chrostowska
Mark Clamen
Roger Conover
Atom Egoyan
Kelin Emmett
George Z. Gasyna
Sarah Nixon Gasyna
Janna Graham
John Greyson
Diana Kuprel
Pamila Matharu
Natalie Neill
Joseph Rosen
Jim Shedden
Timothy Stock
Sonali Thakkar
Ger J. Z. Zielinski

COPY EDITING
Marion Blake
Doris Cowan

IMAGE RESEARCH
Melanie Tinken

PREPRESS + PROOFING
Clarity

LEGAL REPRESENTATION
Caspar Sinnige

THANK YOU
Asim Ali
Gayle Awai-Johnson
Deirdre Bowen
Dorothy Graham
Lisa Klimek
David Michaelides
Dirk Park
Dan Vogel
Robert Wood

CONTACT
www.alphabet-city.org
mail@alphabet-city.org

NEXT ISSUE
Fall 2006
Alphabet City Magazine
no. 11: TRASH

"Suspect" is both verb and noun. To suspect is to create a suspect. Out of speculation, odd fragments, gossip, and half-truths one constructs a tight narrative of motive, means, and guilt, giving fantasy a specific form and face. It happens quickly. Suspicion, as Mark Kingwell argues here, tells an entire story in an instant, a story that is scripted in imagination before anything can be known of the reality.

Suspicion is a glance that generates an implacable tale of guilt. The Latin *specio*—which like the English "look" means both to see and to appear—is the root of "suspect" and also of "speciousness," the dangerous quality of appearing good while being bad. Thus the onlooker can make up his story on the basis of bad evidence; hooded, unaccountable, he sees without being seen. And as Joey Dubuc, Cheryl Sourkes, and Heather Cameron report, the expansion of this type of looking and recording via technological surveillance systems ensures that more and more of the world is visible, but always as mere fragments and blind outputs. We can map the planet and its residents pixel by pixel, but we cannot escape the speciousness of suspicion.

Instead, seeing more only means having more suspects. Their number grows hourly, compounded by the technologies of surveillance, finance, and marketing, technologies that impose patterns of narrative

on the pictures they generate. States respond to these narratives with new spending, laws, and extralegal practices (secret incarceration, various levels of torture, and the like).

Suddenly, we are all of us entwined in this complex of suspicion, and firm ground from which to address the suspect is not necessarily provided. One can seek democratic development in the Middle East without embracing Bush's Iraq war, just as one can support Bush's America and still feel sickened by the dawn raid (24 March 2005) on the New York City home of sixteen-year-old Tashnuba Hayder: she was arrested and deported to Pakistan—a land foreign to her since kindergarten—for visiting suspicious websites. But the imperative to reflect on these stories exists, whether or not they net us a political position. Simon A. Cole tells the story of Brandon Mayfield, wrongly identified as a terrorist on the basis of "infallible" fingerprint evidence. Timothy Stock and Warren Heise retell as a graphic novel the fate of the artist Steven Kurtz, arrested under the USA PATRIOT Act.

Likewise, the shock of these violations of civil liberties should not blind us to the real need for security. In separate essays, Kent Enns and George Bragues explore the tensions inherent in the liberal position and suggest ways of thinking that include defending against real threats and enemies while safeguarding the rights of the suspect individual or nation. In fictional works, Jaspreet Singh and Diana Fitzgerald Bryden illuminate our ambivalence towards both suspected terrorists who have been exonerated and known terrorists who claim to have reformed. These pieces demand a way forward. How does one forgive for being made to fear? What is the appropriate response to the suspect? Can anyone feel secure after terror?

If not, the prognosis is grim. Indeed, the specter of the over-empowered state is depressingly familiar, as S. D. Chrostowska and George Z. Gasyna remind us in their exploration of films from the

1960s and 1970s, films that look at police-state surveillance techniques from a real but darkly comical Communist Poland and a fictional, terrifying totalitarian Italy. Suspicion in the hands of the state is often volatile, self-perpetuating, omnivorous. In Camilla Gibb's "Things Collapse," suspicion and contagion pair up in hellish fashion and a contemporary society purges itself unmercifully in response.

At the same time, we should not be led to say that terror has made empathy for the suspect impossible. Stephen Andrews, by redrawing the by-now classic photographs from Abu Ghraib prison, but erasing the prisoners, confronts us with our involuntary investment in these images. Working toward similar ends, photojournalist Rita Leistner had herself smuggled into Iraq to photograph the occupation. There are also strategies beyond bearing witness to the violence: psycho-analyst Jeanne Randolph, reading Conrad's "Secret Sharer," asks what it might mean to look into another's eyes and, interrupting suspicion, invoke a more deeply considered view. Patricia Rozema's film, made for this book, gives one such moment its close-up.

Developing a response to suspicion is the challenge of our age, and the stakes are high. We must find another way of looking at a violent world, a perspective founded not in fear but in respect and compassion. Technology and historical forces have made our world overwhelmingly complex; our task is to seek both the right way to live within it, and the right way to confront its dangers.

—JK

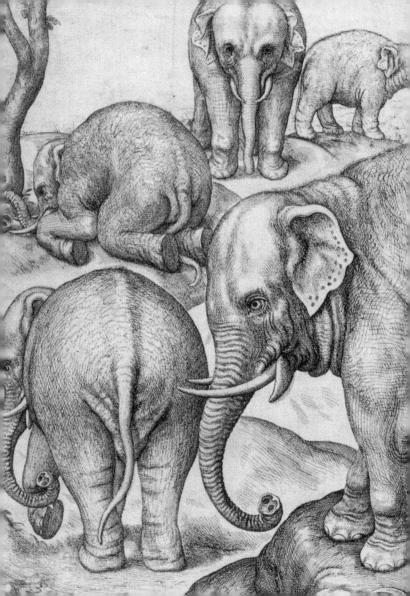

ELEPHANTS

JASPREET SINGH

She was short, four foot nine, from the Pir Panjal mountains of Kashmir, and sometimes the sirens on the streets of Dallas reminded her of elephants. She had moved to Texas for the sake of her son, but the sirens terrified her, and it was too late to adapt. The sirens reminded her of the agony of elephants. In A.D. 528 the White Hun had invaded Kashmir. One of his elephants lost its footing on a high pass, and plunged downwards. The Hun was quite amused by the trumpet-like shriek of the falling creature, and commanded his men to drop another one off the sheer cliff, then another. One by one, the men pushed over some four hundred elephants for his pleasure. For days afterwards the villagers could hear the echoes of dying beasts.

But that happened a long time ago; she was not even born then. And now she felt like a ripe fruit—because she was dead. So much time had passed and so suddenly. Texas had meant nothing to her other than her son. She'd left home to be close to him, despite a bad tumor. The doctor had told her nothing else about the tumor other than its shape. Looks like an egg, he had said. But it was all over now. Being dead was easier than she had imagined.

She was waiting patiently in her coffin at the airport for her final journey home.

Only yesterday the airline had delivered the aluminum coffin to her son's house. A large cowboy coffin, by mistake, and the thing had caused some initial confusion. Then they discovered that the house was not well designed, the stairwell lacked a coffin-turn. Her son and two Mexicans had to rely on the old rope-and-balcony trick to lift the thing to her room. She felt somewhat naked when he began supervising the maid. The maid washed her with a sponge, cleaned and over-cleaned, bleached her ruined bones as if they were kitchen tiles. She wished she could survey her own self in the dim light of a

candle, but all of a sudden light meant nothing, just like darkness meant nothing.

The maid had sneezed while draping her in an embroidered *pheran*. Then her son surveyed the last fragments of her corpse and found it necessary to use absorbents as space fillers in the coffin. The maid had to transfer little Zainab's swimming diapers as well, including the one with Bambi, and this brought tears in tiny eyes.

"Where has Gra-ma gone?" Zainab had asked.

"Beyond the mountains."

Dallas/Fort Worth airport was packed that Tuesday. The airline announced a delay in departure because of an earthquake in Asia. Her son and Zainab stepped into a Mexican restaurant. Planes were visible through the glass panes. Watching them eat, she felt extremely hungry. The worst thing about being dead is not being able to eat. The smell of tortillas spread out towards the lounge and her coffin was not far from there. Tortillas, for some strange reason, never failed to remind her of home.

She watched her son's sleep-starved eyes, his face no longer hidden in his hands. She was happy he was going to grant her last wish—bury her by the ancestral house. But after the burial how was he going to manage? He ate and read far, far beyond need, whenever unbearable news hit him.

Despite sleep in eyes and food on the table he began reading the paper. Other passengers might have perceived that he began reading abruptly, but it was not *abrupt* for her—she had even managed to predict it. "Urdu," she thought, "for my sake, he sometimes reads in our own language." She wanted to say *Urdu was his 'dead mother tongue,'* but she lost all courage to remind him. He was reading from right to left, and that is why the white woman occupying the neighboring table raised her brow.

The woman looked exactly like an advertisement, more so after food and another coat of makeup. Zainab's father raised his head from the paper to survey the advertisement. She had never thought him unsatisfied. But the woman's long hay-colored hair was just like Zainab's mother's hair. She was sure her son was searching for the right moment to strike up a conversation.

"Daad-ee," Zainab asked softly, her tiny finger pointing at the paper, "what is this picture?"

"Zainab, *bayteh*," he began. "This is Saturn. Titan—the moon of Saturn. One point four billion miles away."

"Further than the moon Daad-ee?"

Your father seems to have forgotten the most essential thing, she almost said to Zainab. There are places closer to us than the moon. He was born on the day our blessed Prophet's hair was stolen from the mosque, and I feared, even then, some distant Texas would one day steal him away from me. I didn't want him to study computers. Small, I wanted him to remain—like that dwarf tree in the garden. Kashmir is only 1.4 days away.

There is no famine of nice girls in the mountains. He should have married a girl from Gilgit—she thought. They wear a fine veil of sacrifice, the women over there. His Cuban wife has brought so much bitterness to the family, and *wife* is not even coming to the funeral. Who will take care of the dogs? *wife* had asked. God, I said to myself.

Zainab, your mother drags you to the church every Sunday. I had asked her, What kind of a Cuban are you if you kneel inside the Church? But she had remained silent, because she had no answer.

Her son surveyed the white woman again, away from Saturn and its moon.

Inside the coffin, she felt wet, despite the absorbents. Puddles of viscous fluids from her own body surrounded her. No, I am not afraid

of death, she said to herself. I will leave them alone, after the burial. Only one thing terrifies me. After they dump my body, this family's connection with Kashmir will end. The *connection* will rot. *Ab yahan koi nahin, koi nahin ayehga.* Only damp earth and worms and foul odor of my barbaric *egg* tumor. No, I don't want this little girl to forget her people.

"Open the black bag," she said to her son loudly. So loud was her voice, it spread like a wave and made the corner of the tablecloth flutter. But the man didn't notice. The little girl heard her grandmother for a brief second. Zainab's eyes fluttered like butterflies. The girl kept playing with a fork until it landed on the floor, not far from the bag.

There is a part of me in that bag, she almost said to Zainab. My smell still clings to the clothes, which are no longer mine. The ring that no longer clings to my hands is also in there. The ring will comfort you Zainab—you must have it. I told your Cuban mother so many times: the ring is for Zainab, but she forced the maid to pack it for the *poor* of Kashmir. The ring belongs to Zainab, the *poor* of Kashmir will find a way to help themselves. How much you still don't know Zainab. So powerful your grandmother was. She wove three beautiful carpets to buy this ring. I want you to know that despite all the madness and savagery that has descended on Kashmir, there is still some beauty left, and no one—*no one*—can take it away from us.

But Zainab couldn't hear her at all. The waitress brushed past the bag, her legs naked. Naked legs walked past that foreign-looking man who kept reading his paper, and the white woman who kept twiddling her hair nervously.

Zainab whispered in her father's ear.

"Can you hold it?"

"No, Daad-ee."

"Let me finish the coffee."

"Can't. I can't."

The line outside the washroom was long. Zainab was fast losing that last trace of patience left within her. Father and daughter joined the line.

The white woman didn't notice them leave, but after a while her hands started to twitch, and she looked at her neighbor's table, at Zainab's half-empty plate and then at the knives and forks, as if she had never seen steel before. The woman looked at her watch and then at the bag.

How absentminded my son is, she thought. If this woman steals our bag, how unhappy the Cuban wife would become. And who will take care of the *poor* of Kashmir?

"This bothers me," the white woman muttered.

She could not comprehend those words.

She noticed the white woman looking far and near and then at the watch and then at the bag with stealthy eyes.

Thief, she almost cried from the coffin.

Thief. Thief.

The white woman looked terrified, and hurried away from the table barefooted. Her heels left behind. It seemed as if her skin was on fire.

"Bomb," the woman began shouting.

Bomb. Bomb.

People panicked and rushed wherever their feet led them. Men in camouflaged uniforms appeared, with weapons ready to be discharged.

"An Arab was sitting here," yelled the woman. "He was reading a paper in Arabic."

The police-*wallahs* cordoned off the area.

Time passed, and it passed very slowly until Zainab and her father started their walk back to the restaurant.

"There he is," said the white woman, pointing her finger. Hundreds of eyes stared. There was a sigh of relief in the air.

"Sir, you come with us," said the man in camouflage uniform.

Zainab clung to her father.

"Zain, you stay with aunty."

He had to apply enormous force to separate the girl from his legs.

The waitress held the girl's finger for a while, and then she lifted her up and even kissed her on the cheek, but the girl was hurt, wounded by the undesired kiss. She began crying.

The guards whisked him away, and half an hour later they whisked him back. When he returned the girl was half-asleep, but she couldn't resist an interrogation.

"What did they say to you Daad-ee?"

"Zainab, *bayteh*," he placed his hand on her brow, "they were curious. 'Are you a dog?' they asked."

"And?"

"'Do you live on Saturn?' they asked."

For once she was glad she was dead. She couldn't endure the pain her son was going through.

"Funny Daad-ee. Are there dogs on Saturn?"

"You mean life?"

"Daad-ee is there life on Saturn?"

"One day we'll know."

He held her finger and hesitantly they walked towards the bag. Two officers escorted them. He opened the bag and one by one displayed his dead mother's things. The officers touched her things.

Even in death, she said to herself, I have no privacy.

The metal detector beeped only once, and Zainab's father recovered a piece of metal from his mother's nightdress.

Zainab, the girl, rubbed her eyes with tiny fists, and when the flight took off, she leaned forward in her seat and examined clouds through the angled window. One resembled Gra-ma. She observed its shifting form until the thing disappeared. "Look, Daad-ee, an elephant." She scratched the piece of metal against glass. "Daad-ee, listen." But he didn't listen. She felt she was alone. No one was listening and everyone was silent. She was alone in the universe, afraid of the silence of immense endless space. One by one all things would disappear in that space. But Gra-ma refused to disappear. She was with Zainab now, slipped around the thickest finger, and the shiny ring clung to her tight. She could not tell, she could not tell if the plane was headed to the mountains or to some other place, far, far away from Texas. She was curious if boys and girls and dogs and old people lived there, and if they, too, felt the pull to talk to her.

WHO IS THE SUSPECT?

MARK KINGWELL

The question before us is: who is the suspect?

What does it mean to suspect, to be suspected—or, as the official euphemism has it, "a person of interest"? How is suspicion organized into specific forms: the manhunt, the chain of evidence, the paper trail, the DNA scan, the crime-scene reconstruction? Forms of organization that generate truth from their methods; whose truth, as so often is the case, is determined by those very methods.

Such organization may be assumed, as we say, *ex hypothesi* in any pursuit. May be assumed, must be assumed. For hypothesis is the key to all suspicion, its proposed (presupposed) structure, the answer determined by the kind of question we ask. Hypo-thesis: from the Greek, *hupo*, meaning "under." Under consideration. Under review. Under suspicion. The groundless assumption that gets any theory off the ground. The rhetorical question that instigates the search for the answer.

Or rather, the question that becomes the answer, was the answer all along. And not just when the hypothesis is confirmed, brought out from under; even the rejected hypothesis, like the detective story's false solution or trail of red herrings, the conjectured and refuted narratives, encountered only in order to be discarded, underwrites the assumed logic of the pursuit.

Even, or especially. Again like the detective story, the correct solution, when it is arrived at, forcefully reasserts the order of things that was temporarily suspended or breached by the rupture of mystery. A puzzle solved offers libidinal release, punishment for the guilty, exoneration for the innocent, the joy of structure resumed. Justice, beyond a reasonable doubt.

Who is the suspect? To ask is to answer.

The essay? Organized suspicion in pursuit of a quarry. The quarry? The answer. The principle of organization? The question.

You are the detective.

Detection always begs the question of causality. Who is the suspect? But first: what has been done, and how? What is the chain of events? In *Looking Awry*, Slavoj Žižek contrasts two kinds of detective story and the different ways in which each avoids "the real of desire." In the Sherlock Holmes story, typically short, the detective performs a sort of latent content analysis of a fractured narrative. Consulted or confronted by a strange sequence of events, he enters an oneiric puzzle after the fact. The redheaded man. The dog that did not bark. The one stolen shoe.

In each instance, there is an element of the story that jars just enough for Holmes, with his powerful deductive mind and bowls of stimulating pipe tobacco, to turn the key and unlock the mystery from above, often without leaving the comfort of his armchair. To be sure, sometimes he rushes into movement or sends round one of his Baker Street Irregulars; but with a few exceptions, in particular the novella-length *The Hound of the Baskervilles* and the fatal confrontation with Moriarty at the Reichenbach Falls, Holmes prefers to stay out of the action, aloof and alight.

The solution, when reached, is revealed as simplicity itself, such that onlookers and the faithful amanuensis and stooge, Dr. Watson, often feel inclined to hit themselves on the head and wonder how they could have missed it. We are, of course, meant to do the same. How could we have been so stupid? How could we have missed the significance of the clue?

The genius of the Holmes solution is that it is not, despite his many claims to the contrary, deductive. Deduction proceeds from major premises and established logic, via minor premises, to a conclusion.

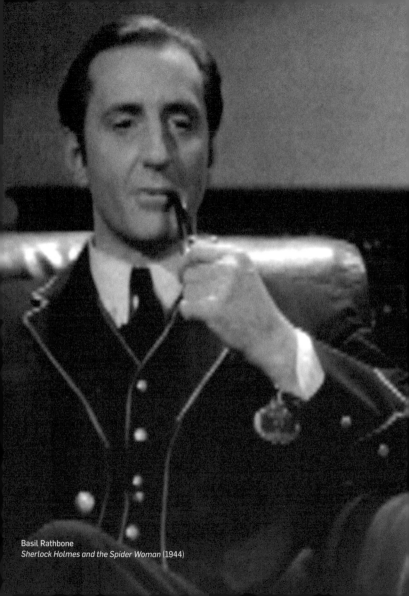

Basil Rathbone
Sherlock Holmes and the Spider Woman (1944)

This is deduction:

(if) All men are mortals.

(and) Socrates is a man.

(then) Socrates is mortal.

The conclusion is foregone, in the sense that it cannot come out any other way once the terms and relations are understood. As Wittgenstein said, in logic there are no surprises. That is not to say that we onlookers cannot be surprised by a result, if we are inattentive or feeble-minded, only that there can be no arguing the case based on claims of counter-intuition. If your intuitions run counter to deduction, they are wrong.

But Holmes is not inductive either. Induction moves from particular cases to general conclusions, proceeding, we might say, bottom-up rather than top-down. This is induction:

The sun has risen every morning.

The sun rose this morning.

The sun will rise tomorrow morning.

Though it is the basis of many a routine claim of fact, not to mention all of empirical science, induction has a fatal flaw, as Stevenson's fellow Scotsman, David Hume, demonstrated. Induction is fallacious; it relies on a suppressed major premise that effectively begs the question. That is, namely, that the uniformity of things is demonstrated by our experience of things. Such an idea may seem uncontroversial, but this premise is the very conclusion that induction is trying to demonstrate. Thus a crippling circularity emerges. You cannot show that the natural world exhibits uniformity by first assuming that it does so, then refer back to that assumption as evidence for your claim that natural events are uniform. We can presuppose that the sun will rise tomorrow—indeed we probably should—but we cannot prove it. Events are not a chain; events are not even events, in the sense of knowable chunks of experience.

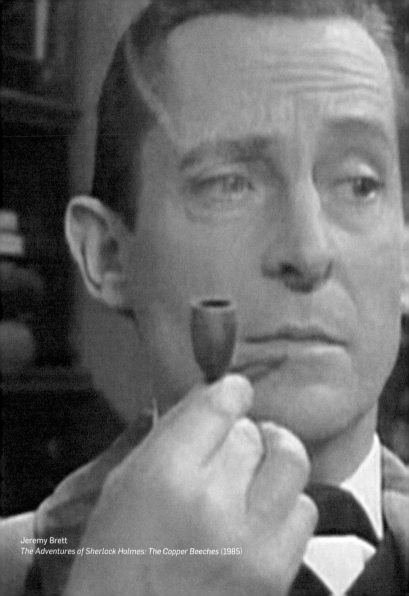

Jeremy Brett
The Adventures of Sherlock Holmes: The Copper Beeches (1985)

A good deal of Holmes's showing-off is induction in a minor key. The recovered hat shows its owner to be a man of means down on his luck, recently returned from India, with a penchant for kippers and fast women.

This small-scale stuff doesn't raise the question of reliable knowledge in any obvious Humean way, but it is as susceptible as any inductive claim to Hume's demolition. It may be the result of method, after a fashion ("You know my methods, Watson; apply them") but it is not deduction, whatever Holmes may say. And, as induction, it is, like all claims of empirical fact, cracked at the base.

This is even more clearly the case in the increasingly advanced empirical methods of suspicion that Holmes inaugurates, the growing wonders of "scientific" detection as it moves from macro (footprints, broken glass, bloodstains) to micro (hair, semen, DNA). Holmes's "powerful lens," the clichéd image of detection via the magnifying glass, is a threshold not just between the visible and the hidden, an interstitial machine for revelation, but also a kind of symbolic, two-way looking-glass marking the line between the Industrial and Atomic Ages; it is a sign of things to come.

The lens reveals the clue: per convention, the fingerprint. The fingerprint the glass preserves is itself a transitional form of trace evidence, the unwitting signature of crime. Nowadays, fingerprints are crude, almost unsought. The exquisite machines of detection today (in fantasy anyway) reveal smaller and smaller bits left at the scene by the suspect: a fingernail, some scraped skin, washed-up blood. Any of these may connect the suspect with the weapon, with the deed, with the guilt.

The advanced extension of Holmes's glass is television's successful *CSI* franchise, with its cast of quirky geniuses combing a confused and bloody crime scene, playing out rival imagined narratives of what

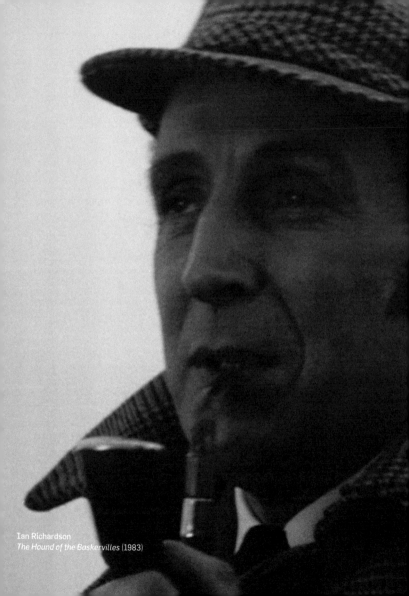

Ian Richardson
The Hound of the Baskervilles (1983)

really happened. The show trades on the fact that all visual narrative is equally real when presented on screen: the false solution can be as vivid as the true one. Bullets blast through human tissue, blunt traumas are inflicted from above or below, organs are rent apart, and we follow the violence from the inside, as it were, enjoying the weapon's-eye view. Here, one advanced technology (special effects) is used to illustrate, and celebrate, another one (forensic method).

But more importantly, we see that the total surveillance society is not achieved by such space-age inventions as the geosynchronous satellite or even, closer to the ground, the ubiquitous police camera. It is, rather, a function of the body's routine garbage, sloughed-off dead skin or random inert proteins in the form of hair or nails. These bits of rubbish are omnipresent, rendering suspicion itself unnecessary. Combined with the pure method of forensic science, there is no need, really, for imagination. Nor, even, for the pervasive suspicion of neighbors and colleagues, the ugly duty-to-inform ethos of *Nineteen Eighty-Four* or post-9/11 America. The television drama preserves a role for human insight, but its premise gives the lie to this gesture towards faithful observation. Here, science does all the work.

The surveillance of bodily waste is always invoked, crucially, after the fact. It is a leaving conjured from leavings. Like Holmes's "elementary" explanations, the forensic account is a reconstruction, a story, a narrative of crime and (eventual) punishment. Always, the story we see on the page or the screen proceeds backwards, not in structure but in content, returning us to the beginning of the story we did not see, the violent crime, and walks us through it, through the unalterable past, to isolate the suspect.

That is why we watch. Not to prevent crime, but in pursuit of a pleasure much more shameful and basic: the spectacle of guilt observed.

It is, in the end, all about us, the viewing audience.

Who is the suspect? It's not who you think it is.

The real logic at work in the typical Holmes story is of a kind more Freudian than rational: it is the logic of the dream. Holmes, in effect, is an analyst who unlocks the mystery by penetrating the narrative and its false solutions (the manifest content) to find the true solution that solves the mystery (the latent content). His smoke-filled study is the crucible for revelation, an analytic situation as controlled and protected as the celebrated couch. It is here that the tale will unfold, the probing mind will take up its playful, yet serious, attitude towards it, and some breakthrough will occur, not from deductive application, but as an emergent property of the situation itself.

For the solution is not always obvious. As Freud suggests, often the true solution—which is to say, the valid interpretation—involves reading the dream as if it were a rebus or word-image tangle, often involving puns or shifts in meaning. A simple example, credited to Voltaire, turns on the symbolic system of language itself. Asked if he was ready for dinner, he wrote a note that read, "Ga"—a tangled sign that can be disentangled this way: "G grand, a petit = *J'ai grand appetit*."

Žižek notes how one of Alexander the Great's dreams was fortuitously interpreted by Aristander. Alexander "had surrounded Tyre and was besieging it but was feeling uneasy and disturbed because of the length of time the siege was taking," the historian Artemidorus recounts. "Alexander dreamt he saw a satyr dancing on his shield. Aristander happened to be in the neighborhood of Tyre.... By dividing the word for satyr into sa and tyros he encouraged the king to press home the siege so that he became master of the city" (Žižek 52). The

key lies in seeing the satyr not as an image but as a word, and hence a coded message: *sa Tyros* = Tyros is thine.

More common rebuses mix words and images, so that, for example, a picture of the letter "i" drawn casting a shadow = "eyeshadow." It will come as little surprise to learn that the word rebus is from Latin *res*, thing, as in the ablative plural phrase *de rebus quae geruntur*— i.e., "the things that are taking place," title of a sixteenth-century collection of riddles from Picardy. "*Res*" is also the root of "real," making rebus, as its function as the clue suggests, a trace of the real. No surprise then that the wryly coded name of the detective in a series of superior mystery novels written by Ian Rankin, and set in multilayered, enigmatic Edinburgh, is John Rebus.

With its apparently standard "techniques" of condensation and displacement, the dream, like the rebus, offers a message only in a logic coded at a meta-level. Its base-level meaning is therefore, because of the layering of metacode over apparent code, at best meaningless and at worst actively misleading. If we are to interpret the dream, we must ignore the base-level coding, move to the meta-level, and attempt to tease out meaning there if anywhere.

The dream logic of the Holmes story is carried by the clue, the unresolved remainder in the original narrative, often minuscule, which does not fit, or seems irrelevant or odd. The clue is a restless element, a node of uncanniness. It will not take its place in the chain of events, or, better, in the narrative that is constructed as a sense-making quest through events. Hence the atmosphere of threatening strangeness that pervades many of the stories. We might say that the uncanny serves to disrupt the relation presumed between narrative enchainment and event-sequence, the ancient metaphysical connection between word and object. The narrative is fractured by the restless clue, and that fracturing in turns calls into question the unstated

presupposition that events can be narrated meaningfully, that there are, indeed, such things as events, bundled arrangements of cause and effect.

Thus the Holmes story, as a narrative about narrative breach, is itself a dream attempting to recode the very possibility of meaning. When the clue, a "trace of the Real" in Žižek's Lacanian terms, is followed, then, the rupture of the mystery is healed, the wrinkles of incongruity smoothed over. The pursuit brings its pleasure, just as any narrative does, and the world is restored—until the next mystery excites Holmes's interest, proves itself worthy of his analysis. The "Real," though apparently pursued, is avoided: the violence of desire is, despite appearances, obscured rather than exposed.

The subdural instability inscribed in the Holmes stories occasionally rises to the surface. Confronted in "The Cardboard Box" by an apparently meaningless act of grotesque violence prompted by overwhelming jealousy, Holmes—the supreme acolyte of causation, the giver of explanations—is moved to melancholy: "'What is the meaning of it, Watson?' said Holmes, solemnly, as he laid down the paper. 'What object is served by this circle of misery and violence and fear? It must tend to some end, or else our universe is ruled by chance, and that is unthinkable. But what end? There is the great standing perennial problem to which human reason is as far from an answer as ever'" (Doyle 52). In "The Yellow Face," the story that follows this downbeat denouement, Holmes rather pityingly explains the desperate actions of a mystified man with words that have an ironic relevance to himself: "Any truth," he acknowledges, "is better than indefinite doubt" (Doyle 69). The various satisfactory solutions, all the "elementary" deductions and guilty suspects justly apprehended, are revealed as quietly desperate avoidance-rituals, ways of dodging the unthinkable.

The hard-boiled detective story, by contrast, does not work according to deduction, nor in the service of some presumed, if illusory, causality of suspicion. Instead, detection proceeds via immersion: Sam Spade or Philip Marlowe enters a cycle of violence that is not yet over, and which typically affects them directly—even if they begin pursuing a mystery at some distance from what will turn out to be the principal one. Here, the detective cannot remain aloof or in any way suppose that he is above the action. Hence, among other things, a crucial shift in person. While the Holmes story is related in the first person by Watson, it effectively renders the narratorial "I" into a third-person narration of Holmes's investigations. The hard-boiled detective's "I" is a true first-person, the literary equivalent of film voice-over. Voice-over may be derided as a cheap narrative device—notice, for example, the second-order mockery in the film *Adaptation*, where an aspiring screenwriter played by Nicolas Cage muses, in a stream of consciousness voice-over, on the dangers of voice-over—but it is a natural for the hard-boiled detective story, which relies on personal immersion in the action.

Philip Marlowe, Raymond Chandler's quintessential hard-boiled detective, takes on the mystery in a thoroughly personal way. He is often in danger, drugged or shot or beaten, on the way to the solution. Here, the solution is rarely a neat tying-up of strange elements; rather, it is a revelation of a pervasive nastiness that the detective is powerless to solve. Though clever, the detective is usually a step or two behind the main flow of action, arriving late on the scene; his often-mentioned tenacity, meanwhile, is a function of quirky pride rather than intellectual discipline. His touchstone is commitment to the client and the solidity of his fee, plus expenses.

What Holmes and, later, Lord Peter Wimsey do for sheer aristocratic pleasure, Marlowe does for money. Against a backdrop of Los Angeleno

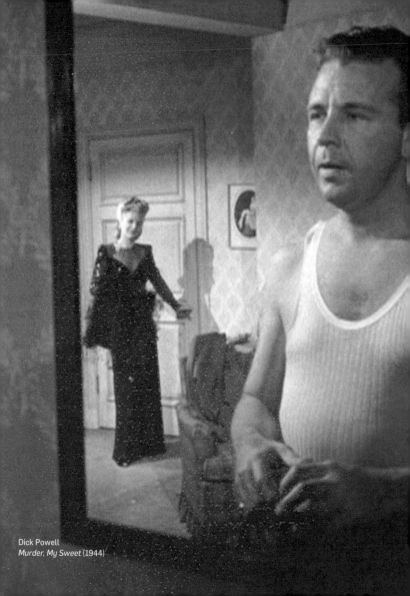

Dick Powell
Murder, My Sweet (1944)

corruption and fakery—gangsters who talk like movie tough guys, cops who take bribes, women who use sex or guns as the moment demands—Marlowe maintains his narrow integrity by reference to a combination of self-denial and capitalist virtue. He's not good, because nobody is, but at least he's straight. And it has very little to do with obeying the law, since the law is already suspect, hence the many tangles Marlowe has with his former colleagues. (It's worth noting that Marlowe's "professional" ethic is transferable, without much modification, to the quarreling thieves of *Reservoir Dogs*.)

The Marlowe story is gritty, urban, and sexual in a way that Holmes stories never are. Holmes's London is never very threatening; it even enjoys some of the foggy nostalgia of a Dickensian Christmas card. There is heterosexual tension here and there in the Holmes corpus, and a celebrated love, but it is hard to take seriously—hence the perverse desire to sexualize the Holmes–Watson relationship, or the Holmes–Moriarty pairing. In the Marlowe tales—significantly, novels of a length suitable for immersion in the corrupt world—the femme fatale character has a starring role.

The femme fatale is this story's own way of avoiding the Real of desire, the structural equivalent of the uncanny clue. There are clues in Marlowe's narratives, but they are not disruptive traces or nodes, just bits of a dark, funny tale in which Marlowe risks temptation. By rendering the threat of corruption sexual, the narrative gives Marlowe the opportunity to reject the suspect advance, or at least keep his responses purely physical: the femme fatale comes on to him, but he is wise to her.

This rendering of the feminine as pathological is of course itself pathological. But the more important point is that it works to hold desire at bay. Violence is not sanitized here, as in Holmes or, more to the point, the "cozy" country-house detective stories that come later

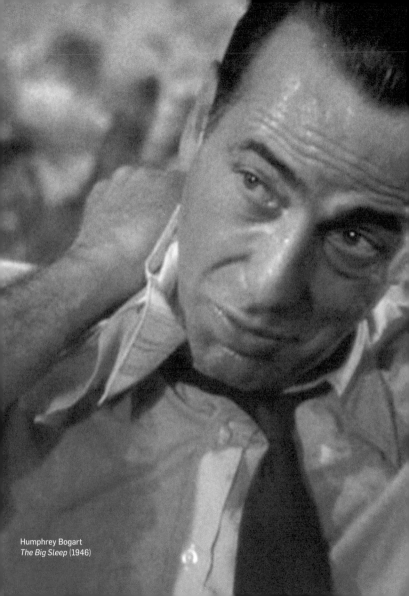

Humphrey Bogart
The Big Sleep (1946)

in the English tradition; it is, rather, transposed into sexual terms, and immediately pushed away. Fear is retooled as self-control, and the overarching ethical structure of straight versus crooked is re-affirmed just as surely as when Marlowe demands his due payment, cash or check.

In spite of the fact that the two forms of detective story are both versions of the literary mystery genre, often enough concerning murder and theft, as well as the fact that they were written just a few decades apart, they offer utterly different textures and motives. The Holmes stories belong to an Industrial Age suffused with scientific optimism, a surface that is, however, broken by an awareness of the illogical workings of their solutions. The Marlowe stories are firmly gripped by twentieth-century pessimism, a kind of amused sadness. The reasonable guy can do nothing to combat the Fall of Man except wisecrack and keep his hands more or less clean. The two forms fuse in the now pervasive form of the "police procedural," the combination of what we might call a soft-boiled detective, no longer freelance, and a lot of routine policework, and/or, these days, improbable banks of advanced technology.

But both conceits, those of optimism and pessimism, and still more the fusion of the two, are smoke screens for a more searching unease, a fear of literally unspeakable desires that the narratives sweat to hold at bay. What if nothing means anything? What if the suspect is not guilty—not because we are all guilty, but because guilt is a fiction, a form of metaphysical comfort?

And thus the analysis of detection, too, is an avoidance: Žižek's tale and, yes, mine are revealed as ways of coping, rituals of argumentative evasion, whose desperation is concealed beneath the surface of reason. The pursuit of the pursuit of the suspect only brings us back, again and again, to ourselves. Who else?

Robert Mitchum
The Big Sleep (1978)

Who is the suspect? We are all the suspect.

——————

Narrative, like the essay, is a form of organized suspicion. In the mystery story this fact is obvious, because suspicion, whether aloof and rational or cynical and immersed, is in the foreground. But that foreground, like the base-level code of a dream, is a distraction from the larger point that all narrative pursues, as its quarry, the very idea of meaning. And even when a given narrative rejects this pursuit in particular, this only serves to underline the assumed fact of the pursuit in general.

"[T]he experience of a linear 'organic' flow of events is an illusion (albeit a necessary one)," says Žižek, "that masks the fact that it is the ending that retroactively confers the consistency of an organic whole on the preceding events. What is masked is the radical contingency of the enchainment of narration, the fact that, at every point, things might have turned out otherwise. But if this illusion is a result of the very linearity of the narration, how can the radical contingency of the enchainment of events be made visible? The answer is, paradoxically: by proceeding in a reverse way, by presenting the events backward, from the end to the beginning" (Žižek 69). To be sure, such illuminating counterexamples can only be found in time-based media, where we can in fact run the story backwards: such films as Harold Pinter's *Betrayal* (1982) or Christopher Nolan's *Memento* (2000). Even here, the discrete chunks of narrative, however fractured and rearranged, still must be "run" forward. (An exception is the short opening and closing sequences of *Memento*, run in slow-motion reverse.) Shifting ending and beginning emphasizes the power of narrative expectation; it does not really challenge it.

The basic impulse of narrative, then, is sequence: this happened, and then this happened. In bare narrative, the sort offered by children

Elliot Gould
The Long Goodbye (1973)

or bores, the sequencing lacks consequence and is reduced to mere stated succession: and then, and then, and then. The lack felt in such a tale illustrates Forster's famous dictum on the difference between story and plot: the queen died and then the king died is a story; the queen died and then the king died of grief is a plot. In adorned narrative, or plot, there must be some demonstrated enchainment of events, the creation of consequence. Only thus is it possible to experience the libidinal release typical of all narrative, and starkly exhibited in the mystery story, classical or hard-boiled.

The essay, since it takes the form of an argument, complicates the illusion of consequence by reversing the polarity. Instead of saying and then, and then, and then, the essay says: and thus, and thus, and thus. (At least, it tries to; many a poor essay may read more like the bare narrative of the child or bore.) The illusion here is that an argument, when valid, possesses that validity all at once. This is the common reading of the Wittgensteinian warning against surprises: you cannot be surprised to have validity demonstrated, because it was there all along. The working out of the argument, whether in a proof or by way of the informal essay, is a mere functional necessity, in the way Socrates demonstrates in Plato's *Meno* that the slave boy knew all along, indeed knew innately, the Pythagorean theorem.

We might call this the illusion of innate validity. Just as the narrative presupposes the very thing it hopes to find—namely meaning—the argument does the same with validity. Surely it is a better description of what is happening to the slave boy to say that he is being taught the theorem, rather than, as Socrates would have it, that he is remembering it? Validity has, as a defining feature, the fact that it must be demonstrated. We may think that it can be grasped at a glance, but even for geniuses of logic this feat is rarely possible, except at a very low level of complexity. And in being demonstrated—that is, in submitting to

the temporality necessary, not incidental, to all argument—argument shows that its affinity to narrative is very close indeed, closer than some would prefer.

Both adorned narrative and demonstrated argument exhibit a complex structure: not and then, and then or and thus, and thus but rather and then, therefore and thus; and thus, therefore and then. The comparison that favors both is to another time-based medium, music. One may record the notations that indicate music, just as one may record the symbols that encode a narrative or an argument; but the respective logics cannot be exhibited except in the playing. The complex structure of the Brandenburg Concertos is fully present only in the experience of hearing them, pattern and meta-pattern unfolded between one silence and another. And then therefore and thus. And thus therefore and then. The argument runs. The story proceeds.

The specific background irony here, as always, is that Plato himself used narrative techniques to advance arguments in favor of innate validity, a hybridity that everywhere challenges not only the coherence of his thought but any simple distinction between events and arguments, consequence and logic. Plato's dialogues thus offer themselves as their own kind of rebus, or dream, complete with a fractured and layered logic that serves, ultimately, to raise more suspicions than it lays to rest.

And so we are confronted with another mystery: what is the valid interpretation, the good story, to tell about Plato? How to interpret that odd set of dreams?

Well, perhaps as the music they are.

———————

And so, to conclude, let me tell you a story.

The burglar came in the middle of the night, believing, I thought (not at the time, only later), that the house must be empty.

It wasn't. I was there, sleeping. Woken by the sound—unfamiliar, out of place—of floorboards creaking in the hallway beyond the bedroom door. An uncanny sound: *unheimlich*, unwelcome, wrong. I live alone. There should be no sounds.

He ran out the front door when he realized I was there. I lay in bed, shocked into buzzing awareness. What to do? A second or two. Then I jumped up, pulled on some boxers, and sprinted out the front door after him. Running barefoot down the sidewalk, really moving.

At the end of the street, I caught him.

He turned, looked at me. What to do?

Nothing much. An angry shove. Nasty words. His mute show of empty hands.

Now what?

When I went back to the house and called the police, the 911 dispatcher was incredulous. I let him go? Yes, because what else? Because you can't sit on someone until the police arrive. Because there is not much force in moral suasion, absent the mechanisms of enforcement.

Above all, because the dispatcher, with her headset radio and illuminated grid of the city spread out before her, sees the streets from a false position, a Cartesian fiction. There is no grid, no cross-hatched structure on which everyone can, theoretically, be located by intersection. No set of names to which the law can be summoned.

In the middle of the night, the grid does not exist. It is revealed as the abstraction it is, the merely notional xy space of scientific method. The street is not a space, it is a place. In that place, two men, alone. There is no causality, there is only proximity. At issue, this

breach of house, this uninvited threshold crossing, the disruption of the private.

There is nothing to say, nothing to do. I have the suspect in hand. The pursuit is ended. Now what?

The law, summoned, eventually comes. Three cars, six guys. A canine unit, German shepherds, a gung-ho youngster in a blue jumpsuit and body armor. A slow summer night. The suspect is long gone.

They apply method anyway, after a fashion. I describe the suspect. They write it all down. Yankees cap. Gray stubble. Dirty cotton shorts. Torn T-shirt.

We drive past the local diner in a cruiser, firing up the siren to make the heads turn. Maybe the suspect is dumb, or desperately wanted a 4 a.m. coffee after his abortive B & E. The dog sniffs and lifts his nose in the air. Nothing. Organized suspicion. But futile, beside the point, too late.

Later, the detectives come. Suits instead of uniforms, a man and a woman. The man talks about Kierkegaard. The woman spreads dark powder all over the windowsill and frame. Nothing. No trace. No clue. He was never here.

He was here. I cleaned up, but traces of the powder are there still.

Later, the requisite uncanny clue: I discovered something missing, that is, present by its absence. My favorite fountain pen, a screw-action Pelikan, tool of my own legal trace, my signature. Also, maker of arguments, instrument of essays, cause of causal fictions. Gone. Not to be found.

Stolen or just lost? Mere routine misplacement, or a hint of some deeper mystery?

We'll never know.

WORKS CITED

Arthur Conan Doyle (1993)
The Memoirs of Sherlock Holmes
Oxford: Oxford University Press

Slavoj Žižek (1991)
Looking Awry:
An Introduction to Jacques Lacan
Through Popular Culture
Cambridge: MIT Press

SUSPECT

PATRICIA ROZEMA

BASED ON MARK KINGWELL'S ESSAY "WHO IS THE SUSPECT?"
SOON TO BE A MINOR MOTION PICTURE

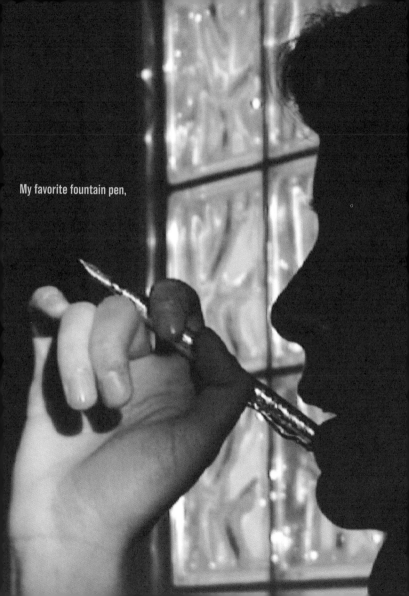

My favorite fountain pen,

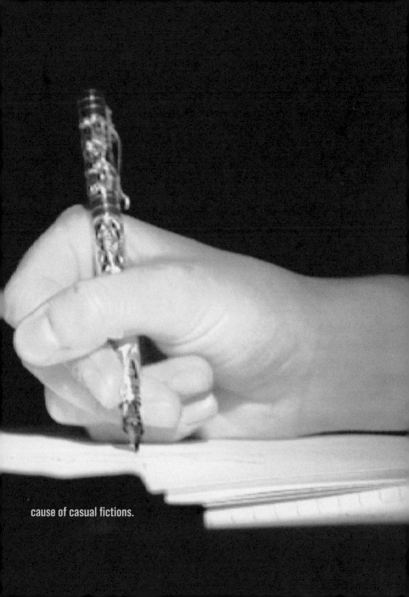

cause of casual fictions.

uninvited
threshold
crossing

the
disruption
of
the
private

creaking
floor
boards

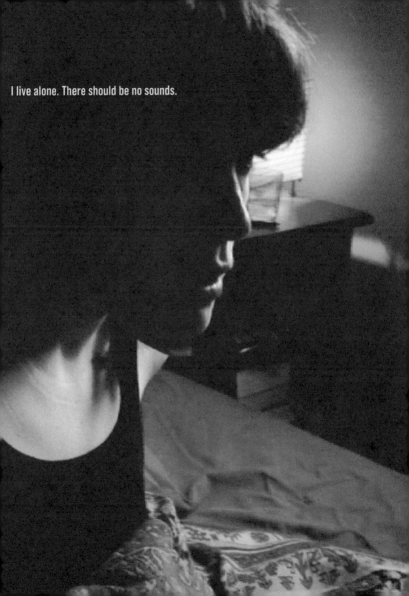

I live alone. There should be no sounds.

unheimlich

unwelcome

wrong

atmosphere →

of →

threatening →

strangeness →

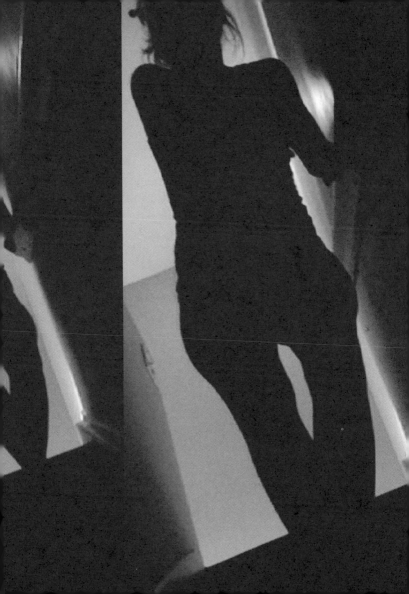

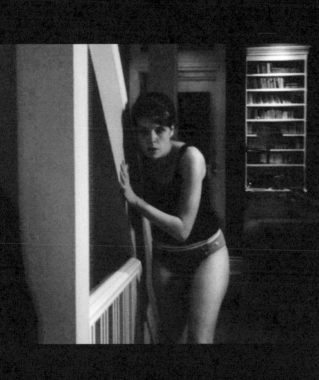

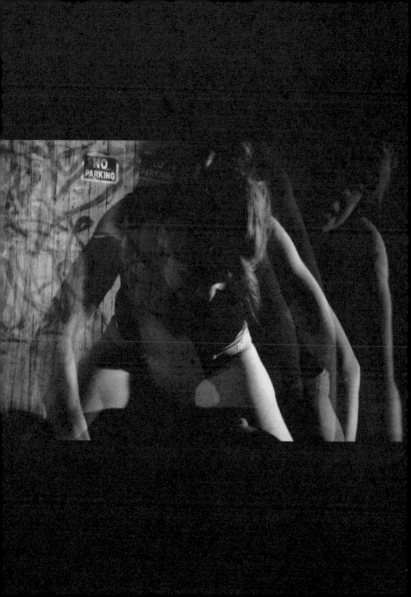

How long will she sit on me?

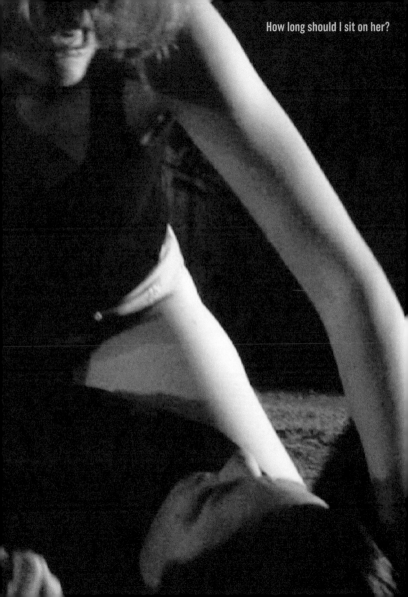

How long should I sit on her?

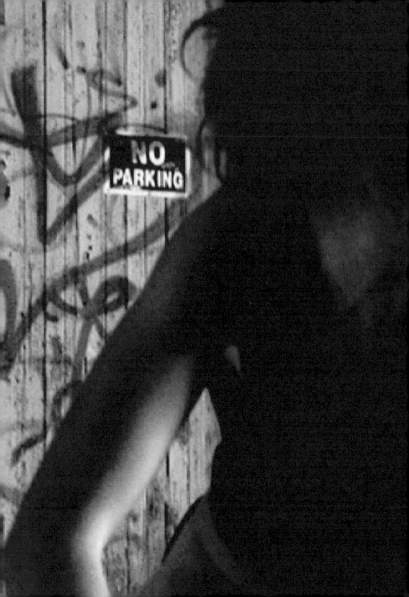

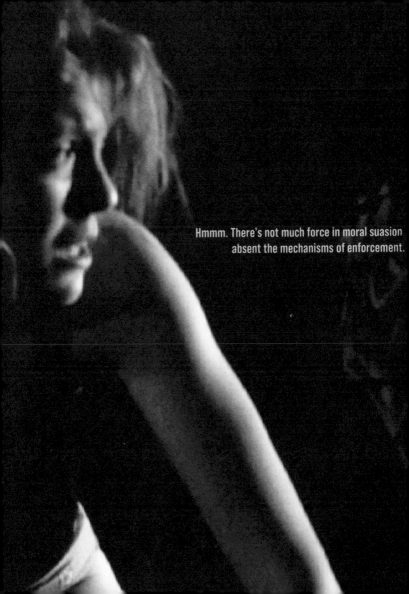

Hmmm. There's not much force in moral suasion absent the mechanisms of enforcement.

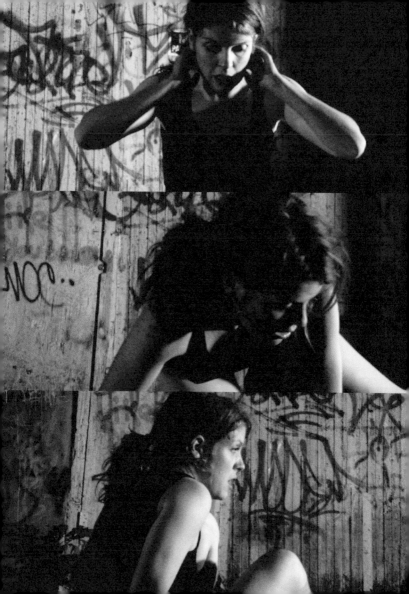

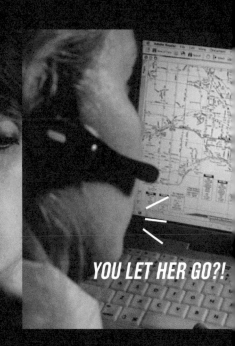

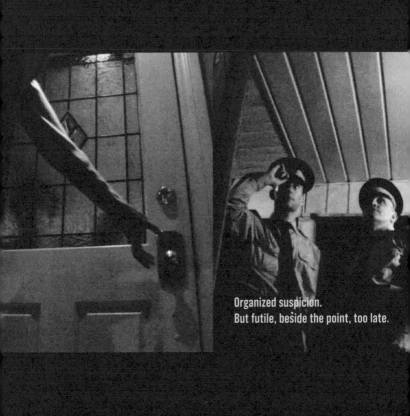

Organized suspicion.
But futile, beside the point, too late.

I, TOO, AM CARRIED ALONG INTO THAT KINGDOM OF MIST, INTO THAT DREAMLAND WHERE ONE IS FRIGHTENED BY ONE'S OWN SHADOW.*

*Kierkegaard

A few days later . . .

Something's missing.

Tool of my legal trace,

maker of argume[nt]

instrument of essay.

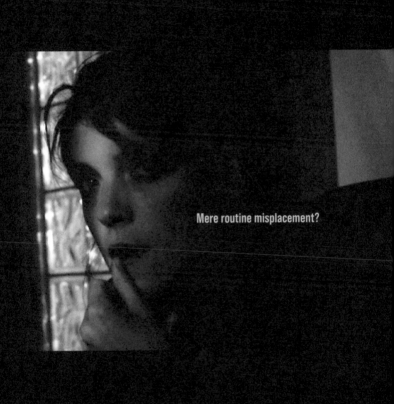

Mere routine misplacement?

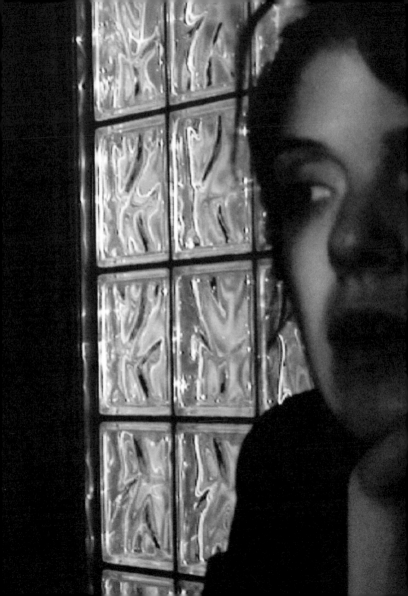

Or a hint of some deeper mystery?

director PATRICIA ROZEMA
with LAURA MACLEAN, SARAH BARBER, CONRAD BERGSCHNEIDER, and TYLER QUICK
producer JOHN KNECHTEL director of photography KIM DERKO
assistant director TIMOTHY STOCK second camera LUKE GROVES and JUSTIN HAIGH
grip NICK BUTLER and CHRIS JODOIN continuity CHARLENE LOKEY
fight choreographer TYLER QUICK casting agent JENNY LEWIS CASTING

DETAINED: IRAQ 2003

RITA LEISTNER / REDUX PICTURES

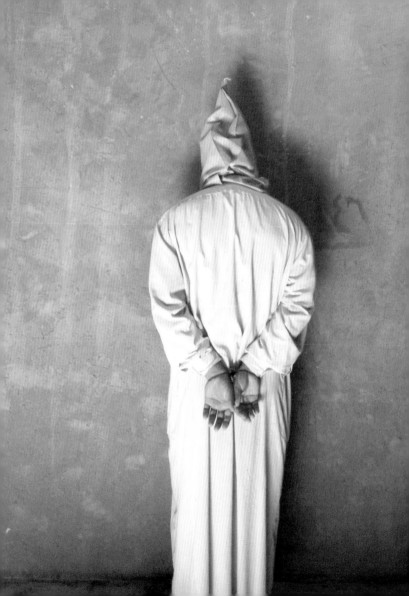

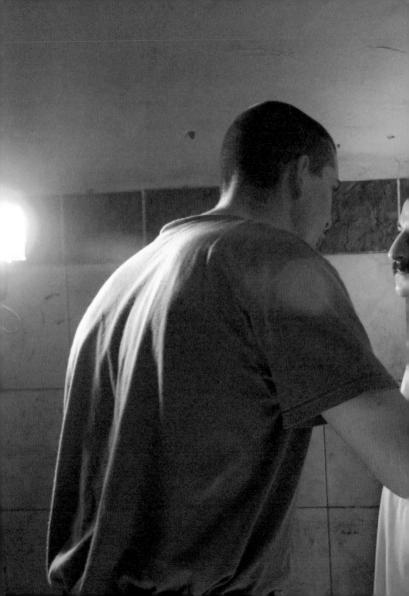

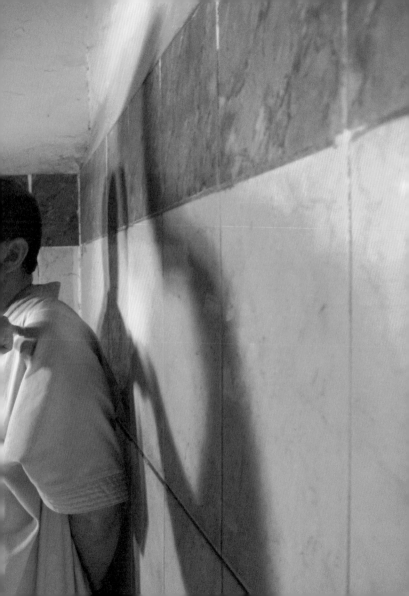

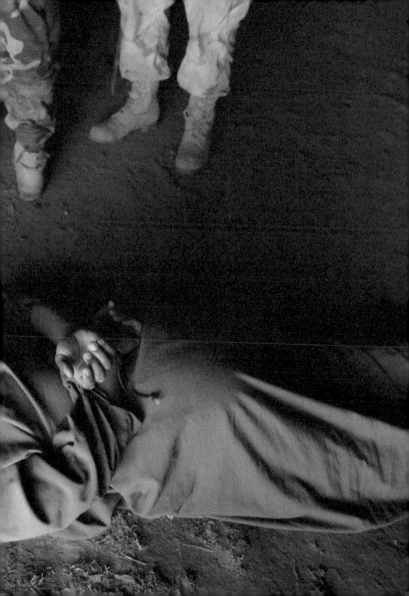

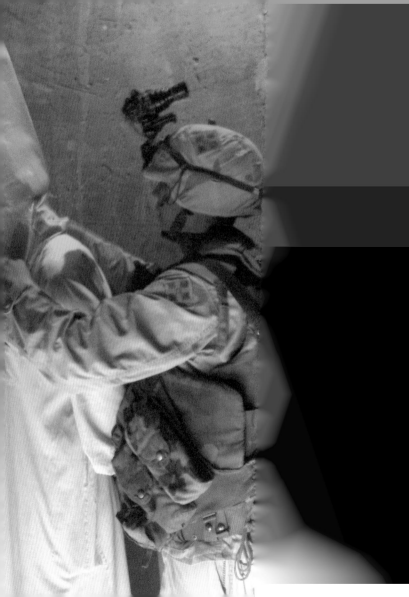

RUMSFELD'S UN
OR IRAQ'S INITI
INTO DEMOCRA

SLAVOJ ŽIŽEK

OWN KNOWN,
ION
PRACTICE

Does anyone still remember the unfortunate Mohammed Saeed al-Sahaf, Saddam's information minister, who, in his daily press conferences, heroically denied even the most obvious facts for the sake of the party line? When US tanks were only hundreds of yards from his office he insisted on continuing his broadcast, claiming the televised shots of tanks on the Baghdad streets were just Hollywood special effects. Who in the wider world, entranced by the spectacle of the war, could help but react to the absurdity of such a person, who, via some obscene fidelity, did not know what was so obviously known? In all this, however, al-Sahaf did strike upon a strange truth; when confronted with the claims that the US army was already in control of parts of Baghdad, he snapped back, "They are not in control of anything—they don't even control themselves!" Later, when the news broke about Abu Ghraib prison in Baghdad, we got a glimpse of this very dimension—that Americans are not in control of themselves.

To assert that American forces are not in control of themselves is to assert that George Bush's regime is not truly totalitarian, something proved by the very fact that Abu Ghraib came to light. In a genuinely totalitarian regime, the case would simply be hushed up. (In the same way, when the Iraq Survey Group did not find weapons of mass destruction it was a positive sign: a truly totalitarian power would have planted evidence to be "discovered.") But what actually happened in response to Abu Ghraib was that, instead of instigating a cover-up, the Bush administration went on the defensive, emphasizing how the deeds of the soldiers were isolated crimes and not indicative of what America claims to stand for and fight for: the values of democracy, freedom, and personal dignity.

However, a number of disturbing facts complicate this simple picture. In the months before the release of the pictures, the International Red Cross was regularly bombarding US Army authorities

in Iraq with reports about the abuses in military prisons there, and these reports were systematically ignored. It was not that US authorities were getting no signals about what was going on—rather that they only admitted the crime when (and presumably *because*) they were faced with its posture of transparency. One of the new torture-prevention measures was a prohibition against prison guards possessing digital cameras or cellular phones with video display—perhaps not so much to prevent further acts of photographic humiliation as to disallow the public circulation of the photos themselves. Also, the immediate reaction of the US Army command to the revelations of torture was noteworthy in this regard, to say the least: the explanation given at the time was that the soldiers were not properly taught the Geneva Convention rules about how to treat prisoners of war—as if to say that one must be taught that humiliating and torturing prisoners is a violation of common decency, not to mention international law.

But then again, this hasty obfuscation may have contained more truth than the Army had intended. There is something distinctly *familiar* about the type of humiliation performed by these otherwise ordinary Americans—more familiar perhaps than the notion of a few reservists *going bad* (in the sense of *bad apples*) in the desert. But what is this familiarity, or, why are the Geneva rules foreign? There is a significant contrast between the typical way prisoners were tortured under Saddam's regime and the acts perpetrated by these inexperienced guards. In the previous regime, the goal was the direct and brutal infliction of pain, while the US soldiers focused on psychological humiliation. Essential to this is the *recording* of the humiliation with a camera, with the perpetrators *included* in the picture, their faces stupidly smiling beside the contorted naked bodies of the prisoners. The American soldiers compulsively recorded what Saddam

worked to keep secret, and ironically it is this behavior that made the American acts vulnerable to exposure.

When I saw the well-known photo of a naked prisoner with a black hood covering his head, electric cables attached to his limbs, standing on a chair in a theatrical pose, my first reaction was that this was a shot of the latest performance art from Lower Manhattan. The very positions and costumes of the prisoners suggest a theatrical staging, a kind of *tableau vivant*, which cannot but bring to our minds the whole scope of American performance art and the "theatre of cruelty," the photos of Mapplethorpe, the weird scenes in David Lynch films, or even the consensual humiliation of contestants on popular reality shows such as *Fear Factor*.

And it is this feature that brings us to the crux of the matter: to anyone acquainted with the reality of life in the United States, the photos immediately brought to mind an obscene underside of US popular culture, say, the initiation rituals of torture and humiliation known as "hazing" that one has to undergo in order to be accepted into a closed community. Do we not see similar photos at regular intervals in the US press, when some scandal explodes in an army unit or in a high school campus, where an initiation ritual went overboard and soldiers or students got hurt beyond a level considered tolerable, were forced to assume a humiliating pose, to perform debasing gestures (like penetrating their anal opening with a beer bottle in front of their peers), to suffer being pierced by needles, etc.? Such humiliation would even be familiar to Bush himself, because of his membership in Yale's infamous and secretive Skull and Bones society—quite apart from questions about his involvement in the torture policies the world witnessed at Abu Ghraib.

Of course, the obvious difference is that in the case of such initiation rituals, one makes a free choice to undergo them, knowing what

to expect, and with the clear aim of gaining membership. This involves both being accepted into an exclusive inner circle, and, of course, being justified in performing the same rituals on new members. Abu Ghraib is obviously a different case: the ritual humiliations were not a price to be paid by the prisoners in order to be accepted as "one of us," but, on the contrary, act as the very mark of their *exclusion*.

But this is not to shift the focus too soon from the topic at hand: choosing to undergo a humiliating ritual of initiation is exemplary of *false* free choice. This instance of false consent and the justification of violence recalls a singularly disgusting ritual from the era of popular anti-Black violence in America's Old South: a Black man is cornered by white thugs and then compelled to perform an aggressive gesture ("Spit into my face, boy!"; "Call me a piece of shit!"). Once the victim complies, the aggressors use the action to justify the beating or lynching that results. Ultimately, the preeminent cynical message is sent by applying to the prisoners the properly American initiation ritual: if you want to be one of us you must first have a taste of the darkest aspect of our way of life—the public exposure of oneself as an object of humiliation.

Recall Rob Reiner's *A Few Good Men* (1992), a drama about two US Marines accused of murdering one of their fellow soldiers. The case revolves around the so-called "Code Red," the unwritten rule of a military community that authorizes the clandestine nighttime beating of a fellow-soldier who has violated or failed to meet the community's standard. Such a code condones an act of transgression. This act is illegal, yet at the same time, perhaps because the transgression is so radical, it reaffirms the cohesion of the group. It has to remain under the cover of night, unacknowledged, unutterable—in public, everyone pretends to know nothing about it, or even actively denies its existence. In fact, the climax of the film occurs when the

character played by Tom Cruise realizes that the exposure of this code is the only way he can prevent the burden of guilt falling solely on the shoulders of the Marines he is defending, and chooses to embody the superiority of the external legal code. He thereby provokes an explosive polemic from the commander (played by Jack Nicholson), which in turn serves to expose the fact that it was the commander's own enforcement of communal code which caused the illegal acts of torture, humiliation, and murder.

While violating the explicit rules of community, such a code represents the community in its purest sense, via pressuring the individual members to enact group identification. In contrast to the *written* explicit law, such an obscene code is essentially *spoken*. The problem is that the Abu Ghraib tortures do not fit into *either* of these two options: while they cannot be reduced to simply the evil acts of individual soldiers, they were, of course, also not directly ordered—they were legitimized by a specific and perverted version of the already obscene "Code Red" rules. To claim that they were the acts of "mutineers, deserters, or traitors in the field"[1] is nonsense akin to the claim that lynchings by the Ku Klux Klan were the acts of traitors to Western Christian civilization, and not the outburst of its own obscene underside—or that acts of child abuse committed by Catholic priests are acts of "traitors" to Catholicism. Abu Ghraib was not simply a case of American arrogance towards a Third World people: in being submitted to humiliating acts of torture, the Iraqi prisoners were effectively *initiated into American culture*; they got a taste of the obscene underside of the public values of personal dignity, democracy, and freedom. No wonder, then, that it is gradually

1. Christopher Hitchens (2004) "Prison Mutiny" http://slate.msn.com/id/2099888/

becoming clear how the ritualistic humiliation of Iraqi prisoners was not an isolated matter, but a widespread practice: on May 6, 2005, Donald Rumsfeld had to admit that the photos rendered public are just the "tip of the iceberg," and that there are much stronger things to come, including videos of rape and murder.

As to the institutional underpinnings of the Abu Ghraib "excess," by early 2003, the US government, in a secret memo, had approved a set of procedures to subject prisoners in the "war on terror" to physical and psychological pressure as a means of assuring their "cooperation" (the memo is fantastically Orwellian: long exposure to strong light is called "visual stimulation"). This is the reality behind Rumsfeld's dismissive statement that the Geneva Convention rules are "out of date" with regard to today's warfare.

In a recent debate on NBC about the fate of Guantanamo prisoners, one of the arguments for the ethical and legal acceptability of their status was that "they are those who were missed by the bombs." That is: since they were the target of US bombing and accidentally survived it, and since this bombing was part of a legitimate military operation, one cannot condemn their fate when they were taken prisoner following combat—whatever their situation, it is better, less severe, than being dead. This is, incidentally, the reasoning concealed behind every claim that the American torture is preferable to that of Saddam's regime.

Yet this reasoning tells us more than it intends to: it transforms the prisoner into one of the living dead (their right to live forfeited by being a legitimate target of lethal bombings). They become cases of what Giorgio Agamben calls *homo sacer*, the one who can be killed with impunity since, in the eyes of the law, his life no longer counts. It is the inverse of the problematic reasoning that informs the movie *Double Jeopardy* (1999): when imprisoned for murdering one who is

in fact still alive, once the sentence is served one has effectively gained the legal right to actually perpetrate the original crime, since one cannot be punished twice for a crime in the eyes of the law. If the Guantanamo prisoners are located in the space "between the two deaths," occupying the position of *homo sacer*, legally dead while biologically still alive, US authorities are also in a kind of in-between legal status which forms the counterpart to *homo sacer*: their acts are no longer covered and constrained by the law—perhaps an unfortunate extension of the thinking which holds acts of war as justified at all. In any case, the US authorities operate within the law in the sense that the law itself contains an empty space. And the recent disclosures about Abu Ghraib only display the full consequences of locating prisoners in this place "between the two deaths."

With increasing acceptance a similar legal nowhere, or utopia, forms the underside of global economics: the strategy of outsourcing—giving over the dirty processes of material production (but also publicity, design, accountancy) to another company via a subcontract. In this way, one can easily avoid ecological and health rules: if the production is done in, say, Indonesia, where the ecological and health regulations are less strict than those in the West, the Western global company that owns the logo can claim that it is not responsible for the violations of the subcontractor, who, from their perspective, is merely complying perfectly with the existing laws, which, while perhaps flawed, are outside of the control and responsibility of the original owner of the contract.

Are we not getting something homologous in regards to torture? Is torture not also being outsourced, enacted in Third World territory, and even left to Third World allies of the US, which can do it without worrying about legal problems or public protest? Perhaps it is the acceptance of corporate outsourcing that has led to the audacity with

which torture is recommended in the American media. Jonathan Alter, in a *Newsweek* article immediately following 9/11, stated "we can't legalize torture; it's contrary to American values," but nonetheless concludes that "we'll have to think about transferring some suspects to our less squeamish allies, even if that's hypocritical. Nobody said this was going to be pretty."

This is now an essential practice of First World democracy: the practice of outsourcing the dirty and necessary underside to legal utopias. We can see how this debate about the need to apply torture was by no means academic: today Americans do not even trust their allies to do the job properly, especially given the political value of security, and therefore it is the practices of the US government itself which must become "less squeamish." This is a quite logical result, once we recall how the CIA has for decades instructed Latin American and Third World American military allies in the practice of torture. And it is not only in this regard that the West no longer trusts the less enlightened aspects of life to be borne by the primitive Third World. In this context we can see in American fundamentalism another new resolve—taking on the previously unpalatable absurdities of religious faith. Perhaps in response to American televangelist Jerry Falwell's claim that 9/11 was caused by "the pagans, and the abortionists, and the feminists, and the gays and lesbians," American culture is taking back the business of salvation and getting "right with God"—and in so doing adding cataclysm-proofing to the new security initiative.

In March 2003, none other than Rumsfeld engaged in a little bit of amateur philosophizing about the relationship between the known and the unknown: "There are known knowns. These are things we know that we know. There are known unknowns. That is to say, there are things that we know we don't know. But there are also unknown unknowns. There are things we don't know we don't know." What he

forgot to add was the crucial fourth term: the "unknown knowns," things we don't know that we know. If Rumsfeld thinks that the main dangers in the confrontation with Iraq are the "unknown unknowns," the threats to operational success about which we cannot even hazard a guess, then the Abu Ghraib scandal shows there are dangers in the "unknown knowns" as well. These are the disavowed beliefs, suppositions, and obscene practices we enact but don't allow ourselves to see, and which—via practices such as outsourcing—are becoming increasingly easy to ignore. In this context the assurance of the US Army command that no "direct orders" were issued to humiliate and torture the prisoners is ridiculous: of course no such orders were issued, since, as everyone who knows army life is aware, this is not how such things are done. There are no formal orders, nothing is written, just unofficial pressure, hints, and directives delivered in private, legally fictitious ambiguities reminiscent of the paper trail of the "final solution." This is the increasingly innovative practice of sharing a dirty secret.

Bush was thus wrong: what we are getting when we see the photos of the humiliated Iraqi prisoners on our screens and front pages is the true image of "American values," the very core of the obscene enjoyment that sustains the US way of life. To invoke Samuel Huntington, these photos show a clash between Arab and American civilizations—not as a clash between barbarism and respect for human dignity, but as a clash between anonymous brutalism and good old American spectacle. It is the face of the "democratic" practice of torture, a total lack of guilt by way of remaining ignorant of what is known. And Rumsfeld, who certainly has mastered the double-think of press conferences at least as much as his Baathist counterpart Mohammed Saeed al-Sahaf, perhaps simply doesn't know that the following is perfectly reasonable for his fellow Americans: if Iraq

really wants to join the First World, it should be equally prepared to undergo the appropriate initiation.

One has here a proof of how, to paraphrase Walter Benjamin, every clash of civilizations is the clash of the underlying barbarisms. The barbarism of sovereignty shows itself in Abu Ghraib: laws do not really bind *me*, I can do to you WHATEVER I WANT, I can treat you as guilty if I decide so, I can destroy you if I say so. The universal and unconditional rule of Law can only be sustained by a sovereign power that reserves for itself the right to proclaim a state of exception, i.e., to suspend the rule of law(s) on behalf of the Law itself—if we deprive the Law of its excess that sustains it, we lose the Law itself.

We can see that the idea of just preemption itself depends on a willful ignorance of democracy's darker side. And we should not assume that an ignorance of democracy's darker side is unrelated to the thought of a just preemption. Here another kind of lack of vision is present in the context that surrounds the Iraq War. There is now an invisible Enemy that legitimizes the logic of the preemptive strike, similar to other Enemies in the twentieth century because it is also universally opposed, but distinct in that its face is never known. Precisely because the threat is virtual, the goal is always to strike before it comes into being—otherwise it is too late. In other words, the omnipresent invisible threat of Terror legitimizes the all-too-visible protective measures of Security, which themselves pose an even more substantial threat to democracy and human rights. With the war on terror, the invisible threat causes the incessant actualization—not of itself, but of the measures against itself. Again we see the significance of *Nineteen Eighty-Four*: the power that presents itself as being all the time under threat, living in mortal danger, and thus merely defending itself, is the most dangerous kind of power.

BEFORE AND AF

STEPHEN ANDREWS

ER

Abu Ghraib Erased

STEPHEN ANDREWS 123

124 SUSPECT

Interrogation Room #1 Erased

Interrogation Room #2 Erased

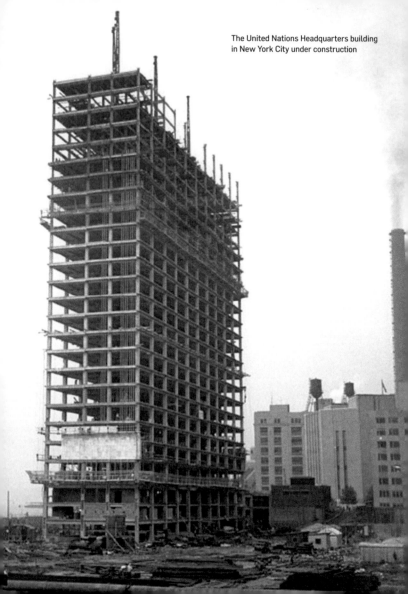

The United Nations Headquarters building in New York City under construction

SUSPECT STATES: KANT'S ADVICE FOR THE UNITED NATIONS

GEORGE BRAGUES

With the end of the Cold War, the United Nations seemed on the brink of finally embarking on its original mission "to reaffirm faith in fundamental human rights" and "save succeeding generations from the scourge of war" (*United Nations Charter*). It was the US–Soviet conflict, after all, that largely consigned the UN to the margins of international politics after its founding in 1945. It did not take long for the UN to exploit this opening to make its presence felt on the global scene. In 1990, the UN Security Council approved the use of force for what eventually turned out to be a thirty-four-nation campaign, launched in January 1991, to liberate Kuwait from Iraqi invaders. That was the first time the UN Security Council played a decisive role in a major conflict since 1950, when a Soviet boycott of the council enabled the US and its allies to obtain authorization to fight the Korean War.

But as the 1990s progressed, the UN's legitimacy was eroded by the inability of its peacekeepers to prevent the atrocities committed in Somalia, Rwanda, and Bosnia. Nor did it help that the Security Council in 1999 proved unwilling to sanction the intervention of forces in Kosovo to defend ethnic Albanians from Serbian aggression. To top it off, the US, alongside Britain, appealed to the Security Council in early 2003 for a resolution authorizing an invasion of Iraq, recognized that it would not be able to obtain the necessary votes, yet invaded anyway. This sidestepping of the UN was justified mainly by the argument that Saddam Hussein's regime represented a serious danger to other nations. In making this assertion the US and Britain, along with the forty-eight nations in the so-called "coalition of the willing" that originally joined them in occupying Iraq, effectively condemned the UN as irrelevant to meeting the challenges raised by what we might justly refer to as suspect states—to wit, states that threaten other states.

Observing that the UN thus faced "a decisive moment" in its history, Secretary-General Kofi Annan appointed a panel of fifteen

experts, each from a different nation, to evaluate the UN's role in the contemporary international arena and provide recommendations (Annan 2004). The group, known as the High Level Panel on Threats, Challenges, and Change, tabled its report in December 2004. On the capital issue of the appropriate use of force to deal with suspect states, the panel did not heed calls to relax the restrictions on a state's right to self-defense. Instead, the panel reaffirmed the notion that an imminent threat is required to unilaterally act on that right. To deal with non-imminent threats more effectively, the panel proposed that the membership of the Security Council be enlarged so as to render that body more representative and more reflective of those countries that proportionately contribute the most to UN efforts. No recommendation was made to change the veto system, whereby any one of the five permanent members of the council—US, Britain, China, France, and Russia—can nullify any measure.

Immanuel Kant, the eighteenth-century German philosopher, was among the original exponents of collective security, the regime that the UN is dedicated to instituting. As a result, Kant's thought offers us the possibility of reflecting on the UN through a fresh mental lens, unencumbered by the ideological grids imposed by the dominant political passions of our day. Indeed, Kant's work remains of central and contemporary importance to the UN. In his recent account of the UN founding, Stephen C. Schlesinger identifies Kant as a key philosophic influence on the eventual development of an organized assembly of nations (18), while the UN's *Universal Declaration of Rights*, centered as it is on the assertion of "the inherent dignity and worth of the human person," reflects the core premise of Kant's moral philosophy.

Kant describes our overwhelming moral duty to further the cause of collective security through a coalition of democracies. At the same

time, Kant stresses that collective security cannot be realized until history has progressed to the point of equating national interest with moral duty. Until then, from the Kantian standpoint, the goal of bringing suspect states to account through the global rule of law must adjust itself to the Hobbesian world in which nations continue to operate. On all these scores, the UN panel fails.

The Moral Basis of Kant's International Politics

Against the realist tradition in international relations—epitomized by Thucydides, Niccolò Machiavelli, and Hans Morgenthau—Kant rejects the idea that governments interact with each other in an amoral universe where the logic of national self-interest entirely rules. Instead, princes, prime ministers, presidents, and other potentates are called to heed the moral experience of everyday, decent persons. Their understanding is the starting point for moral thinking, inasmuch as the task of the philosopher, for Kant, is to make rational sense of ordinary experience, as opposed to interrogating that experience in the hopes of arriving at some deeper, more firmly grounded, view of things. That sort of examination, Kant figures, can only lead to skepticism.

Now, deep down, every morally respectable individual is conscious that there are certain rules of conduct that should be followed, no matter what the circumstances. Therefore, whenever a conflict arises between doing what is right and what is to one's advantage, decent persons recognize that the former is to be preferred. From this, Kant deduces that morality entails a set of unconditional and universal commands, namely laws. Not only that, he infers that the highest good for human beings is the possession of a good will. By this he means a disposition to perform one's duties for their own sake and with reverence for the moral laws, rather than from any view of gratifying one's desires and passions. As a result, Kant parts ways

with the utilitarian tradition, which claims morality to be a derivative of policies likeliest to maximize human welfare. Since politics is the arena in which people collectively try to promote their well-being, it follows for Kant that governments must also ultimately bow to the dictates of morality.

As to what exactly those dictates specify, Kant claims that reason cannot theoretically discover the moral laws "out there" in nature or in God. It is up to us to deploy our reason to give a practical reality to morality, by having reason legislate its own laws. These must be universal and unconditional, in accord with the intimations of ordinary moral consciousness. Kant's famous formula for doing this is the categorical imperative: "Act only according to the maxim whereby you can at the same time will that it should become a universal law" (Kant 1983, 30). In elaborating this, Kant's account is rather intricate, engendering countless debates among his readers, but he does eventually restate the imperative with a clearer rule: "Act in such a way that you treat humanity, whether in your own person or in the person of another, always at the same time as an end and never simply as a means" (Kant 1983, 36). This is the aspect of Kant's moral teaching that is most invoked in contemporary debates, particularly in the claim that human beings are worthy of respect and concern and are not to be treated as objects or commodities.

Seen in this light, war poses a very obvious moral difficulty. For whatever purpose it is fought, whosoever interests it is designed to advance, war often presents the spectacle of one group using another within the same society. This is most evident when a nation's army is mobilized merely to further the ambitions of an elite class or that of a single ruler. Yet even in a modern Western democracy acting unanimously in self-defense, professional soldiers bear the greatest risks, and are chiefly the ones to give up their lives for the country.

The rest of the citizenry, meanwhile, stays away from the battlefield, safely following events on television. Also standing to benefit from present sacrifices are the unborn of future generations. Accordingly, Kant demands that standing armies be abolished, for, "paying men to kill or be killed appears to use them as mere machines and tools in the hand of another (the nation), which is inconsistent with the rights of humanity" (Kant 1983, 108). Only the use of a voluntary, citizen militia, whereby people fight more of their own battles, can stop war from using persons as dispensable objects. But a citizen militia can be gradually substituted in place of standing armies only as we get closer to the consolidation of a perpetual peace. Besides, whatever type of force is used, war still requires that people sacrifice resources to finance a military complex that could otherwise be allocated towards activities that develop our moral faculties. No wonder Kant declares that, "the greatest evil that can oppress civilized peoples comes from wars" (Kant 1983, 58).

A Federation of Democratic Republics

To rid the world of war, it is necessary to have a theory of how wars occur. Like Thomas Hobbes, the seventeenth-century English philosopher, Kant saw that war results from the combination of human selfishness and the anarchic condition of international relations. No common authority exists to bind the different states to a single code of conduct. In this state of nature, governments are free to seek power at the expense of others whenever they calculate that the benefits of doing so are worth the costs of executing their designs. To preserve their security in the face of this calculus, nations must make adequate military provisions in order to render it more costly for others to assail them. War, then, takes place either because a suspect state attacks another and meets resistance or because an arms buildup causes

states to perceive each other as suspect and tensions rise to the boiling point. Given such an account of war, and assuming human selfishness cannot be changed, a method of ensuring peace immediately suggests itself: have states agree to an international social contract in which each gives up the freedom to use force as they see fit, and instead adheres to the will of the combined body.

While Hobbes never broached this solution, Kant argued it could be realized through a federation of democratic republics. He proposes a federation, rather than a world government, fearing that the latter would be hard pressed to control so large a territory without relying heavily on coercion. World government raises the horrible prospect of global tyranny. So too, the policy of Kant's federation is to use force only in self-defense, to preserve the security and freedom of each member against suspect states. Though it has a right to do so, the federation is advised not to compel other nations into joining it. Nor does it have any right to intervene in a suspect state's affairs and change its constitution to a democratic form in order to create a new candidate for the federation: "A nation is not...a possession. It is a society of men whom no one other than the nation itself can command and dispose of" (Kant 1983, 108). Instead, Kant hopes that the example set by the coalition of democracies in the federation will serve as a model for other nations to follow.

Kant wants the federation to be restricted to democratic republics, because he reckons that such governments are much less likely to go to war. In what is now referred to as the democratic peace argument, Kant claims that authoritarian regimes can easily declare war, inasmuch as the key decision makers need not worry about personally suffering the costs of battle. An autocrat "can decide to go to war for the most meaningless of reasons, as if it were a kind of pleasure party, and he can blithely leave its justification (which decency requires) to

his diplomatic corps, who are always prepared for such exercises" (Kant 1983, 113). In a democracy, by contrast, the key decision makers are the people, the very ones who must bear the brunt of the sacrifices. In other words, democracies enable the calculation whether or not to commence hostilities to better reflect war's true social costs.

Needless to say, the UN bears a less than perfect resemblance to Kant's federation of democratic republics. No event has made this gap more glaring than the 2003 installation of Libya as the chair of the UN Human Rights Commission. According to Freedom House (2003), only 87 of the 191 (46 percent) UN's member states are classified as free. To be sure, the trend has been improving since 1973, when just 53 states throughout the world were considered free. The ratio is better in the Security Council, the UN's main policy-making body, where 11 of the 15 current members are classified as free. However, among the five permanent members with the veto, just three are free; while China and Russia are ranked, respectively, as not free and partly free.

In the Kantian view, UN reform should be directed at giving the democracies a greater say in the formulation of policy. For starters, the membership of the Human Rights Commission, or at the very least its chairmanship, would be restricted to recognized democratic states. Instead, the UN panel recommended that the Commission be open to all member states, while saying nothing about imposing any limitations on who gets to be the chair. To his credit, Kofi Annan subsequently rejected this recommendation. He proposed the abolition of the Human Rights Commission in favor of a new "Human Rights Council" to be made up of nations with good track records on human rights. A Kantian might also demand that the Secretary-General, the public face of the UN, come from a democratic country. The panel, too, could have granted NATO, the closest analogue to Kant's league

of democratic republics in the modern world, more leeway to act, instead of requiring it to obtain Security Council approval like any regional organization. Then there is the idea of mandating that the non-permanent members of the expanded Security Council be democratic states, which the panel ignored.

Skeptics will counter that democracies can just as easily go to war as non-democracies, insofar as the populace can be taken in by political elites seeking to divert attention away from domestic problems. Yet from 1816 to 1980, there were 416 wars, of which just 12 involved democracies fighting each other ("The Politics of Peace" 17). A number of academic studies favor the democratic peace argument (Oneal and Russett; Rousseau et al.; Dixon).

The Right of Self-Defense

If suspect states are best dealt with through democracies using force solely to maintain their own security, the question that naturally follows is how that policy of self-defense is to be pursued. The UN's answer to that question is laid out in Chapter VII of its charter, in which the Security Council is assigned the responsibility for determining whether a threat to the peace exists and, if so, what sort of measures ought to be taken. In other words, no member state can act on its own to meet a perceived suspect state; it must take its case to the Security Council—except, that is, if the conditions of Article 51 are met, namely that one is either under attack or is confronted by an imminent threat.

Noting the ascendance of terrorism and the spread of nuclear weapons, scholars and politicians have increasingly challenged the imminence standard. In the past governments were able to deter suspect states by pledging such a massive response to an actual or imminent attack as to negate any potential gains by the aggressor.

Today, this may no longer suffice. Suspect states might escape detection by covertly handing nuclear weapons over to terrorists, who themselves have no territorial interest that can be hit. Suspect states with nuclear ambitions can be more safely dealt with while they are still developing weapons of mass destruction than when they already have them. Finally, the leaders of suspect states do not care about how their populations might be affected by a military response to their belligerence (Posner and Sykes 9; *The National Security Strategy* Sect. v). In defense of Article 51 as it currently stands, the UN panel argues that if a truly strong case exists in favor of acting against a particular non-imminent threat, the Security Council will recognize it. What is more, once any one country invokes self-defense to meet a distant peril, it will set a precedent for other countries, destabilizing the international system.

For Kant, the issue is to be decided by determining whether or not the relations among states currently operate under the rule of law. For that to be the case, a common set of rules that states are constrained to follow must prevail. Thus, Kant criticizes prominent international law thinkers of the seventeenth and eighteenth centuries, singling out Hugo Grotius, Samuel Pufendorf, and Emmerich de Vattel for elaborating codes of inter-state conduct based on natural law and tradition, as well as custom, and then calling it the law of nations. By Kant's reckoning, such a law never stopped any nation intent on going to war from actually doing so, and therefore cannot properly be called a law. Applying this logic to our situation, 291 wars have taken place since the UN's founding in 1945. Again, only two have been sanctioned by the UN. That is all the evidence we need, from the Kantian view, to conclude that international political life continues to be mired in a Hobbesian state of nature. In this lawless state nations nonetheless have rights to exercise, among them the right to

act preemptively in response to "the menacing increase in another state's power" (Kant 1991, 153).

The Need for Hope

Yet none of this does away with the moral imperative to remove ourselves from the international state of nature towards a federation of democratic republics. Caught between this imperative and the power politics of international affairs, our time demands what Kant calls "moral politicians" as opposed to "political moralists." Whereas the latter rationalize their pursuit of advantage with a lot of moral talk, the former prudently defend their nation's interests in a way that is truly consonant with morality. This position is perhaps best expressed by the maxim "always so to proceed in their conflicts that such a universal cosmopolitan nation [the league of democracies] will thereby be introduced, and thus to assume it is possible…and that it can exist" (Kant 1983, 89).

To sustain the hopes of moral politicians, and those of their well-wishers, Kant puts forward a theory of historical progress. Kant is not so optimistic as to believe that matters will improve because people shall become more moral. In a variation of Adam Smith's invisible hand tailored to international politics, Kant posits that the individual and collective pursuit of gain will eventually bring about the elimination of suspect states and thus perpetual peace, without anyone consciously intending it. Driving this forward will be the growing destructiveness of wars, made possible by the technological advances of increasingly prosperous societies. So destructive will these wars become that nations will finally acknowledge it in their interest to form a federation. Another factor will be the growth of commercial ties between nations, or what we nowadays call globalization. War will simply end up being viewed as economically unviable.

While the UN panel could hardly have been expected to further the historical process by encouraging war—although, bizarrely enough, the implication of Kant's reasoning is that such a course would be useful—it could have lent more vigorous support to the idea of strengthening commercial ties between nations. As is the case with the democratic peace argument, studies do corroborate the thesis that globalization reduces conflict (Weede; Oneal and Russett). Alas, in Kantian eyes the UN panel comes off as being too much the moralist and too little the politician.

WORKS CITED

Report of the Secretary's High Level Panel on Threats, Challenges, and Change (2004)
A More Secure World: A Shared Responsibility
http://www.un.org/secureworld/

Kofi Annan (2004)
Note by the Secretary-General
United Nations General Assembly, 59th Session

William J. Dixon (1994)
Democracy and the Peaceful Settlement of International Conflict
The American Political Science Review 88.1

Freedom House (2003)
Freedom in the World Country Ratings
http://www.freedomhouse.org/ratings/index.htm

Immanuel Kant (1983)
Perpetual Peace and Other Essays
Ted Humphrey, trans.
Indianapolis: Hackett

——— (1991)
The Metaphysics of Morals
Mary Gregor, trans.
Cambridge: Cambridge University Press

John R. Oneal and
Bruce Russett (1999)
The Kantian Peace: The Pacific
Benefits of Democracy,
Interdependence, and International
Organizations, 1885–1992
World Politics 52.1

Eric Posner and Alan O. Sykes (2004)
Optimal War and
Jus Ad Bellum John M. Olin Law and
Economics Working Paper No. 211
The Law School at the
University of Chicago
http://ssrn.com/abstract_id_546104

David L. Rousseau,
Christopher Gelpi, Dan Reiter,
and Paul K. Huth (1996)
Assessing the Dyadic Nature of the
Democratic Peace
The American Political Science
Review 90.3

Stephen C. Schlesinger (2003)
Act of Creation:
The Founding of the United Nations
Boulder: Westview Press

National Security Council (2002)
The National Security Strategy of the
United States of America
http://www.whitehouse.gov
/nsc/nss.html

The Politics of Peace (April 1, 1995)
The Economist

United Nations (2005)
United Nations Charter
http://www.un.org/aboutun
/charter/index.html

——(2005)
Universal Declaration of Rights
http://www.un.org/Overview
/rights.html

Erich Weede (2004)
The Diffusion of Prosperity and Peace
by Globalization
The Independent Review 9.2

LIBERALISM: OR WHAT RIGHT IN A SHIPWRECK

KENT ENNS

LOOK LIKE

In an ancient discussion about natural justice, what we today would call universal rights, a Roman named Philus reports on the claims of the skeptic Carneades who holds that wisdom is superior to justice. To make his point, Carneades tells the story of a strong man tossed into the sea during a shipwreck. As he flounders desperately in the dark waters he sees a weak man clinging to a narrow plank. To save himself the strong man must push off the weak and seize the plank for himself. Why not? There are no witnesses to threaten future retribution. Of course, the strong man could refuse to push off the weak man, could decide to act justly. But he would throw away his own life. Philus concludes that: "political justice is not really justice but prudence; natural justice is indeed justice, but it is at the same time folly" (Cicero 68).

What is surprising is that after Philus's sobering remarks, his interlocutor, Laelius, *doesn't* respond directly to the charge that, in terms of political judgment, universal rights (natural justice) are folly. Instead of deliberating on how the regime ought to handle the question of its own survival, or the advent of its enemies, Laelius extols the heartfelt protoliberal virtues of the Stoic doctrine of natural law: "right reason in harmony in nature. It is spread through the whole human community, unchanging and eternal, calling people to their duty by its commands and deterring them from wrong-doing by its

Note on the image: Géricault's *The Raft of the Medusa* (1819) depicts survivors from the wreck of the *Medusa* off the coast of Senegal in 1816. One hundred and fifty people who couldn't get into the overfull lifeboats made a raft and tied it to the boats, but they were soon cut loose and abandoned. Mutiny, insanity, mutilation, thirst, famine, and cannibalism soon followed. After thirteen days adrift, fifteen survivors were recovered. The captain, an incompetent seaman of noble birth, was widely criticized in the popular press for ensuring the survival of the senior officers and himself while simply abandoning the lower ranks.

prohibitions...all peoples at all times will be embraced by a single and eternal and unchangeable law....Whoever refuses to obey it will be turning his back on himself" (Cicero 68–69; cf. Locke 271).

In a now predominantly secular age, some two thousand years after Cicero authored his *Republic*, liberalism is perhaps the closest many of us will come to theological belief. And, as with most types of belief, our minds are opened to certain claims, closed to others. We recognize the irreducible and irreplaceable worth of each and every human being. We stand against those who would violate human rights in the pursuit of their own particular goals. We abhor the death and suffering that accompany war. Imbued with notions of universal respect, we, like Laelius, can barely countenance the notion of "enemies." How did this come about?

Any version of liberalism, however non-prescriptive about values or human nature its proponents believe themselves to be, will have a regulative dimension. It will have something to say about the way the world is, how it ought to be, and it will include a set of assumptions about what individuals really are, and what moves them (Sandel 14). And liberalism will have this difficulty with the concept of enemies because it considers that every individual belongs to a universal class of rights-bearing "humanity" (Kant 37–38; cf. Manent xvi). Only later (if ever) can liberalism entertain the notion that individuals might more accurately be considered as culturally formed citizens, who may or may not be appropriately guided or motivated by rationality, and who belong to particular (and perhaps highly defective) regimes.

To think of regimes entails the possibility that there are individuals or groups who are utterly opposed to a regime, its policies, its influence on the world. Clearly political regimes can and do have enemies. But from the perspective of liberalism, "enemies," even terrorists, are to be understood first as disenfranchised and oppressed

emissaries of *humanity*, whose every complaint against the world, against a particular regime, must be investigated and taken seriously. "Enemies" represent not so much specific threats to regimes, but rather implicit critiques of regimes.

Liberalism, as a philosophy, has several core principles that can be reduced to a single claim: states exist for the sole purpose of protecting the absolute rights of individuals—who are understood as largely "unencumbered" in their capacity to choose different ends (Sandel 19). Rights (sometimes referred to as "liberties") are thought of as not merely the result of political convention or legislation; rather they are said to exist "absolutely and unqualifiedly" irrespective of any particular regime, in a kind of timeless purity (Mill 17). In modern political regimes, a protected sphere of immutable individual rights is understood as a beneficial outcome of sound political arrangement, *and* as a standard or "eternal rule" against which a society's legitimacy can be tested (Locke 357–358). Hence rights violations, whether in pursuit of extra-territorial aims or in the protection of "the homeland," define a border that must not be crossed, a limit to state action. In fact, modern Western-style liberal democracies often construe rights as *the* political good, the "first virtue of social institutions" (Rawls 3), the basic "entitlements" (Nozick 206–207), and the "trumps" (Dworkin xi) that the rules of the political community must uphold as their very raison d'etre.

Why must rights be upheld? So that individuals may determine for themselves what good, what aim, to pursue; for implicit within liberalism is the Hobbesian claim that none is more wise than oneself in determining what good is worth pursuing. Further, as rational and self-legislating, individuals are properly subject only to those laws of which they may also consider themselves to be the author (Kant 38; *Federalist Papers* #51). This self-legislating account of human beings underpins every political notion of universal sovereignty, simply because

universal sovereignty entails the basic presupposition that everyone *ought* to be consulted, is *worth* consulting, and that this obligation is to be recognized and fulfilled through the legitimizing mechanisms of modern democracy. For liberalism, states are best construed as politically neutral zones in which rights-bearing individuals may pursue their own ends, as long as they don't impede the similar pursuits of others. This long-standing principle of non-interference, when attached to the quasi-theological values of universal sovereignty in modern democratic theory, becomes the operative foundation for a whole range of positions, from left liberalism to libertarianism and various theories of the market (see, for example, Rawls, Nozick, von Mises).

Procedural neutrality—a commitment by the state to refrain from hindering or helping different life plans that individuals or groups might have—bolsters liberalism's central commitment to individuals and ostensibly preserves an unbiased institutional and legal background for their self-seeking activities; quite simply, it provides an unbiased court of appeal in the case of disputes between individuals and businesses. Most significantly for our purposes, this neutrality protects citizens from illegitimate or prejudicial action by the state (the rule of law). But a question we're confronted with is whether so-called liberal states do indeed prejudicially promote one particular version of the good, openly or covertly. The "official" account runs: since the state has a monopoly on the coercive use of force, and since, historically, governments conjoined with dogmatic theological beliefs have shown themselves to be toxic entities, liberals understand that questions of religion must be distinguished from political matters. (The Wars of Religion and the English Civil Wars, both of which followed the partial dissolution of the authority of the Church of Rome in the sixteenth century, so brutally drove home this point that state secularism itself became a dogma, one promoted by Hobbes, Grotius, Locke,

and Spinoza, among others.) This separation of politics and religion isolates religion from political decisions regarding the legitimacy of the pursuits of citizens, but this separation also prevents the state from investing in *any* conception of the essence or nature of the human being other than the bare assertion of its calculative, self-interested rationality, its autonomy, its freedom. This principle is sometimes expressed as the priority of the right over the good.

Modern political philosophy has been engaged in an ongoing attempt to deflate theological interests (that is, their claims on political rule), and to protect the procedural neutrality (equal rights, rule of law, due process, bicameralism) of regimes from domination or subversion by those who claim a higher knowledge of higher things (or by those who are simply mad or malevolently power-hungry). Yet, in insisting on procedural neutrality, modern political thought has also insisted on a stripped-down account of what it is to be human (calculatively self-interested, autonomous—see, for example, the tenth of the *Federalist Papers*). Such an account appeals to the broadest possible constituency, to what Tocqueville referred to as "that immobile point of the human heart" (Tocqueville 228). In short, greed or self-interest narrowly understood. But it may simply be the case that achieving an expedient consensus has not produced a complete understanding of political association or of the human beings who inhabit and rule regimes. The insistence on a particularly narrow definition of what it is to be a human being (and indeed a citizen) ignores broader conceptions of what human beings are, what, for example, molds and motivates them in less obvious ways. To abjure a broader means of analysis and description means that, when confronted by irrationality or erotic or self-aggrandizing violence, the liberal does not know how to respond. Why? Because he lacks not only an understanding of others, but of himself. While the liberal

may indeed grasp, if only intuitively, that political actors of the most persuasive and lethal kind can be carried, erotically transformed, even enlarged in a particular sense, by the utterly human propensies for competition, glory, and mastery over the procedural, the liberal moralist himself is unmindful that it is but a rarefied version of this same propensity that constitutes the quasi-philosophical movement involved in his own striving for universal principles (which ostensibly account for the inner nature of human beings and the appropriate forms of political association). And this liberal moralist, though himself *unavowedly* competitive, believes he thereby masters competing moral and political visions. Neither type, highly aggressive political actor or universalizing moralist, can resist attempting to convert the political into the arena wherein his valorized longings, his morality, may have freest play. Because politics *is* the arena where competing visions of the best life, that is, competing moral views of what it is to be a human being, what it is best for human beings to do and to strive for, are played out. Put another way, politics is never about power, but rather always about what to *do* with power.

The inability or refusal of secular liberalism to advance a theory of human nature, beyond meagerly positing rational self-interest and the rights of self-determination, comes with further limitations. First, liberalism's investment in the concept of procedural neutrality makes it extremely difficult for it to recognize that the legislative design of liberal democracies represents the *constitutional* advocacy of one particular mode of life over others. Thinkers otherwise as disparate as Aristotle and Hayek, for example, were both able to recognize that democracies were, in fact, highly susceptible to domination by the interests of the wealthy, and they grasped that in *reality* democracies are best described as plutocracies (or oligarchies). Which is to say, economically liberal democratic regimes are *not* neutral: they foster

the interests of wealth and thereby uphold it as the highest good (see Aristotle 1279b; Hayek 32, 134). Second, the major monotheistic religions are able to specify and name evil because they hold to larger claims about what it is to be a human being, and they "know" what it is to *deviate* from being an upright human being. More to the point, for our purposes, classical political philosophers (Plato and Aristotle, for example), while highly suspicious of the claims of religion, can also recognize instances of seriously defective humanity because they hold to a larger theory of what it is to be a complete and properly rational human being. They recognize that, where possible, politics must be rigorously protected from the undue influence of defective individuals. But procedural liberalism, since its account of the "complete" human being is limited to a rights-enshrined self-interest, finds it difficult not only to specify in what way certain individuals, certain types, are defective (or even evil), but to declare its enemies. For liberalism typically believes its enemy is *both* rational (since acting out of self-interest) *and* suffering from a failure of rationality (that is, an inadequate adoption or internalization of the universal truth of the universal rights of self-determination). Yet, since humanity is a category that transcends all politics, the rights of the "enemy," the suspect, must be upheld procedurally by the liberal polity. Indeed, a failure to preserve, uphold, and protect such rights is the beginning of the end of a government's legitimate claim to rulership. Recently, confronted by direct assaults on the (universal) regime, liberalism has been troubled by rights violations, violations that from the perspective of the regime may have appeared necessary, or were defensible, but which from the perspective of *the* liberal political entity, the individual, were morally untenable aberrations of procedural norms. Thus it is that liberalism in our day finds itself in a position that, being political, rather than merely moral, is perhaps untenable.

When confronted with certain political emergencies liberalism lacks a principle on which to act decisively. Politics is more than what is accounted for by the universalist axioms of liberalism. Perhaps, to its credit, even when the regime is at stake, liberalism (committed first to the defense of humanity) strives to uphold what it conceives to be the supreme political goods. It is a vigilant witness against those who would violate rights, even in the pursuit of avowedly just (rights-preserving or rights-promoting) actions, domestic or foreign. But if citizens are faced with attacks upon the territory, infrastructure, property, and persons of the state to which they belong, they may be contending with enemies who simply are not available to the procedural regularities of the regime (the attackers are based on foreign soil, or they have concealed themselves within the society). What, then, is to be done? More attacks are imminent. How far ought states go to expose and expel attackers, traitors, terrorists, sympathizers, and supporters in pursuit of the protection of its citizens (and, though this is largely unaddressed within liberal modernity, how far to uphold or assert a state's reputation for might, honor, and integrity—territorial and otherwise)? It is paradoxical but true that the expansion and protection of rights will always produce violations; and there will never be a pure noncoercive universal regime. And liberals, much like Laelius in his grander and more effusive moments, pretend not to know this. If a government seeks, by military means, to protect or establish basic human rights beyond its own borders (or defend them from perceived threats) there will be violations. At minimum, extra- or quasi-legal incarcerations. At the extreme, torture, killings. But will such violations inevitably and irrevocably destroy the legitimacy of the offending government or regime? To those who bear the burdens of office (that burden sometimes being precisely the viability of the political organism) liberalism's answers

have not proved sufficiently reassuring to dissuade regime leaders from initiating controversial action.

Confronted by an incomplete understanding of regimes, I wonder if, rather than a politics, contemporary liberalism might better be described as a morality, that is, as yet another set of claims or ideas about the best way of life. Every day, people live and die for the sake of ideas. For the liberal moralist who denounces "Western imperialism" without offering meaningful alternative political actions (other than incessant deliberation), the risk of irrelevancy is more terrible than many have grasped. A typical gambit is that violations of *jus in bello* (justice in the course of war) inevitably subvert even the most defensible and noble of principles with which one began, *jus ad bellum* (the just cause of war). And there lies the risk: in articulating what in one sense (narrowly Kantian) are morally unassailable positions—e.g., any violation of rights even in the ostensible pursuit of rights (for the sake of preserving or extending the franchise, we might say) betrays the moral principles that were appealed to in order to justify the action— the moralist unwittingly gives up on the real, and takes refuge in dispensing lofty condemnations of the bespattered actors of the age. Such moralists (or who we might more specifically refer to as members of the cultural left) retain a quiet inner preserve of moral purity and become a secular version of what Hegel called "beautiful souls." But can we not ask of any set of principles that consistently fails to produce a maxim by which one may act if it is indeed truly a morality (let alone a politics)? For liberals, this is among the great enigmas of the age: how can liberalism be so right and so useless at the same time?

For Aristotle (among many others) feasible government at minimum depends upon the state being able to defend itself against its enemies. In fact, in the *Politics*, Aristotle specifies that under "constitutional" or republican regimes the minimum requirement of

citizenship is to own the heavy arms of the hoplite soldier (Aristotle 1279a, 1297a). Citizenship includes participation in the *risks* of political society, including death. But why, for a certain type of rights-oriented and procedurally minded liberal in our age (as opposed to the more politically nuanced and regime-oriented liberalism of figures like Edmund Burke and Alexis de Tocqueville), has the notion of death become anathema to politics? The universalist logic of a more strident liberalism insists that it "knows," that it is right in its judgments about political association, but it remains unwilling to countenance the notion that lives may be staked on defending or pursuing that idea, a vision of the best life. As Derrida pointed out, albeit in the rather sanitized context of a discussion of Walter Benjamin's *Critique of Violence*, "The parliaments live in a forgetfulness of the violence from which they were born" (Derrida 47).

Confronted with the life-and-death struggle, the liberal conception of humanity falters, or rather, it is inadequate for political decision-making. Liberalism is adept at, is designed for, advocating better legalistic procedures to preserve and promote the political good—rights—in a polity whose very viability is not at stake. When the stakes are raised, however, liberalism provides no internal conceptual criteria for protecting the polity from extreme threats (including, of course, murderous despots, religious fanatics, terrorists, and terrorist supporters), other than an obligation to insist on maintaining legalistic procedure and neutrality. The rights of those who share one's viewpoint are to be as protected as the rights of those who do not. This principle also guides liberalism's encounter with the establishment or restoration of democratic regimes. Yet such actions will almost necessarily involve the violation of the principles of human dignity and rights: the extralegal decimation of a few entrenched interests might be necessary, a few extralegal murders of entrenched families

might be required, to achieve procedural neutrality. In fact, much more may be required. And to the horror of the liberal moralist and other "beautiful souls," this endeavor, however noble or ignoble, will never be sufficiently free of other political and economic interests. Why? Because the world is as it is. Only the narrowest of politically potent constituencies has ever been motivated solely by the idea of rights. And so what do liberals do? They make procedural appeal to the universal principles of rationality and autonomy. Surely censures from international bodies, economic sanctions, diplomatic pressure, will educe, in time (a time pregnant with death), that moment of mutual recognition when, in Harold Laski's dictum, government by discussion can begin.

Recognition is another way of describing the hope that underlies the notion of rational humanity at the heart of the liberal conception of politics. And certainly procedural liberalism can be described as a philosophy, perhaps almost a theology, of hope. This, perhaps, is what Carneades meant by folly. And it has a long history. The Stoic doctrine of Laelius did not survive the collapse of the Roman Empire intact, but the then-current Hellenistic notion of an inviolable law that resides within us was soon proposed in another form by a follower of a messianic teacher named Jesus. Paul, at Romans 2:15, tells us that the law is written on the hearts of men. What the metaphysical doctrines of Stoicism and Pauline Christianity share is that each binds an inwardly graspable principle of truth (conscience, or knowledge of right and wrong) to a universal valuation of humanity. And the Pauline teaching had one particular advantage over the Stoic: over fifteen hundred years of dissemination and promulgation throughout the West (and beyond) by the longest-lived, and one of the most widespread, institutions on earth, the universal Church of Rome and later its Protestant offshoots. What is of moment here, setting aside the question of the specific truth

of the Stoic natural law doctrine or the Pauline notion of conscience, is the underlying claim that *every* individual is ascribed an inestimable value that cannot be justly overruled by the wise, the passionate, or the domineering. Each and every individual counts and, ultimately, is to be consulted concerning what pertains to his or her person, property and, eventually, sovereignty. Admittedly it has taken over fifteen hundred years for the institutions of Europe to begin to comprehensively reflect and foster the attested universal valuation of each human being. Even when this assertion is stated most forcefully in the Enlightenment, the specific value ascribed by secular argument to each human being has the traction of plausibility only because of a long and thorough theological preparation of Western humanity to receive the "truth" of this teaching, this unnuanced universal valuation. Which, along with its inheritors in the narrow conceptions of twentieth-century liberalism, finds its culmination in the Kantian notions of duty and universal rights and perpetual peace.

This Kantian principle of the universal dignity of humanity is established by the inner verification of self-worth, by the de facto assertion of rationality (by virtue of being autonomous), and by legislating the extension of "universal laws to every other will" (Kant 40–41). In discovering oneself to be autonomous one is then consecrated by a greater dignity simply by extending the category of autonomy to all of "humanity," now also characterized by both dignity and rationality. It worked for Laelius and it worked for Paul. In fact, it worked for the Enlightenment. The problem with this inner verification procedure is that it provides no criterion for limiting the field of its application. The entirety of humanity receives infinite (irreplaceable) value in this dispensation, and in "knowing" the rightness of this moral feeling (as Kant called it), liberalism thereby believes itself to have also grasped the criteria of *political* association

and all standards of political judgment. Aristotle's clarification is apt: "They are misled by the fact that they are professing a certain limited conception of justice into thinking that they profess one which is absolute and complete" (1280a).

For the ancient Greeks the true substance of humanity, of what it was to be preeminently human, was a matter of an ethnic-national (or perhaps linguistic) and intellectual dispensation. Politics was an association for some good, rather than the de facto promotion of an oligarchic conception of the good under the guise of neutrality. Since they were not blinded by the modern liberal conception of neutrality, the ancient theorists were able to discern what good a regime upheld (whether democratic freedom or wealth or virtue). This allowed the regime to distinguish between its friends and its enemies. But how different it is in a modernity that yet lives in the secularized apotheosis of a still unvanquished theology. To be fully human, to partake of what is highest, requires only that the modern individual look inward. There he will find his rightful orientation to what is the good. By looking inward and then casting his regard to a beyond without limit, the modern individual finds himself bound to a transpolitical category of universal recognition: humanity. One cannot deny that the liberal project has met with astonishing success, that it has indeed attracted an amazingly broad (though leveled) constituency. But with regard to certain features, certain inexpugnable traits, of the political, it remains blind.

Liberalism cannot be the complete account of political association, at least not until the advent of what Kant called the "kingdom of ends," where "everything has either a price or a dignity" (Kant 40). Liberalism in its now most pervasive formulation requires a world governed by the principles of autonomy, of economic self-determination, of procedurally neutral protection, and of the valorization of all humanity.

A world yet to come. But until then, liberalism's moral-political vision (with its ostensibly secularized "natural justice," with its deferral to "objective," legislatively legitimized procedures and standards), prevents it from contemplating other important political realities. The true nature of regimes and the nature of human beings. And enemies. Whether states or factions or individuals, there are indeed enemies who refuse to (perhaps cannot) recognize the universal principles of liberal modernity and who will endeavor to destroy or destabilize the procedural regime. And though Tocqueville was right when he claimed, "A long war almost always places nations in this sad alternative: that their defeat delivers them to destruction and their triumph to despotism," this did not prevent him from thinking *through* the necessity for liberal nations to defend themselves and prosecute foreign policy, particularly against enemies in whom agreement and decision is "complete" (159), sadly the liberal moralist of our era can contemplate no decisive, that is to say timely, *political* response to the absolute threat to the procedural organism. From the deck of a broadsided ship he gazes down at the floating debris, wondering at which plank he'll grasp, wondering who would dislodge him from his scrap of crooked timber. Yet, in times of emergency, liberalism is certainly not without its uses. Much of today's liberal discourse can provide a salient chorus to the political actors of the age who, with their dirty hands, with their lingering frissons from contact with the life-and-death struggle, with their chances for immodest glory, must be kept mindful of a dissatisfied constituency, a murmuring conscience of the regime, that, while being reluctant to act ex-procedurally, is nonetheless loath to forget.

WORKS CITED

Aristotle (1995)
Politics
Ernest Barker, trans.
R. F. Stalley, rev. and notes
Oxford: Oxford University Press

Jacques Derrida (1992)
Force of Law: "The Mystical
Foundation of Authority"
Mary Quaintance, trans.
*Deconstruction and the Possibility
of Justice*
Drucilla Cornell, Michel Rosenfeld,
David Gray Carlson, eds.
New York: Routledge

Ronald Dworkin (1978)
Taking Rights Seriously
Cambridge: Harvard University Press

Alexander Hamilton,
James Madison, and John Jay (1982)
The Federalist Papers
Garry Wills, ed.
New York: Bantam

F. A. Hayek (1982)
*Law, Legislation and Liberty, Vol. III,
The Political Order of a Free People*
London: Routledge & Kegan Paul

Immanuel Kant (1993)
Grounding for the Metaphysics of Morals
James W. Ellington, trans.
Indianapolis: Hackett

John Locke (1690; 1988)
Two Treatises of Government
Peter Laslett, ed.
New York: Cambridge University Press

Pierre Manent (1994)
An Intellectual History of Liberalism
Rebecca Balinski, trans.
Princeton: Princeton University Press

John Stuart Mill (1991)
On Liberty and Other Essays
John Gray, ed.
New York: Oxford University Press

Robert Nozick (1974)
Anarchy, State, and Utopia
New York: Basic Books

John Rawls (1971)
A Theory of Justice
Cambridge: Harvard University Press

Michael Sandel (1992)
The Procedural Republic and the
Unencumbered Self
Communitarianism and Individualism
Shlomo Avineri and
Avner de-Shalit, eds.
New York: Oxford University Press

Alexis de Tocqueville (2000)
Democracy in America
Harvey C. Mansfield and
Delba Winthrop, trans. and eds.
Chicago: University of Chicago Press

SHOCKS

**ALPHABET CITY INTERVIEWS
NAOMI KLEIN**

Alphabet City: Lately you have been writing about Iraq, and American political tactics in Iraq. What model of democracy and freedom do you think the Americans are putting in place in Iraq at the moment?

Naomi Klein: The model for democracy and freedom in Iraq is a combination of liberal electoral democracy and free markets. We've been told since 1989 and the so-called "end of history" that this is the only way to rule. And the architects behind the invasion of Iraq are true believers. They genuinely believe that this is the optimal way to run a country, and that this is fundamentally what all people want. The problem arose when they started to implement some radical market reforms immediately after the invasion, such as de-Baathification, which was essentially a neoliberal, not a neoconservative, policy of privatizating of the state for the sake of creating markets.

Now I believe that Paul Wolfowitz really *believed* that Iraqis wanted this. The model is of the "extreme makeover." To me, it wasn't a coincidence that during the two years of the Iraqi occupation Americans were sitting at home watching an explosion of *Extreme Makeover* reality television shows. The shows and the war share a common narrative: a team of experts descends on your home, life, closet, relationship, and pronounces that you are totally hopeless. They throw everything out. You hand yourself over to stylists, career counselors, art directors, etc.: essentially "experts" in one or another aspect of life. You are reconstructed into an entirely new person by surgery or by the bulldozing of your home.... And I think this describes the neocon/neoliberal narrative about Iraq: Halliburton, Bechtel, KPMG, all of these private multinational corporations—who are experts in engineering, accounting, the oil industry—would implement this extreme makeover of Iraq, which had been turned into a blank slate by the "shock and awe" bombing. The country had,

in their minds, been erased for the sake of being reborn.

And I think there was something exciting, actually, for these true believers to have what they considered to be a blank slate like Iraq because Iraq had been sealed off from the world since this whole new economic era began in 1989. The First Gulf War began in 1991, that's when the sanctions began. Unlike the introduction of neoliberal economic policies in the former Soviet Union or in Latin America, there was no local government they had to negotiate with. They didn't have to twist any arms or convince anyone it was a good idea. I mean they were running the show; it was an occupied country in the hands of the US and Britain. I believe that that was their vision: implement this radical economic construction, give birth to a new nation, culturally, economically, and politically. That included everything from a brand-new television station to treating the holy sites as tourist destinations to privatizing the banks and the oil industry. Every aspect of society was contracted out to "experts" before the war even began.

The problem began when Iraqis didn't respond like the contestants on an extreme makeover show, with weepy enthusiasm and abject gratitude. Instead, they became angry with these reforms and started to resist. They began to exercise their newfound freedom—like the fact that they were able to publish newspapers, like the fact that they had access to satellite television, like the fact that they could organize themselves politically and start political parties—to reject these economic reforms. You started to see local elections happening, some very critical articles in the local press, and some extremely critical coverage on stations like Al Jazeera and Al Arabiya.

And this wasn't unreflective…there were themes that Iraqis were resisting specific US policies. There was a poll that was conducted by the International Republican Institute asking the Iraqis in this period if they could vote for a politician, what sorts of policies would

they vote for? Would you vote for a politician promising to create jobs in the *public* sector—a statist government? And 49 per cent of Iraqis said that they would. And they asked would you vote for a politician promising to create jobs in the *private* sector? And only 4.5 per cent of Iraqis said that they would. It became clear that rather than this radical compatibility or even identity between free markets and free people—which the Bush administration believes in so strongly that it is actually a plank of the national security strategy of the United States—there was an open clash between the desires of these so-called free people and the free market.

In the beginning, Iraq was the suspect nation extraordinaire—it was the most suspect nation with the most suspect weapons, it was really plucked out of a set of possibilities and given primary importance…

…and it was perfect for that because of the sanctions. The label of suspect is most powerful when there is very little information about the suspect. Suspicion really indicates a lack of information. Obviously language barriers help with that, but also when you have a country that is sealed off by policy—you can't travel there, people can't travel from there to visit your country, you can't even publish books from there—there is ample opportunity for so much misinformation. There was a deliberate policy to have no information, or communication, coming out of Iraq. So it was a perfect suspect.

Yet it went from total suspect to total projection of the Wolfowitzian ideal.

You saw this come out really powerfully when there was almost a delight, on the part of the Americans, in the destruction of the country. There was the "shock and awe" of the bombing, but also, in

the looting and burning afterwards. There was no attempt made to protect the country. It was really the incarnation of the myth of redemptive violence, the idea that Iraq was being cleansed by fire, and it would be reborn. And the nucleus of cells for that rebirth was the only structure that they guarded, the oil ministry.

I think what you are seeing in Iraq is the use of shock as a political weapon, and the most dramatic example of that was the war itself, the "shock and awe" campaign which pummeled the ground, preparing it for this new country. When that didn't work and people resisted anyway, they had to use other forms of shock to control the population. You started to see increasingly repressive and heavy-handed tactics such as the collective punishing of cities like Fallujah, which CNN called "Shock and Awe II." But also on an individual level the use of shock in Abu Ghraib, as a means, I believe, less of extracting information and more of social control. I don't think torture is an effective interrogation technique and I think people know that. What torture is really good at is making people fearful—it's a message. In this sense, I'm not even convinced that information is as tightly controlled as we may think it is, in terms of information escaping from Guantanamo or Abu Ghraib. I think that it is part of the use of torture that rumors of torture *must* escape. Its primary effectiveness as a tool is as a warning to the broader population that if you step out of line you end up in one of these dark places with no rights whatsoever.

So I think that shock, in terms of a means to political control, was also related to the imposition of economic shock therapy, because as the population rebelled against the economic conditions postwar, increasingly shocking tools and methods had to be used to try to frighten people into submission. The phrase "economic shock therapy" is a really disturbing one that economists use. It actually comes not from torture but from early psychiatry. The person who invented shock therapy as

a treatment for mental illnesses was an Italian psychiatrist who got the idea, he said, from visiting a slaughterhouse. He watched how the animals were prepared for slaughter by electroshock; they were shocked and then became obedient. They had a small seizure and then they were very easy to herd to slaughter, and for some reason he thought that this would be a good thing to try on his patients, that this seizure would create the control or the calmness that was lacking.

The theory of economic shock therapy is that you shock the body politic in the same way as you shock the body with shock therapy treatment and people are unable to react and defend themselves. You don't privatize the schools first and then the health care; you do it all at once. So the body politic can't respond to everything all at once and it enters into a state of seizure. Shock therapy was used right after the collapse of the Soviet Union when people didn't even know what country they were living in. And in Latin America it was the Chicago boys who moved in right after the military coups. So if you look at that model you also see where torture comes in, because it was the shock of the coup, the shock of the collapse, the shock of the changes, and the shock of the reforms, but you also have the shock of the torture all alongside which was a warning to anyone thinking of resisting these reforms that the absolute worst thing will happen to you if you try to resist. So all of these forms of shock work together.

The logical limit of this method is the disappearance—it is the most extreme absence of information. In Argentina, where 30,000 people disappeared in the seventies, the Argentine generals really perfected the use of disappearances as a political tool. Pinochet's 1973 coup in Chile was brought in with a massacre, it was just a bloodbath where 3,000 people died, it created a huge uproar. The generals in Argentina had their coup three years later in 1976 and they learned—and they say this—they learned from the mistakes

Pinochet made. They didn't feel that the massacre model—which provoked international outrage—they didn't feel it was the most effective form of social control. It was better just to snatch people out of their homes into these places that they didn't even admit existed, the concentration camps all around the country. And they would deliberately allow bodies to wash ashore—they would just arrive as warnings. They would never admit that anybody had been made to disappear, and when their mothers would ask for them, the Mothers of the Plaza de Mayo, they would just say, "Well, maybe they went to Europe." But the warning was more powerful, than the bloodbath, that this could happen to anyone, but with the simultaneous denial that anything was even happening.

So because it's structured on absence there's no event, no public object, to address yourself to in resistance, psychologically or politically.

Yes. And there are a few other ways in which this was an effective means of social control. People were tortured inside the camps for information, and the people I talked to who were inside the camps said that they didn't have the impression that the information was even being used for anything, the point was just to gather information but also to send the broader message that information is dangerous.

I was talking to an Iraqi student at a Canadian university and he was politically active but not about issues relating to Iraq, or relating to being Muslim, or any issues relating to the war on terror, and I asked him why and he said, "Because I study biology and the combination of being Iraqi and studying biology I think would make me a suspect." In his mind he had already internalized all of these signals about what makes you a suspect and he was already adapting accordingly, and one of the ways he was adapting was by not speaking

out on these issues. He was self-censoring. Social control is most effective when the messages are sent strongly enough that people censor themselves and don't have to actively be censored. I think there are a lot of stories like that. I have another Iraqi friend at another university, who, when he doesn't shave for a few days, there are complaints about him—other students feel threatened because he fits the profile. So he's internalized the idea that looking a certain way makes him a threat, that makes him fit the profile of the suspect.

It's almost beyond your control what kind of information will trigger that "suspect" profile in a computer or in the mind of an analyst.

Except for one thing: opposition. Fighting the system is virtually a guarantee of drawing attention to yourself. And this is what politically makes such systems self-perpetuating—because the people who would be most outspoken against them are so acutely aware of themselves as suspects that they have internalized the message that the best thing to do is to be as innocuous as possible, as quiet as possible. So it's working, I would say it's working.

Where is the counterforce?

I think we are in a strange moment. I don't think it is a moment for either optimism or pessimism, and that the utterly unrepentant unilateralism of the Bush administration, and the shredding of international law at every level, and the promotion of the people who are most disdainful of the rule of law both internationally and within the US, from John Bolton at the UN to Paul Wolfowitz at the World Bank to Alberto Gonzales as attorney general, is creating space outside the US for dissent.

There is a global hegemony around the core issues about how we should live. I would say that pre-Bush, under Clinton, there was a real consensus—the power blocs were all pretty much on the same page in terms of pushing neoliberal economics and this sort of "liberal democracy plus free markets equals peace and harmony" agenda. The real hawks and neocons in the Bush administration didn't like that period. These are warriors, fundamentally, and there was a moment in his second inaugural address in which Bush referred to the years between the Cold War and September 11th as "years of repose, a sabbatical." They don't like a lack of war—war is what they are good at. They are comfortable thinking of the world as great clashes between civilizations and I think that without some greater purpose America is just a shopping mall. They want shopping infused with holy purpose. In the Cold War you were fighting Communism by shopping. And we saw that immediately after September 11th, Bush's message was quite literally "go shopping for your country, go shopping or the terrorists win." In between, in the years of repose, shopping was just shopping—banal and in its own way, questionable.

But I think that the embrace of the war model, "with us or against us," has created spaces around the world for many different forms of dissent, and that the new lack of consensus in the world is a source of optimism. I was in Argentina when the war began and there was this wonderful feeling of being off the radar, of not being important to the centers of power. You know, when Latin America is on the radar it's never been a good thing. You have a little bit of that talk around Cuba and Venezuela now, but there was this feeling when we were in Argentina; there were incredible explosions of social movements, they went through five presidents in three weeks, factories were being occupied and turned into workers' cooperatives, and no one was noticing. So there is a way that other parts of the world, by not

embracing the US "with us or against us" model, are not part of that dichotomy and I think there's reason for optimism there, because over against the US's laboratory in Iraq you get other local laboratories, which inevitably produce other ways of governing, other ways of living, and they are starting to work. Venezuela is right now a very powerful counterexample for Iraq, because this is another oil-rich nation that is embracing redistributive policies, precisely the policies that Wolfowitz tried to fight with everything he had from emerging in Iraq.

Because the imperial attention is elsewhere.

This is the thing. When we were in Argentina making a film about occupied factories, all the cameras were leaving; all the big cameras. The big cameras were leaving and the little cameras were arriving. There was just a little bit of breathing room, a feeling of not being the primary suspect. But that'll change. The hope is that by the time it changes there will have been a chance for these social movements to get strong enough that they are in a better position to resist, because usually they get stamped out before that even happens.

This liberating aspect of a lack of suspicion ultimately serves to show how torture, and war in general, are blinding and debilitating for democracy, which is why it is called shock and awe, why it is called shock. It prevents you from thinking about anything but the horror in front of you and this process is tremendously beneficial to those in power who don't want us asking these questions about who is served by torture.

How do you personally respond to this blinding effect?

I went to Iraq when I did and to do the research that I did, because I knew that shock—both the shock of the people and the shock of the nation—was being used to turn it into a free-market laboratory. It wasn't as if they were hiding it, but nobody was acknowledging the local legitimacy of the resistance average Iraqis were feeling, or observing market changes on a local level. And this is natural. In the context of a war you cover the blood and the bombs, not the fact that they are selling off the water system and that they've announced the privatization of state companies. When I was in Iraq I had to fight every human and journalistic instinct in me in order to focus my research on the economic side and treat the bombs as secondary. In that sense it was utterly counterintuitive, what I was doing. I mean we would be driving down a highway with bombs going off all around us and we would keep driving, not stop, so that we could get to a state-owned vegetable oil company so that we could interview the workers about plans to privatize the company. Every journalistic instinct is telling me to stop, and my photographer was ready to kill me, because obviously it is a lot sexier to take pictures of things blowing up than to talk to people in a factory. But I believed, and continue to believe to this day, that we can understand the bombs better and can understand the torture better, by not seeing it as primary, not being blinded by the human sensationalism of it all. We can understand it all better if we look to the role it plays in producing concrete goals: a political and economic agenda. Only when you expose this agenda as primary can you have truly effective resistance.

BRANDON MAYF

SIMON A. COLE

LD, SUSPECT

On March 11, 2004, ten bombs exploded in rapid succession on trains in Madrid, Spain. One hundred ninety-one people were killed and thousands were injured. In the early hours after the attack suspicion primarily fell on two parties: Basque separatists, who had waged a long campaign of terror against the government, and Al Qaeda. A consensus soon emerged that the bombings were an Al Qaeda attack. Synchronized explosions are an Al Qaeda hallmark, and Spain was a prominent participant in the US-led invasion of Iraq. The Spanish National Police (SNP) identified numerous suspects, mostly Moroccan. Twelve were jailed, seven blew themselves up during a raid, and others were freed on bail.

On May 6, a United States Attorney in Oregon filed an affidavit requesting that Brandon Mayfield, a thirty-seven-year-old immigration lawyer who lived in Aloha, Oregon, outside of Portland, be held as a material witness in the Madrid bombings (Immergut). The affidavit listed several reasons for suspecting that Mayfield had some knowledge of the bombings. Chief among these was the fact that FBI print examiners had determined that Mayfield was the source of a "latent" (or crime-scene) fingerprint that had been recovered from a bag of detonators found in a van parked near the Alcalá de Henares train station outside Madrid, through which of all of the bombed trains had passed. Latent print examiner Terry Green called the match "a 100% identification," and the match had been corroborated by two other FBI examiners.

But there were other reasons that Mayfield was suspect. He had served in the US Army, rising to the rank of lieutenant; he had converted to Islam in 1989; and his wife, Mona, was Egyptian. His legal work primarily consisted of representing Muslims in immigration and other civil proceedings. Mayfield had attended the Bilal Mosque in Beaverton, Oregon, which had also been attended by the so-called

"Portland Seven," who were convicted of conspiracy to wage war against the United States. Mayfield had even represented one of the Portland Seven, Jeffrey Battle, in a child custody case. The affidavit reported that a telephone call had been logged from Mayfield's home phone to Pete Seda, the Director of the US offices of Al-Haramain Islamic Foundation in Ashland, Oregon. Six of the Foundation's worldwide offices had been designated terrorist agencies by the US Treasury Department's Office of Foreign Asset Control. The affidavit also asserted that the Foundation had distributed Qur'ans in US prisons which contained an appendix entitled "The Call to Jihad in the Qur'an." In addition, the affidavit stated that Mayfield advertised his legal services in Business Link Directory which it described as "a Muslim yellow page directory" and linked, through two intermediaries, to Osama bin Laden himself.

Although Mayfield was officially held as a material witness, it is clear that he was, in fact, a suspect. The use of the material witness statute to hold individuals who are actually suspects is not uncommon, and such individuals are often given a choice between giving the authorities information or being indicted themselves (Wax and Schatz). (We now know, of course, that Mayfield would not have had any information to give, even were he so inclined.)

On April 7, 2005, the US Justice Department acknowledged, as Mayfield himself had long contended, that the FBI had used a secret search warrant to execute clandestine searches of his home. The FBI copied computer drives and documents, took DNA swabs, and snapped more than 300 digital photos. Although the more specific issue of whether the surreptitious search would or would not have been legal before the passage of the USA PATRIOT Act is still being contested, the relevance to that act of Mayfield's experience as a suspect is clear (Eggen).

Yet at the same time that Mayfield was being held as a suspect and the evidence gathered in these clandestine searches was being scrutinized, he was in possession of strong exculpatory evidence. He did not have a passport. He claimed not to have left the United States in ten years, and the government could offer no proof to the contrary. Other than the telephone call to Seda, there was no evidence of any communication between Mayfield and suspected terrorists.

In one sense, the Mayfield case illustrates the evidentiary power of the fingerprint. The ability of a fingerprint match, absent any other evidence, to sustain a guilty verdict has been long established in US law (*Grice v. State*), and has given rise to the popular belief in the supposed "infallibility" of fingerprint evidence. Indeed, Judge Robert E. Jones, to whom the affidavit was presented, noted "that he had previously tried a case where a single fingerprint sent the defendant to prison for life" (Wax and Schatz).

At the same time, however, the case illustrates the way in which a seemingly innocuous set of facts may, when contextualized by a presupposition of guilt, appear to be extremely "suspicious." The retrospective construction of Mayfield as fitting a terrorist "profile" implicates the practice of profiling more generally by demonstrating that when the profile is constructed post-hoc, in order to justify an already-formed conclusion, nearly any set of facts may be construed as "suspicious" (Risinger and Loop 274; Moriarty). More broadly, the Mayfield profile casts doubt on the validity of the host of post-9/11 profiling efforts, like the short-lived "Total Information Awareness" program, which rested upon the dubious assumption that valid profiles can be constructed from the extremely small sample of known terrorists.

Seen through the prism of the incriminating fingerprint, Mayfield looked quite suspicious indeed. The military training, the conversion

to Islam, the Egyptian wife, the contact with the Portland Seven—all of this made Mayfield seem not just "suspicious" but perhaps the perfect suspect. Early reports suggested that Mayfield, with his military service, might fill a crucial gap in the SNP investigation: the absence of a suspect with explosives training. Even the lack of suspicious evidence seemed suspicious. The affidavit stated, "Since no record of travel or travel documents have been found in the name of Brandon Bieri Mayfield, it is believed that Mayfield may have traveled under a false or fictitious name, with false or fictitious documents" (Immergut). The very lack of a trail stood in marked contrast to the 9/11 bombers' almost complete unconcern with concealing their movements (National Commission on Terrorist Attacks), and could be interpreted as evidence of Mayfield's criminal ingenuity. In other words, Mayfield was damned if he had traveled outside the country and damned if he hadn't. Things got even worse for Mayfield on May 19, when a court-appointed independent latent print examiner, Kenneth Moses, concurred with the FBI's attribution of the Madrid print to Mayfield.

All of this is to say that, had matters remained as they were in mid-May, Mayfield was very likely to have been convicted for, literally, having a hand in the Madrid bombings. The combination of fingerprint evidence and Mayfield's suspicious "profile" would have posed an extremely difficult challenge for his defense. During his confinement, Mayfield was told he was being investigated for crimes punishable by death (Kershaw), a sentence which might only have been avoided were he to be extradited to Spain.

However, even the earliest press reports of Mayfield's arrest were tinged with doubt. On May 7, it was said that the Spanish police felt the fingerprint match was "not conclusive" (Schmitt, Barabak, and Rotella). On May 8, it was reported that the Spanish had "serious doubts" and

The latent print from the Madrid bombing scene.

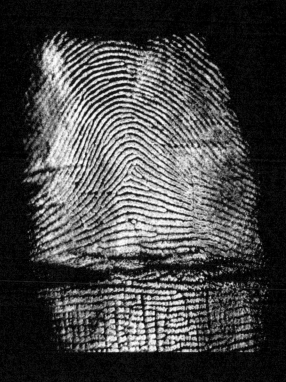

Brandon Mayfield's inked record print.

that, although the FBI claimed to have found fifteen matching "ridge characteristics" between the Madrid print and Mayfield's print, the Spanish could only find eight ("Spanish Investigators Question Fingerprint Analysis"). We now know that during this interval, FBI examiners traveled to Madrid to try to convince the Spanish that the identification was legitimate. On this occasion, the FBI reportedly declined to examine the original evidence and instead "relentlessly pressed their case anyway, explaining away stark proof of a flawed link—including what the Spanish described as tell-tale forensic signs—and seemingly refusing to accept the notion that they were mistaken" (Kershaw).

By May 20, however, the SNP had identified Ouhnane Daoud, an Algerian national residing in Spain, as the source of the print. Faced with this, the FBI reexamined the print and retracted its identification of Mayfield. Mayfield was immediately released, and the FBI issued a rare public apology (Federal Bureau of Investigation). Mayfield, however, insisted that he had been discriminated against because of his religious beliefs and spoke of "material witnesses languishing away" in the custody of the US government (Tizon and Schmitt). The denial of due process initially applied to "suspect populations" like immigrants is gradually being extended to citizens as well (Cole 2003).

The Mayfield debacle was clearly important to the ongoing debate on the trustworthiness of latent print identification as evidence. Although cases of fingerprinting error have been known of as early as 1920, and as recently as January 2004, the Mayfield case exposed the unreliability of latent print identification in more public a manner than ever before. Pointedly, the Mayfield case deprived defenders of the fingerprint's "infallibility" of their customary strategy of characterizing all cases of error as aberrations unrepresentative of "normal"

practice. While past errors had been blamed on, for example, incompetent examiners, the Mayfield error had been committed by FBI examiners, the supposed pinnacle of the profession. Indeed, only two years earlier, an important US federal court opinion on the validity of fingerprint evidence had upheld the accuracy of latent print identification specifically as practiced by the FBI, holding that, "Whatever may be the case for other law enforcement agencies, the standards prescribed for qualification as an FBI fingerprint examiner are clear" (*United States v. Llera Plaza* 566).

The understanding that fingerprinting may be "suspect" evidence must be examined within the larger context in which the entire vaunted FBI laboratory (Office of the Inspector General; Kelly and Wearne; "Ex-FBI Biologist Falsified DNA reports")—and, indeed, forensic science in general (Jonakait; Saks; Risinger and Saks)—have become suspect. It has been suggested that the resistance to testing the validity of latent print identification stems not from worries about how latent print examiners will perform, but from a reluctance to set a precedent for reconsidering other trace evidence techniques, such as firearms and tool mark examination, hair and fiber analysis, and arson investigation.

It is not possible, in the Mayfield case, to claim that the examiners were unqualified. Nor is it possible to claim that confirmation of an identification by a second examiner would prevent error, since the Mayfield identification had been verified by two additional examiners. Nor could it be claimed that defense consultants would detect any erroneous matches, since Moses had corroborated the erroneous identification. Indeed, Moses's corroboration, coming from a respected independent expert whose bias if anything would be expected to tilt toward the defendant for whom he was appointed, provided the most disturbing evidence that whatever causes fingerprint misattribution

it is something even more insidious than mere "pro-prosecution bias" (Giannelli; Cole 2005).

Deprived of its usual explanatory mechanisms, the FBI was forced to choose from an unpalatable menu of reasons for the error: that latent print examiners were more prone to make mistakes in "high-profile" cases (thus undermining any serious claim to objectivity) (Stacey 713); that a worldwide database search could find two very similar (though not absolutely identical) small areas of "friction ridge skin" in two individuals; or, most explosively, that the "suspicious information" about Mayfield's profile leaked into the laboratory. Thus, the Mayfield case raises at least two disturbing possibilities: first, that a fingerprint database match to an innocent suspect may not be as unlikely as had been widely assumed; and, second, that "suspicious facts" may contaminate the purity of the database-trawling process.

Indeed, in the background of the Mayfield case stands a little-noticed, but vastly important shift in criminal justice toward generating suspects through database trawling. The Mayfield case raises vexing questions about how this new class of "suspects," called "cold hits," are to be treated, both statistically and ontologically. On the one hand, a cold-hit suspect invokes the cool "mechanical objectivity" (Daston and Galison) of information technology. The absence of subjective factors like "suspiciousness" makes the "match" all the more convincing. At the same time, it has been argued that cold hits lose probative value because as the database grows the evidence is increasingly likely to match someone (National Research Council Commission on DNA Forensic Science 134–136; contra Balding). One might think that a cold database match subsequently confirmed by "suspicious facts" would be the most convincing evidence of all. But the Mayfield case demonstrates that a database match

can actually generate the very "suspiciousness" of facts that might otherwise seem innocuous.

Moreover, the Mayfield case revealed the routine overselling of the value of fingerprint matches. Although many press reports expressed shock that a "100% identification" turned out to be erroneous, most failed to recognize that latent print examiners are in fact prohibited by the rules of their profession from offering confidence levels of less than 100% (International Association for Identification).

But, without question, the most frightening lesson to be drawn from Brandon Mayfield's misfortune concerns his extraordinary good luck. Mayfield had been named as the source of a latent print from the scene of a politically charged mass murder by three experienced FBI latent print examiners and by a respected independent examiner who had been appointed by the court essentially on Mayfield's behalf. Were it not for the tenacity of the SNP, Mayfield would likely have faced execution in the US or life imprisonment in Spain.

Which brings us to a broader point: the Mayfield case is about more than the seemingly "technical" matter of how often latent print attributions are "right" or "wrong," or how serious the wrongful conviction crisis in the US, and similar countries, really is (Scheck, Neufeld, and Dwyer; FPT Heads of Prosecutions Committee Working Group; Huff). The Mayfield case tells us more broadly about how members of suspect populations are transformed into suspects, and potentially into convicts, or even the condemned. Cases like Mayfield's, where there is consensus that the process has gone wrong, offer a window into the workings of the process more generally (Westervelt and Humphrey). Suspects are culled from suspect populations, often using evidence and procedures that are themselves suspect (Cole 2001).

Let us imagine for a moment that the Mayfield fingerprint attribution did stand. Even the tentative initial press reports put forward the emerging narrative: Mayfield, either working from inside the US or traveling with false documents, provided the demolitions expertise for a plot involving mainly Moroccan labor. Despite the seeming absurdity of orchestrating a post-9/11 bombing in Spain from inside the United States—why not from Spain itself, or Morocco, or Algeria, or anywhere where the glare of surveillance would be less than it is in the US?—it is difficult to doubt that the vast majority of the American public would have viewed this scenario as plausible. Imagine for a moment the implications of the American public believing in such a plot: the US, it turns out, does indeed, as government officials have been claiming, harbor Al Qaeda cells within its body politic, not merely in the form of suspicious-looking recent Middle Eastern immigrants, but even in the form of White Muslim attorneys. These cells are so frighteningly sophisticated that they are able to orchestrate massive surprise attacks outside the country.

What would the implications of such a scenario being "real"? How would the world we live in be different from the one we inhabit today? What differences would have been realized in the debate over the renewal of the USA PATRIOT Act? How would we think differently about crime, terrorism, suspect individuals, and suspect populations? When we suspect falsely, using suspect evidence, we do more than misjudge an individual; we spin a false reality. Mayfield gives us a glimpse of one such reality that we narrowly escaped. But within how many are we already cocooned?

WORKS CITED

D. J. Balding (1997)
Errors and Misunderstandings
in the Second NRC Report
Jurimetrics 37

David Cole (2003)
*Enemy Aliens: Double Standards
and Constitutional Freedoms in
the War on Terrorism*
New York: The New Press

Simon A. Cole (2001)
*Suspect Identities: A History of
Fingerprinting and Criminal
Identification*
Cambridge: Harvard University Press

Simon A. Cole (2005)
More Than Zero: Accounting
for Error in Latent Fingerprint
Identification
*Journal of Criminal Law
and Criminology* 95

Lorraine Daston and
Peter Galison (1992)
The Image of Objectivity
Representations 40

Dan Eggen (2005)
Flawed FBI Probe of Bombing
Used a Secret Warrant
Washington Post April 7

Ex-FBI Biologist Falsified DNA
Reports (May 19, 2004)
Associated Press

Federal Bureau of Investigation (2004)
Statement on Brandon Mayfield Case
Washington D.C.:
US Department of Justice

FPT Heads of Prosecutions
Committee Working Group (2004)
*Report on the Prevention of
Miscarriages of Justice*
Department of Justice, Canada

Paul Giannelli (1997)
The Abuse of Scientific Evidence
in Criminal Cases: The Need for
Independent Crime Laboratories
*Virginia Journal of Social Policy
& the Law* 4

Grice v. State (1941)
151 S.W.2d 211
Texas Criminal Appeal

C. Ronald Huff (2004)
Wrongful Convictions:
The American Experience
*Canadian Journal of Criminology and
Criminal Justice* 46

Karin J. Immergut (2004)
*Application for Material Witness Order
and Warrant Regarding Witness:
Brandon Bieri Mayfield, No. 04-MC-9071*
United States District Court for the
District of Oregon

International Association for
Identification (1980)
Resolution V
Identification News 30

Randolph Jonakait (1991)
Forensic Science:
The Need for Regulation
*Harvard Journal of Law and
Technology* 4

John F. Kelly and
Philip K. Wearne (1998)
*Tainting Evidence: Inside the Scandals
at the FBI Crime Lab*
New York: Free Press

Sarah Kershaw (2004)
Spain and US at Odds on Mistaken
Terror Arrest
New York Times June 5

Jane Campbell Moriarty (2001)
Wonders of the Invisible World:
Prosecutorial Syndrome and
Profile Evidence in the Salem
Witchcraft Trials
Vermont Law Review 26

National Commission on Terrorist
Attacks (2004)
*The 9/11 Commission Report: Final Report
of the National Commission on Terrorist
Attacks Upon the United States*
New York: Norton

National Research Council Commission
on DNA Forensic Science (1996)
The Evaluation of Forensic DNA Evidence
Washington: National Academy Press

Office of the Inspector General (1997)
*The FBI Laboratory: An Investigation
into Laboratory Practices and Alleged
Misconduct in Explosives-Related and
Other Cases*
Washington: US Department of Justice

D. Michael Risinger and
Jeffrey L. Loop (2002)
Three Card Monte, Monty Hall, Modus
Operandi and "Offender Profiling":
Some Lessons of Modern Cognitive
Science for the Law of Evidence
Cardozo Law Review 24

D. Michael Risinger and
Michael J. Saks (2003)
A House with No Foundation
Issues in Science and Technology 20

Michael J. Saks (2000)
Banishing *Ipse Dixit*: The Impact
of *Kumho Tire* on Forensic
Identification Science
Washington and Lee Law Review 57

Barry Scheck, Peter Neufeld,
and Jim Dwyer (2003)
*Actual Innocence: When Justice Goes
Wrong and How to Make It Right*
New York: New American Library

Richard B. Schmitt, Mark Z. Barabak,
and Sebastian Rotella (2004)
Oregon Attorney Arrested Over
Possible Ties to Spain Bombings
Los Angeles Times May 7

Spanish Investigators Question
Fingerprint Analysis (May 8, 2004)
Associated Press

Robert B. Stacey (2004)
A Report on the Erroneous
Fingerprint Individualization in the
Madrid Train Bombing Case
Journal of Forensic Identification 54

Tomas Alex Tizon and
Richard B. Schmitt (2004)
FBI Exonerates Ore. Attorney
Los Angeles Times May 25

United States v. Llera Plaza (2002)
188 F.Supp. 2d 549
Eastern District of Pennsylvania

Steven T. Wax and
Christopher J. Schatz (2004)
A Multitude of Errors:
The Brandon Mayfield Case
The Champion Sept./Oct.

Saundra D. Westervelt and
John A. Humphrey, eds. (2002)
*Wrongly Convicted: Perspectives
on Failed Justice*
New Brunswick:
Rutgers University Press

REGULATING TRAFFIC: AMSTERDAM, BEIJING, LONDON

HEATHER CAMERON

Visual surveillance has evolved from traffic cameras staring at over-filled highways to intelligent systems designed to construct and then pick out a suspect from a flow of information. Unlike the police lineup, where unknown people are identified based on appearance and voice, these systems in part use identifiers undetectable by the human senses. New systems look to 256 points in the iris or small changes in body temperature to sort people into groups. Systems that merely read vehicle license plates as they move through a monitored area seem old fashioned, until you realize the cameras and software can identify and search hundreds of plates per second.

Despite the lack of control rooms and massive cutbacks to security staff, the human element in surveillance is not disappearing. It is simply being resituated. Human ingenuity is behind the powerful algorithms that power the software and statistical analysis of human beings that set the normative bands we must all fit into if we are to not arouse the machines' programmed suspicion. Ultimately, too, it is a human being who acts upon the information gleaned by the machine: pulling people out of the flow of human traffic to take further medical tests, issuing a ticket, demanding a passport when the iris scan fails.

Three world cities have recently implemented surveillance systems at their thresholds. Beijing installed a thermal imaging system to help identify possible SARS carriers at the Beijing Capital International Airport in April 2003. London introduced congestion charging and new enforcements for traffic offences in the spring of 2002. The British system watches Londoners in cars, buses, and taxis through static, closed caption television (CCTV), and outward looking bus-mounted camera systems. Amsterdam's Schiphol Airport launched a pilot project to test their iris-scanning border-passage technology Privium in October 2001. Each of these systems sets a new standard for automated screening activity and each raises questions about the enforcement of

norms, the specificity of identification, and the possibility for discrimination in systems built to minimize the need for human contact.

At the height of the SARS crisis in April 2003, the Chinese authorities decided to install FLIR (forward looking infrared) thermal imaging cameras in the Beijing Capital International Airport, as one of the symptoms of contraction of SARS is an elevated body temperature. Thermal imaging cameras look like video cameras, but instead of interpreting light they register temperature and present this information on a monitor in different colors, allowing the human viewer to "see" heat. The flowing images can be quite psychedelic, with blurred edges and a palette ranging from cool blues and greens to hot yellows and reds. In a fraction of a second the camera software identifies and locks on individual faces to take a temperature reading, before moving on to the next heat signal. Passengers with a temperature of over 38 degrees Celsius are flagged via their coloring on the monitor, and a siren is triggered to alert waiting guards. The person with the elevated temperature is then quarantined and subjected to further tests by medical personnel.

One of the problems with these cameras is that they have not proven sensitive enough to small differences in heat. Nor are they consistently or accurately calibrated, and therefore have shown wide ranges of error. If normal human body temperature is 37.5 degrees Celsius and these cameras are supposed to trip the alarm at 38 degrees Celsius, there is a problem when the range of error is in some cases as high as ± 1.4 degrees.

Range of error is a central issue for any automated system based on sophisticated algorithms that basically break down to a complicated set of matching laws. If the programmer calibrates the matching parameters too tightly there will be many so-called false negatives, people who should have matched the condition but did not. False

positives occur when the matching criteria are too loose, catching everyone in the net. False positives create difficulties for enforcement since trust in the system fades and the public is not as likely to support a project that regularly sets off false alarms or causes inconvenience for a great number of passengers. The fact that the system is automated, and therefore assumed to be free of human bias, makes it more difficult for those caught falsely to free themselves from suspicion.

Interestingly, systems built on surveillance infrastructure are sold to citizens as a means of providing extra comfort, not extra security. Congestion charging for cars entering central London has proved to be popular and has succeeded in dramatically reducing car traffic on inner London roads. Roadside cameras photograph the license plates of all cars entering and leaving the congestion charging zone. Owners of cars with license plates not registered with the system are sent a bill. This system is completely automatic and captures hundreds of cars every minute. There are no human operators who watch as the video cameras scan the license plate numbers. Unless, of course, the license plate is linked in the computer with some other crime, in which case an alarm goes off and the car's last location is transmitted to the police.

Many criminal traffic offenses have recently been demoted to bylaw offenses and are now enforced by local boroughs. In the past, police were too busy to do much about clogged bus lanes, but boroughs armed with CCTV realized they had an excellent opportunity to improve the efficiency of public transport as well as generate substantial income through ticketing revenue. Most boroughs contracted out their right to issue tickets to Transport for London, which set up control rooms where operators watch bus lanes in real time during peak hours using data transmitted by existing CCTV cameras. The control rooms are quiet, with muted lighting and anti-bomb netting on the windows. An atmosphere of sustained concentration fills the rooms as operators

watch certain intersections, zooming in to capture a license plate and, by hand, record offenders' plates in logbooks. After logging the offending vehicles in real time, the operators review a recording of their session, issuing tickets to the offending vehicles noted in their log. In comparison to the fully automated congestion charging system, bus lane enforcement has substantial labor costs. However, each ticket issued is worth £100 and at peak times there could be hundreds of offenses per hour.

In addition to the static roadside cameras and steerable CCTV cameras, Transport for London has been installing cameras on double-decker buses looking onto the road in front of them as well as inside of the bus (to discourage and prosecute vandalism). Bus marketing campaigns tell car drivers that "4 out of 5 buses now have CCTV" as a means of promoting compliance with bus lane laws. The fact that most buses do not, in fact, have outward looking CCTV is not mentioned in these ads. The goal of such campaigns is to create a deterrent effect while further constructing parking in a bus lane as an anti-social behavior only slightly less disturbing than drinking and driving. The buses flow much more freely under this enforcement regime.

Ostensibly, the operators of Amsterdam Schiphol Airport's Privium program are also concerned with parking. Part of their marketing campaign for the biometric border-crossing technology is priority parking for their members. Privium members pay €119 a year for the right to a good parking space and to bypass the lines of people waiting for passport control at one of Europe's busiest airports. Members proceed through dedicated turnstiles where their identity is verified by an iris scan, rather than a border guard's glance at their passport photo. The system, which was piloted in 2001–2002, is now fully operational and is being installed in other airports around the world.

Frequent travelers who are European citizens can apply for membership. If they fit the enrollment criteria, they must register themselves at the Privium Service Point and Lounge at Schiphol Airport. After they have filled out a short questionnaire, black-and-white close-up digital photos of their irises are taken. These photos are used to create a pattern, which is then encrypted and stored on a membership card along with passport information. In order to lower costs and dispel the fears of privacy advocates there is no central database where all of the iris images are stored. The card only proves that the person carrying it is the same person who registered his or her iris scans and passport with Privium.

Privium members traveling through Schiphol go to a Privium gate beside a regular passport control station and present their Privium card to a card reader and computer monitor. The monitor instructs them to progress through a silver turnstile to the iris reading station. Privium members must be at least 150 cm tall (four feet, nine inches), and it is impossible for wheelchair users to access Privium since one has to stand and bend at the waist to look into the iris reader at a forty-five-degree angle to the ground. (This position gives Privium its strange logo, which seems to depict a man bowing before a column.) If the iris scan matches what has been registered on the card, then another gate is opened and the Privium member can proceed. If there is a problem—as in a non-matching scan or police interest in the person—a different gate opens, putting the Privium member before a border guard with a locked turnstile at his back.

Despite this series of gates and turnstiles, the Privium process is remarkably open, allowing the border control officers and all the other passengers to watch someone use the system. In part this is a security measure, because iris-scanning biometric systems have been tricked by amazingly simple methods such as holding up high-resolution

printouts of people's faces or using contact lenses with a false iris pattern printed on them. Some hackers have even developed algorithms to present still photos of faces as slightly swaying to trick the iris-scanning camera into believing it is reading a live image. This question of "testing for life" is key to the next generation of biometric systems, which build temperature sensors, pulse sensors, and other biomedical devices into body scanners to make sure what they are scanning is a living person and not a wax replica of a finger or a photograph of an eye.

Like the other scanning systems discussed, Privium is a technology designed to pre-select and direct traffic. As in Beijing, a major consideration is the setting of the matching limits: not so high that it keeps properly registered people out (false negatives) and nor so low that it lets people who do not match through (false positives). Like London's congestion-charging plan, Privium members are sold on the system by the fact that it saves them time and offers a premium service. People pay for the privilege of being scanned and tracked because it allows them to distinguish themselves through special services: the right to use a private automobile rather than a bus, priority parking at the airport, free coffee in the Privium Service Point. These technologies are sold as systems that provide more comforts for a small pre-screened group, which in turn allows greater enforcement attention to those who cannot buy their way into the club. The mass scanning of people in an airport for border control or quarantine is clearly made easier by the use of computer pattern-matching capabilities. However, these matching capabilities are effective only within set limits. This is the future of mass transportation: a system that promises quicker and safer transit in exchange for more pervasive surveillance.

THE SEQUEL

JOEY DUBUC

SEQUEL

Imagine you are a real person, with real feelings, fears, dreams, and desires. None of this is difficult. Notice that when you touch yourself, you have simulated sensory experiences. Look around. You're in an international airport, showing your passport to a customs officer. This is your second time in the city known as The Sequel. The going theory is that The Sequel is dreary and populated by stiffs. But the truth is, for a prefab metropolis, The Sequel is a pretty happening place. Its political and economic viability has haphazardly spawned pockets of radical resistance to counter its own status quo. This makes for good times or at least a ripe sense of urgency. You're only on a stopover between cities but you are ready.

Those concerned with privacy, *ease your fears*: we will provide you with a Digital Suit™ to mask your identity, turning you into a panoply of shifting colored blocks that hypnotize everyone around you into disregarding your physical features. You slip the strange fabric on and instantly become an abstraction of your former self. Surprisingly, and fortunately, no one will have any clear recollection of the digital kaleidoscope your body has now become.

And here you are:

METRO

The Sequel International Airport sits directly above the Sequel Metro, the city's subway system. Down the escalators and beside the ticket booth is a map of the Metro. You are at "Airport." The "Downtown" station is for tourists shopping for souvenirs, and you already have a miniature version of The Sequel: a nifty snowglobe that gives your kitchen the appropriate "kitsch" factor. You know of two things you like to do in The Sequel. The Sequel Gardens are famous around the world for the most spectacular diversity of flora: Malaysian banyans coexist with Andean lupins via the latest in botanical tricks. Quite meditative. But there's also Ben's Arcade in t he Newmarket Shopping Center, which houses a rare video game based on Hitchcock's *North By Northwest*. With only a few hours to spare, your choices are limited.

You examine the map:

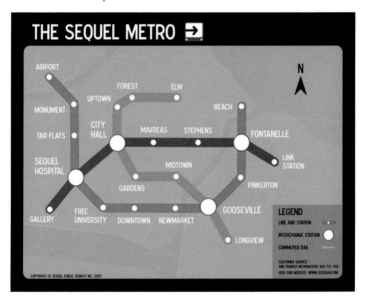

You purchase a strip of transit tickets from an indifferent clerk, go through the turnstile and wait for the train.

If you've decided to go to the Sequel Gardens, go to TROPICS

If you've decided to play *North By Northwest*, go to ARCADE

ARCADE

You know your way around the mall. Ben's Arcade is between a shoe store and a camping equipment outlet. The arcade's customers are always the same: school kids skipping classes in order to "morph" into "Zagrok" or "Kaladon" and use "The Lotus Flower" on their enemies. Ben follows the tradition of putting the newer games in front and, for those who don't evolve well with technology, there's a lonely section in the back that has a good variety of older machines: *Tetris*, *Dungeons and Dragons*, the original *Street Fighter*, and your beloved *North By Northwest*. Only one other person is playing in the backroom, some guy in a suit. You pull out a handful of change from your pocket, walk over to the game, place your quarters in a row over the screen and get yourself a stool. The game's dash is speckled with cigarette-burn craters, telltale signs of a bygone era when smoking was permitted in public places. You're poised to drop the 25-cent piece into the slot, but you see the suit looking at you, smiling and pointing to some sort of pamphlet.

If you'd rather forget about the would-be religious freak and play the game, go to N × NW

If you find the man rather curious, go to DFC PAMPHLET

TROPICS

It's easy to love the glass-domed Sequel Gardens: a completely indoor tropical landscape. The Gardens are so incredibly vast visitors are required to wear a locked GPS bracelet so no one gets lost. At present time you are blip #34 to the Gardens' mainframe computer. As you stroll along the well-designed paths, you stop at a massive transplanted kapok tree to rest. Sitting down, you feel something lumpy, reach underneath and find a wallet. Hmm…nobody in sight, only ferns, orchids and imported insects. The Gardens probably have a Lost & Found. You open up the wallet and look at the driver's license: "Noel Russell," a 47-year old male with a full head of gray hair (not a good photo). The wallet contains a few hundred dollars, all the major credit cards, a bank card, and a piece of paper that reads "PIN -7734." This "Noel Russell" is either very forgetful or extremely stupid. You're willing to bet that "7734" works with the bank card.

If you want to leave the Gardens and try the bank card, go to ATM

If you want to take the wallet to the Lost & Found, go to LOST & FOUND

ATM

Mr. Russell has chosen The Money Tree as his bank. You leave the Gardens and walk over to the nearest corresponding ATM. The Money Tree is the number one financial institution in town due to a recent marketing strategy that deftly appeals to the public.

You insert the bank card into the slot and the code works.

The prompt pops up and an animated version of the Talking Tree™, with onscreen text and pre-recorded sounds proceeds to ask you a series of questions.

Welcome to
THE MONEY TREE

What action would
you like to perform?

> Deposit
> Bill Payment
> Withdrawal ──────┐

└─For which account? Available Funds

> Savings - $ 3, 781, 637. 71
> Checking - $ 320. 08
> Platinum Credit - $ 7, 137. 05

How much will you be withdrawing today?
ENTER AMOUNT : ─.

A college kid in a toque behind you clears his throat to remind you that there are limits to how long you can stand around looking at your statement. You're in an uneasy ethical test: either take $10,000 out of Russell's account, or press "cancel." The Talking Tree smiles at you and winks.

If you take the cash, go to THIEF

If you cancel all actions and get money from your own card,
go to SNEAKERS

SNEAKERS

Unrealistic as it may sound, you're far too honest (or timid) to take what isn't rightfully yours. We can all agree that the system isn't perfect, but thievery is no solution to the problem. You can't complain: life is good. Ups and downs, to be sure. But how exactly did so-and-so make his millions? Maybe Mr. "Noel Russell" is responsible for those Asian minors who, in the poorest of conditions, stitched the running shoes you're now wearing. Maybe taking this money would be the greatest, most radical form of justice and you're just too chickenshit to step up and finally move from political thought to political action. Now hold on: five seconds ago you made up your mind to forget about the money and you're already debating yourself? Either you bring the wallet to the police or figure out a long-term plan to pull this scheme off. Flip a coin, for Christ's sake.

If you go to the cops, go to **POLICE**

If you go back to the ATM to get the cash, go to **THIEF**

THIEF

The clicks and whirrs of the ATM are a drum roll to the 10 K spitting out of the slot. You excitedly stuff your newfound capital into your pockets and scan for witnesses. But when the machine returns the card, you inadvertently rub your thumb against it, smearing it with an oily rainbow of sweat. You may be leaving evidence behind. The card is radiating some pretty bad energy, like a karmic time bomb, and it might be best if you got rid of it *and* the wallet, *pronto*. What others call "your mind" produces a slideshow of dirty fingerprints in close-up detail: DNA seeps into the card, double-helix strands spiral into the porous areas of the plastic—all traces to be uncovered by some police scientist. No turning back at this point: you are a thief.

Feeling a little paranoid? Want to get rid of the card? Go to ERASER

Or maybe you think you can use it a little longer? Go to LAM

LAM

Everything is happening too fast. You're addicted to the rush. You run from ATM to ATM collecting ten-thousand dollar servings from the Sequel Trust, First National, and over a dozen Johnny Cash Machines. After filling a whole backpack with bundles of bills, you buy a beater and drive out onto the highway. At Exit 17 you book yourself a room under a false name. You order bourbon and a day-old sandwich from room service. There must be at least $350,000 in the bag. Going home is out of the question. You have to move someplace and start over. You take a sip of bourbon and turn on the cable. Why does TV look so foreign in other places? Flipping the channels, you eventually fall asleep to the ping-pong of witty banter on a late-night talk show. In the morning you drive off, planning your new life in exile. For some, 350 large might not seem like a lot of money, but for you it's a nice little nest egg. A second chance. And you know what? You actually get away with it.

The end.

DFC BUSINESS

And a business card:

Sal Drinkwater's sense of self-satisfaction is simultaneously appealing and irritating. His air of confidence is tinged with so much arrogance it provides a certain credibility to his questionable tract. This is encapsulated in his sales pitch for his organization: "Join the DFC. You don't have any other choice, and besides, it'll be fun. Become someone else. I mean, we'll kill you if you don't, but maybe you'll like it so much that you'll forget how monotonous it is to be you." Sal removes his shades and laughs, as if he were selling a Ferrari. That a proposal of this caliber doesn't come along every day is quite apparent. The fact that the DFC agent isn't offering any time to think about it is enough to have you biting your lower lip in consternation.

If you think this guy is a crackpot and want to take off, go to BLOCKS

Or, if you're fascinated and scared shitless and want to follow Sal to the DFC Offices, go to OFFICE

There is no reason to fake it. You understand this.

DFC OFFICES

At the Offices of the DFC a secretary sits at a desk adorned with the DFC logo, "WE DON'T EXIST." Like any other office, men and women in business apparel shuffle papers along a maze of partitions, zipping their heels against the carpeting and thereby creating static electricity. Your fictionalization is an elaborate process overseen by a committee that has scheduled role-playing sessions in simulated environments. Your imminent plastic surgery and low-level brainwashing will provide you with a new appearance, new knowledge, and new talents. Oddly enough, the DFC is giving you a choice between two sealed legal envelopes labeled "samba" and "banality." Your Digital Suit™ is replaced with a custom-made Second Skin™ which attaches itself to your skin parasitically with microscopic bio-tethers, seamlessly changing your appearance.

If this is all too much for you to handle, go to RESEARCH

If the word "samba" promises an interesting future, go to GIG

If you felt that the DFC was trying to use reverse psychology on you, go to BANALITY

RESEARCH

You prefer the term "stage fright" to "performance anxiety." But the DFC committee overseeing your case has complete confidence in your abilities as a fictographer. They're sold. After the bandages are removed, you look up and down at the freak show that is your new body, and decide that you have to make a getaway. Being unrecognizable to yourself has that effect. When you leave the DFC Offices, rather than getting on the Metro towards your new home, you hail a taxi and beeline it to the bus station. You look a little shifty, but no one seems to mind. On the bus you figure that you have to start a new life, with or without the DFC. Little do you realize that this is exactly the character that the DFC has in mind for you: a fugitive with a new body, completely paranoid, inevitably secretive, and incapable of ever going back to your previous life. They call this "research."

The end.

GIG

Your new identity as an avant-garde pop/rock musician has been planned for over a decade. The DFC had been releasing albums of "your" work under the name "Lem." You yourself have been a fan for years. The music, speckled as it was with an earnest call to arms, inspired a generation of bohemians to pick up their guitars and Molotov cocktails to lay the groundwork for a revolution. But why would the DFC put so much effort into trying to incite a potential uprising? This question will be left unanswered. The DFC has instructed you to meet with The Sequel's resident political avant-rock outfit, the Explanation, in order to put on a benefit concert for a local anarcho-syndicalist activist group, tonight. The Sequel rockers are stoked and ready to take you to the venue.

If the idea of playing live—without any practice or even a soundcheck—with a bunch of strangers seems preposterous, go to MUSEUM

If you feel that you've gotten this far, go to SAMBA

SAMBA

Backstage the musicians are getting ready by smoking reefers, drinking whiskey, and going through the motions. The house lights dim and the stage is flooded with blue and pink laser coronas. You take to the stage and when you count, "one, two, three, four," the Explanation kicks in. You pizzicato your way through a five-chord samba that you wail over like an electric banshee with off-kilter new-wave melodies. At the critical moment, the tune simplifies to the ground zero of its funkiness. The blasts of counterpoint from the brass section warrant hoots and whistles from the crowd. The audience feels your love and you, in turn, feel more alive and connected to the universe than ever before. And then it dawns on you: you're a phony. Or maybe (you think) the DFC is indirectly promoting some twisted ideology. Or maybe this samba is an expression of political helplessness. As you sing the final verse, your voice resounds with joy and hope, and yet…was it Vinicius de Moraes who once remarked that a samba without sadness was like a wine that would never get you drunk?

The end.

MUSEUM

Ditching your future as "Lem," you hop on the Metro. You're short on ideas as to how to get out of this Second Skin™, which inconveniently has no zipper. You need time to think, in a public place where nothing can happen. You decide on the Sequel Art Gallery, a fine museum that houses choice pieces by Canaletto, Vermeer, and a debatable Caravaggio. In the SAG you wander nervously and end up next to a rusting steel cube which carbon-dating would confirm harkens from 1961. With no one in sight, you touch the cube's edges, which seem glazed with a whitish liquid. In the SAG's security room, a guard stuffs his mouth with forkfuls of reheated spaghetti, lazily eyeing you on a TV monitor as if it were a rerun of the most boring sitcom ever. In this episode, you feel the Skin™ falling apart around your own body, until you feel your own flesh melting with it, and you gurgle your last breath as you liquefy into a puddle of milk.

The end.

POLICE

In the blue pages of the phonebook, you locate the closest police station. You explain to the officer at the desk that you found this wallet and that, of course, you did look through its contents and even tried the card out, at which point you became overwhelmed by a sense of honour and duty. The cop is pleased enough with your story until he looks through Noel's ID. He then quizzes you aggressively and insists that you stay for questioning. The police are very curious about who you are. The enquiry is almost philosophical. They take you to a photo booth and ask you to walk in so you can tell your story. The whole thing. You slide the curtain and sit on the swivel chair. A mounted microphone waits inside, and you put a few quarters in the machine and tell them everything about yourself. From the beginning.

The end.

DFC PAMPHLET

He hands you a pamphlet which unfolds like an accordion:

 The Department of Fictional Characters

Welcome to the Department of Fictional Characters

Congratulations! You've been recruited by the Department of Fictional Characters (DFC). Any attempt at tossing this pamphlet will be met with futility. Welcome to your new life! Get comfortable with the idea of being employed by a covert government agency that engages in activities that the average citizen would find reprehensible. Your work with the DFC will be of service to your country and your people. But let's drop the patriotic rhetoric: you have little loyalty towards this nation. Your motivations are personal.

FAQs

Who is the DFC?
The DFC is a government agency that collects information and oversees specialized strategies in disinformation. We have a special name for this: *fictography*. We call our agents *fictographers*.

What is fictography, exactly?
A fictographer is a special agent who undergoes cutting-edge plastic surgery to become an entirely different person, to live a new reality, collecting data that will be sent back to the DFC.

Why was I chosen by the DFC?
Our research team, which have been studying you since childhood,

have determined that you perfectly fit the profile of a DFC agent. Your candidacy for the DFC was scrupulously considered. To truly understand an individual, you must inhabit them in every way, and this takes a special kind of person willing to take on the gait, the drawl, the very breath of an individual, in order to completely possess the character you are assigned to become. You, whose talent for almost anything, whose unfathomable genius, knows no bounds, are the ideal candidate for the DFC.

What will happen to my old identity?
In a nutshell, your old self will meet with "death™." The DFC draws from a vast repertoire of methods to fake an agent's death. Be assured that if you have a social network or family ties of any significance, your death will be tastefully executed. Let's be honest: you could leave your life behind in an instant, without an ounce of regret. That's the kind of person you are. *We know.* Otherwise we wouldn't have approached you.

What if I refuse to work for the DFC?
Since we're already prepared to fake your death, it would simply be a matter of making a few switches if we were put in the unpleasant position of having to kill you. But really, why bother? You shouldn't worry so much.

HIGH SCORE

After hours of playing, you quickly look at your watch for the time. Your flight leaves in a half-hour. Your mastery of the little digital Cary Grant is faultless, and with only three levels left, you've managed to put in the highest score this game has ever seen, outmaneuvering "BOB" and "SIC," who were worthy challengers. With time running out, you thrust the joystick and ecstatically send Thornhill careening off Roosevelt's Yankee hairdo. Before heading back to the Airport, you electronically tattoo your initials into the game. The Sequel's residents must contend with the fact that you are the number one player of this game.

The end.

LOST & FOUND

The contrast between the artificial jungle of the Gardens and the modern layout of the lobby is astonishing. Since everything is more or less automated at the Sequel Gardens, the staff look as if they'd rather be out fishing. The college student behind the information desk doesn't even seem to know if there is a Lost & Found, and is trying a little too hard to persuade you to relinquish whatever it is you found in the Gardens. This little punk would probably pilfer the wallet and spend it on drugs, but how would you know? He might be a good kid. Who can say? Either way, he can't really be trusted nearly as much as yourself. The burden you bear is yours, and yours alone. Unless you're having second thoughts about trying out PIN-7734....

Either try the bank card out and go to ATM

Or, take Noel's belongings to the authorities, and go to POLICE

ERASER

If only it were as simple as throwing the damn thing out. In order to dissociate yourself from the card, you must be systematic and resourceful. It takes eleven minutes to find a pharmacy and purchase rubber gloves, spray bleach, and an abrasive sponge. Afterwards, you walk into a coffee shop, ask for the washroom key and empty your shopping bag onto the counter. Outfitted with the gloves, you douse the contents of the wallet with bleach, scrub everything thoroughly, dump the lot into a trash bin on a street corner. You slip the $10,000 between a sandwich of magazines, and the airport security are none the wiser. But spending the money becomes impossible when you finally get home. You become very neurotic about all of the microscopic fibers of clothing you've left behind in The Sequel. You destroy the entirety of your wardrobe, scour your house of filth, cultivate an obsessive-compulsive inclination for cleaning. The money is hidden underneath a trap door in your kitchen, and you never spend a single dime.

The end.

GAME OVER

Unfortunately your skills as a gamester have dwindled over the years. Your hand/eye coordination is a little rusty. The miniature version of "Roger Thornhill" you had been controlling now lies dead in a pool of pixelated blood. *North By Northwest* doesn't end this way at all. For a moment you examine the game's screen and feel troubled by your own fate. The cartoon death in front of you is a preview of things to come.

The end.

BANALITY

Your new home is located in a small suburb on the outskirts of The Sequel. You have a nine-to-five job overseeing shipping and distribution for a small company that makes widgets. The work isn't exceedingly challenging, but your co-workers are friendly enough, and you find satisfaction in the routine, the noncommittal repartee at the water cooler, and in the copious amounts of alcohol consumed during happy hour on Fridays. Your character isn't self-reflexive by any stretch, and you acclimatize yourself to being contented with what the world has given you. In fact, this is the happiest you have ever been. Perhaps the DFC has given a sense of purpose to your steady, trouble-free, apathetic existence.

The end.

BLOCKS

Sal Drinkwater is emotionally unaffected by your desire to leave. This doesn't prevent him from candidly producing a pistol. As you begin running away, the DFC "fictographer" fires two stray bullets into a Donkey Kong and a Donkey Kong, Jr. His last round is a sure shot in the belly, but you feel no pain as the Digital Suit™ appears to have absorbed the slug. Sal smiles and nods a courteous goodbye. When you feel that the coast is clear enough, you walk out of Ben's Arcade towards the Metro. Walking a few paces, you notice one of the Digital Suit's™ cubes fall to the ground. Not particularly wanting to lose a section of your forearm, you start feeling considerably unhinged. Everything holding you together ceases to be a metaphor and becomes real as the cubes lose whatever glue was binding them together, and your body topples over itself into a pile. The cubes can be reused and resequenced into a myriad of different configurations as the building blocks for a thousand different identities.

The end.

N × NW

You are "Roger Thornhill," as played by Cary Grant, in a charming tribute to Hitchcock's masterpiece. Thornhill is mistaken for "George Kaplan," a fictional agent devised by the American government. Your objective is to make your way to Mount Rushmore to obtain the microfilm and save Eve Kendall from the dastardly Philip Vandamm. The controls aren't all that straightforward, but your affection for the game makes it that much more fun.

Ready? Begin!

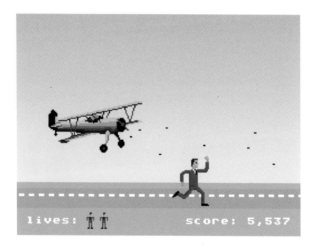

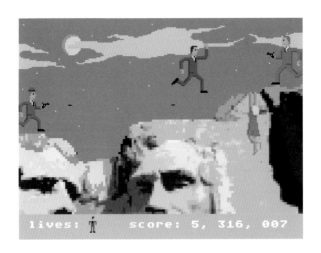

```
lives: 🕴    score: 5, 316, 007
```

If you do this and that,
go to HIGH SCORE

If you do that and this,
go to GAME OVER

INTERFERENCE

CHERYL SOURKES

Library Fri Dec 1 2 17:21:25 2003

Date: 29-May-2004 Time: 17:33:06

09.11.2002, 09:56:30 - BOSKOVICE

4:08:31pm 27-JUN-2003

SEKTOR'S SUSPI

GEORGE Z. GASYNA

It is feasible that these film reels survived wholly by accident. If all the others had been destroyed, then logically these ones should have been as well. It is highly likely that these particular reels were cutting-room rejects.

—Former director of the Sektor Surveillance Project

How do we establish our knowledge of others? Sometimes this process seems like a kind of intersubjective game, an epistemological exercise driven by suspicion. That's what attracts our attention in the first place, our suspicion. It is almost inevitable, too, that the suspicion will spread to both sides: we suspect the Other, but the Other suspects us. Just such a conflagration of suspicion can be seen in the case of the Polish secret police.

In the 1960s and 1970s, the Polish Ministry of Interior Affairs created secret surveillance tapes, which were recently discovered and made into a documentary with commentary provided by three former employees of the state security agency Sektor. The film was released, along with so much other Communist-era treasure/trash, for consumption in the new Poland.

From the commentators' discussions about the activists, politicians, and religious figures once under their surveillance, it quickly becomes clear that Sektor's agents were ideologically programmed to perceive their subjects as suspect. However, what is most striking about these secret tapes is the oppressive, grinding banality of it all—a banality that, sadly, is all too real for those who experienced life under totalitarian regimes. The case of Poland, especially its recent transformation to a US-style free market economy, presents a fascinating case study of how the images and techniques of the preceding system—the self-styled (administrative) dictatorship of the proletariat—came up for sale on the bazaar of television advertising, to be aggressively hawked alongside

Nokias, digicams, and all manner of newfangled security devices for the car and the home. In this consumerist paradise (especially as simulated on TV), these new models of surveillance, now domestic rather than national, came to be viewed as particularly desirable; they have become the new markers of success, *de rigueur* both as practical necessities and as potent status symbols.

In participating in the documentary, former agents of the state security apparatus showed that they felt immune to public scorn, and could let the world in on the secrets of their former craft, their dealings with suspects, and their normalization of the mechanics of surveillance. So now we know: *this* is what was going on all those years. Oddly enough, none of these specialists in the apparatus of state terror sounds like Dr. Evil. The question insinuates itself: this tape and these voices, are they all that remain of the socialist terror generation? Their high-tech gadgetry is now readily available at any Wal-Mart.

Sektor comprised state bureaucrats and administrators—spies, in a word—who viewed themselves as artists, technicians, and film-makers. They considered themselves, it seems, a necessary complement to the artistic factories of resistance operated by the Wajdas and the Kieślowskis. They were simply doing their job like anyone else, they tell you in unison, and doing it well. As specialist "contractors" for a "service department"—as one former agent euphemistically described his line of work—they were uniformly proud of the performance they extracted from their East German Praktica cameras and from their specialized montage and editing equipment. Their voices convey satisfaction with the tactics used to pursue their quarries on their peregrinations through the city, with their sophisticated cinemato-graphic techniques, and with their ingenious tricks for hiding the equipment while doing fieldwork (for example, in an attaché case

or behind a decorative flower on a baby pram). This was a matter of business, not war: the three narrators speak of rising costs and of ever-tighter deadlines, especially in the wake of the protests that grew particularly frequent during the early Solidarity days. Eventually, before it all went up in smoke in 1989, the main "service department" in Warsaw expanded to include twenty-eight operatives.

But who were their suspects? Sometimes it was the intellectual maverick and publisher Adam Michnik (presently the editor-in-chief of the daily *Gazeta wyborcza*). Sometimes it was the Catholic unionist leader Tadeusz Mazowiecki (later Poland's first post-Communist prime minister). It could also be the poet and essayist Stanisław Barańczak, or the philosopher and activist Leszek Kołakowski. In short, anyone with access to public means of communication, anyone involved or connected somehow with the "cultural" or literary circles, anyone who resisted the socialist regime, could become an object of the official apparatus of state suspicion. And then there were the supplementary, incidental, suspects.

Maybe the object was to put pressure on them a little.... On the other hand, at that time the surveillance people would not have to go out of their way to be discreet. In fact in some cases it was better to show persons of interest that we had them in our sights, so to speak.... On some occasions the camera would be only partially camouflaged, so that they would know that they were being watched—to frighten them a little, maybe. Besides, they must have realized that there were being watched...these were worldly people, after all.

—Former director of the Sektor Surveillance Project

In addition to tracking the requisite intellectuals and political opponents, Sektor's cameras filmed religious holidays, sports events, and the like, "just in case something might happen." And, during the filming of the harvest festival of 1968, something extraordinary did indeed take place. The clandestine camera placed in the stands is monitoring a parade below. Suddenly, the operator turns the camera to one side. The image shudders, and a striking figure comes into view: a man who has just moments before set himself on fire, in a protest against the Soviet invasion of Czechoslovakia. The burning man is quickly surrounded by plainclothes agents, led away from the gathering crowd and into a waiting car, which is then seen speeding away. This startling scene of self-immolation forms little more than a vignette; though the man's presence is dramatic, nightmarish, and spectral, he only briefly fills the screen. There is no question here of any intended filmic spectacle; the entire event is *incidental*.

All that survived is the brief image on the flickering screen culled from a cutting-room cast-off.

WORKS CITED

Piotr Morawski (2002)
Tajne Taśmy SB (Secret Tapes)
Telewizja Polska SA, Program 1

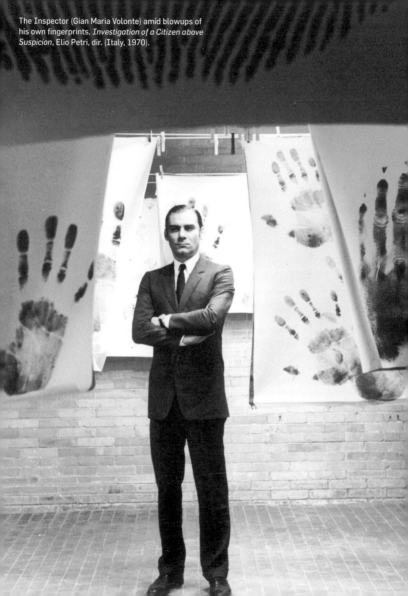

The Inspector (Gian Maria Volonte) amid blowups of his own fingerprints, *Investigation of a Citizen above Suspicion*, Elio Petri, dir. (Italy, 1970).

ABOVE SUSPICION

S. D. CHROSTOWSKA

Suspicion—handmaid of law and harbinger of justice—creates suspects. Now suppose that someone who has made a career of suspecting others risks all to bring suspicion on himself. And what if, while in law's service, exercising suspicion and judgment, he loses faith in the law's application? What if the agent of the law turns *agent provocateur*?

These possibilities frame a little-known film by Elio Petri, *Investigation of a Citizen above Suspicion* (1970). To view this film merely as a Kafkaesque satire of Italian fascist authoritarianism would be to overlook the existential crisis at its core. The film's central character is an unnamed cop (let us refer to him as P) who slashes his lover's throat on the day he is promoted from chief of homicide to chief of political intelligence, responsible for national security. He methodically interferes with the murder investigation, planting clues, then destroying them. When the police ignore this conspicuous and incriminating evidence, P takes even bolder measures to implicate himself. To his chagrin, although he should be an obvious suspect in the killing, he is absolved of suspicion. For while he prides himself on being above the law, above suspicion, able to get away with murder, he also represents the law and should be able to incriminate himself.

P increasingly directs his efforts towards the disclosure of his guilt, yet the agency of law enforcement seems bent on deflecting solid proof. To further his project, he coerces a common citizen (by invoking his duty towards the state) to act as a witness, but when he realizes P's status, the man retracts his testimony. The sole eyewitness to the murder is a student radical (another of the victim's lovers) who is a suspect in the bombing of intelligence headquarters. During what is technically the "subversive's" interrogation, P pleads with him to turn P in, but is refused on ideological grounds. Not only is his non-collaboration conducive to blackmail, it is in the student's

interest to keep P and his colleagues in power to further the cancerous system's collapse. Meanwhile, the investigators continue their tacit agreement to preserve P's integrity. Exasperated, he decides to make a full confession of his guilt, thereby reaffirming his devotion to the law yet, at the same time, defying its functionaries. In the ambiguous concluding sequence (narcissistic dream or nightmare?) P is forced to sign a statement declaring his innocence. He allows himself to dream of an acquittal even as he carefully prepares for his impending arrest.

Thus, P takes advantage of his powerful position in the political hierarchy to test the limits of his authority. His elevation above suspicion, through what he calls a "long unbroken exercise of power," incites him to expose the corruption of the system that has invested him with such power. P's haughtiness and self-hatred are also stoked by his victim's earlier mockery of his profession and her sexual humiliation of him. While continuing to flaunt his guilt, P later sees this as an extenuating circumstance. The murder serves a double purpose: a settling of personal accounts and a pretext for becoming suspect. Indeed, the film's opening sequence shows a calculated act of vengeance by someone simulating a *crime passionel*, precisely executed and deliberately flawed.

The unifying theme of most of Petri's films is the ironic ethical experiment. In *Investigation of a Citizen above Suspicion* the existential crisis may be either symptom or source of the pathology of power: power corrupting or power corrupted. In this imbroglio, P walks a fine line between criminality and justice. He is both perpetrator and victim, suspected and suspecting. It is not a simple case of "the enemy within"; he is not pursuing his nemesis or pleading impotence in return for salvation. Unable to find himself in this hall of mirrors, seeing only fractured motives and morally compounded isolation,

P cannot bear to be above suspicion. He is desperate for redemption, not through exculpation but through condemnation.

What propels P to the paradoxical contest of ego versus ideal, conceit versus abjection, is the realization that the law is nothing as long as authority in law's name is entrusted to human hands. Appointed as a sentry of the law, he realizes it is the law that absolves him. To salvage his fading ideal, he works at self-sabotage. His effort is thwarted, however, for he is cast above the law by the threat his flagrant actions pose to the power structure. P's loyalty to the law can only be expressed through his wish for punishment under the law.

PURGATORIO

ARIEL DORFMAN

Purgatorio could be understood as a sort of intellectual and emotional sequel to *Death and the Maiden*—a way in which I continue to delve into some of the themes I touched upon when I imagined Paulina Salas putting on trial the man she believes to have raped and tormented her under a Latin American dictatorship (similar but not identical to Chile's). Situated in a claustrophobic dreamscape outside ordinary time and space, my new play tries to take that dilemma a step further: Can there be forgiveness and reconciliation if we have committed monstrous deeds? How can we be expected to repent of those deeds without destroying our own identity, the bedrock of our past, who we are today? And what if repentance is not enough? After all, how do we know if someone is really repentant or only faking? And what if the one person who holds the key to my redemption happens to be the person I have hurt most in this world?

It was the last of these questions that I was most interested in exploring. I conjured two characters, a Man and a Woman, who would have to simultaneously interrogate and heal each other, to be the therapist for the other's redemption, the means to his, to her damnation, the guardian of heaven or hell. The challenge was to create a twist in theatrical time where such a switch of identities would be possible and not seem artificial, allowing me to play with the audience akin to how each of my protagonists plays with the other, hides from him, from her, from their own selves.

This narrative reversal, this examination of how a victim can become a victimizer, is hinted at in this excerpt, the first of three sequences, which ends just as such a reversal is about to take place. But this may be enough to suggest how *Purgatorio* intersects with the current need of contemporary men and women to look with new eyes at the dilemmas posed by terror and violence, as well as the interrogation and surveillance that have been the responses to that situation.

—AD

The play should be performed without an intermission. A white room. Austere. No decorations. High up on the walls, a couple of slits let light filter in. A small bed, carefully made. A table. Two chairs. Reminds us of a room in an insane asylum or a prison where conjugal visits take place between inmates and their spouses. One door, with a small window, meshed with wire, through which somebody outside could look in. On the floor, against one of the walls, a small mirror.

In the room, a MAN and a WOMAN. She is dressed elegantly in dark colors, even black perhaps. She has long hair, almost to her waist. He has a doctor's white gown on. Dark clothes underneath. Glasses. A physician's bag next to him.

M So you want to escape. Good.... (He takes a knife from the bag.) Here's the knife.

W You said nobody was going to get hurt.

M That depends on you, doesn't it? Pick up the knife. Pick it up. (She picks up the knife.)
Good. Because it depends on you, doesn't it, if somebody gets hurt? Doesn't it?

W Yes.

M Well, well. Real progress.

W I said the same thing to you yesterday.

M That was a different yes. This yes came from the heart.

W You can tell?

M I've got that knack. I dabble in yeses. Aren't you lucky that I was assigned to you?

W Yes!

M Good! Now let's see if we can make some more progress today. Look what I have here.
(He brings out a video-camera from the bag.)

W	Tell me again how it works.
M	You've forgotten?
W	I like it when you explain it.
M	It's a camera. It films.
W	It films.
M	It takes images of you and me, of this room, of what we'll be doing and it captures those images, keeps them in here. Then, later, we can show the scene to anybody we want. We can repeat the scene over and over, as many times as we want. And they, the people in charge, can see what happened. That's why we're doing this. Remember? To show them. To prove it can be done. (He places it on a tripod.)
W	To show them. To make them admire me again. So they understand who I am, what I could do again if I ever felt like it. To make them tremble.
M	Without hurting anyone. (The WOMAN puts the knife down.)
W	I don't want to play anymore. I don't want things to get worse. For this to make things worse. If we're caught....
M	How can things get worse?
W	They could stop you from coming.
M	But not because you're trying to escape. You're supposed to try and escape. It gives you a flavor, a hankering for really leaving this place. It keeps you dreaming. I promise. Nobody will ever use that against you.
W	Not even if I break out? Creep down the corridor past the sleeping guards stuffed with drugs, make it to the floor below, get out the front door and—
M	And find yourself right back here, in this room, me and you and this knife.

W And your promises.

M And my promises.

W You can promise all you want. How can you know? I mean, do you snore at night?

M What do you mean?

W At night. Do you snore?

M I don't sleep, you know that. Here we don't—

W Back then, before. When you were—did you snore at night?

M No.

W How do you know? How could you? Only the woman who slept at your side, only she would know if you snored or not.

M The person I loved would have woken me up.

W I didn't. He snored, my man—and I never woke him up, never told him. I would just watch him, listen in the dark first and then as it began to dawn, watch his lips moving ever so slightly, the breath and sound coming in and out of his body, dreaming of me. I'd draw his silhouette with my hands, like a shadow protecting him. Like the ointment I once spread all over his body. Rub, rub, rub, each piece of skin. Covering, protecting him with these hands. From far and then from near.

M But you never woke him.

W So he never knew. Just like you will never know. What they're planning, the people in charge. Or if you snore.

M Unless the person I loved were to tell me someday. If I were to meet up with that person.

W Is there a chance of that happening? You know how things are organized here. Has that ever happened, you know, a man and a woman who back then, before…?

M Never. It's against the rules.

W The rules. The rules. I'm sick of these rules. I'm sick of this place.

M You know what you have to do if you're really sick. Any time you're ready. But I mean really ready.

W You know, back then, I mean, before, nobody ever guessed my plans, nobody ever knew what went on in my head. It was my one advantage. They never imagined that I could do what I did, not even in their nightmares. It was my one advantage over them.

M Over him.

W Yes. Over him too. And now these other people, the ones who send you here every day, every day, they know I'm a big risk, they watch me all the time.

M They don't need to watch you. They're an Institution. The oldest one around. They have other things on their mind. Committee meetings. Things like that.

W Well, I'm tired of them knowing everything about me, you knowing everything, when I don't—

M Everything? I wouldn't say that. I wouldn't say we've come that far yet. There are lots of things you haven't told me.

W You leave and I sit down on that bed and I think of what else, what I could have forgotten, but nothing comes, for years it seems nothing has come that's new. You've picked through my past as if it were a dead vulture. As if you were a vulture. There's nothing left. Not even the bones.

M There is something left.

(The WOMAN refuses to answer, stubborn.)

All right. Let's go somewhere else. What if you were back there. On your island. If you could go back to your island. The island you never saw again. Isn't there one thing, one place…?

W Yes. On my island there's a bay where I'd—the Bay, the Bay of— I've forgotten its name again. Not far from where I first saw him.

M Your man.

W This happened before he came, before I—the name's right here, somewhere in my brain, that bay. I had a bad reputation. People said bad things about me. My father never listened to them. Maybe he should have. Maybe my brother should have. But they wouldn't hear a word against me.

M They trusted you.

W They trusted that girl, yes, the one who got up early in the mornings, before the dawn, to catch the sun coming up, to thank the sun, because the sun just gives and gives and never asks for anything in return. Only that we thank it, that we should be like it. This is something I never told you. A mile or so up the hill, just before you leave the last houses, there were some cats. Kittens, really. And when the first one saw me, he—or who knows if it wasn't a she, in cats it's hard to tell, even in humans we don't always really know—when this little thing, male or female, would see me, he'd start to mewl, almost caw, sweetly. And run towards me and when I kept on climbing—I was looking for berries and leaves and flowers, preparing brews in my head, that early in life, that early in the morning, what can heal, what can kill, what can make you dream, what can bring the dead back to life, what can make a man love a woman forever or close to forever, and just in case, just in case, what can burn the skin and set it on fire if it's inside a dress, and that blade in the foliage will do, yes, that yellow one, say its name or give it a name before using it—so I kept on climbing, and it would run ahead, the kitten. The poor thing thought I was bringing it some food, its milk.

M How did they sound?

W I'm not good at sounds.

M I'd like to hear you try.

W Meow, meow, meow, like that, calling. To someone who had

stopped coming, who had died or been sacrificed to the gods or grown weary or been sold into slavery—and they thought I was that person. They'd almost but not quite rub against my legs—and then, at some point, I'd leave them behind, when I passed a cave on my right hand side. I guess that was their hiding place, I guess that's when they realized that I was not who they were waiting for, that I was not going to bring them anything. Maybe then they knew that the person who had fed them had died, his body hacked into pieces and cast into the sea, was never coming back. Except the next day when I climbed up that hill again—or maybe it was two days later—they'd repeat the whole welcoming ceremony all over again, overjoyed that I'd come, bearing gifts. Only I wasn't. Each time I wasn't. Bearing gifts. By then, my man had come, I had seen him and we had stood in front of each other like two trees swaying to the same wind and I knew he would take me far away, across the sea, that I would open the kingdom to him, reveal its secrets and how to conquer it.

M Just as you had opened your heart to him?

W Yes. I showed him who I was, I let him see everything. Even what I would…so by then, I couldn't be bothered with kittens and such. But that's my regret, that's where I'd like to go. I'd like to bring them some milk, maybe some warm bread. Baked by my own hands. My own hands. See if they're still waiting for me. Imagine how surprised they'll be, those tiny animals. Because then they'll know they weren't wrong, I was the person they were expecting. My soul, my gentle soul.… I know what you're thinking. You're thinking how could somebody like me—these hands, these very hands—

M And they'd be safe with you? Later? The kittens?

W I knew that's what you were going to ask.

M You haven't answered my question. The kittens. Did you ever think of hurting them?

(The WOMAN picks up the knife.)

W What do the rules say about keeping the knife? (Pause.)

M What did you feel, tell me what you felt when your man told you he was going to marry another woman, that girl. When he said he was doing it for you, for your boys. For your own good, he said.

W Did I tell you that?

M How else would I know?

W Then I don't need to tell you again.

M You know, you're not being very cooperative today.

W What if today turns out to be different?

M Today doesn't seem very different so far. Am I missing something?

W You know, that proverb you asked me to think about yesterday. The Chinese proverb.

M If a woman opts for revenge...

W ...she digs two graves. Yes, that one. I've been thinking about it. If a woman opts for revenge, she digs two graves. I've been thinking that maybe I did kill myself. That all the time I thought I was digging his grave I was also digging mine. That this is where I am now, in the grave I've dug for myself. And that he must be in another room with someone else tormenting him—

M Is that what you think I'm doing? Tormenting you?

W Someone like you tormenting him, that's what I've been thinking. That maybe I don't need to torment him from here. In my head. That I don't need to say to him in my head how much I hate him. Instead I can see him, hear him, imagine him, in the next room maybe, somewhere in this building, and he says to whoever it was his bad luck to draw as a visitor, someone just like you, I can hear him cry: Stop. Don't you think I've suffered enough?

M That's a bit—overwrought, isn't it? Melodramatic? He doesn't sound like much of a man to me. Sounds like a crybaby. A whiner. Not at all how you've described him. What the legends say about him.

W People like you can turn anybody into—you wear us down. You've probably worn him down.

M So you imagine him saying, Enough, enough.

W At some point, yes. He breaks. And that's when you—

M Not me.

W Someone like you, answer him, you.... What does somebody like you answer him? Tell me that and maybe I can—maybe it's what I need, just one more little push. To get him out of my system. That's what I've been thinking.

M Even if I knew, I couldn't tell you that. It's against the rules.

W Who will ever know? You said they're not watching. Go on. Indulge me. Tell me how you would react, how you would corner him, question him, if you were his visitor—

M I'm not.

W Just imagine you were in charge of him and he was standing in front of you and he said, Haven't I suffered enough?

M All right. I'll play your game. Until the end—when the end comes, then it won't be a game anymore. And in any game, there are rules. Tell you what. Start me out. With the first thing you'd tell him. Give me that and I'll take it from there.

W All right. You can never suffer enough.

M That's it? What you'd say to him? You can never suffer enough.

W Yes. Now it's your turn.

M I'd say to him: You can never suffer enough. I'd say to him: Who's responsible? The woman who goes mad or the husband who drove her mad? You are the one, I'd say to him. You are the one who abandoned her.

w	Yes.
M	You are the one who said she was dangerous, said, Look what she did to her own father, to her own brother.
w	Things that I did for him.
M	Things that she did for you, I'd say to him, to save you, out of love for you.
w	Yes. And he smiled. Don't forget the smile.
M	You smiled, I'd say to him, you smiled, think of how she must have felt when you smiled at the thought that she would be thrown out on streets with her boys....
w	Streets we didn't recognize.
M	Without a language to defend herself and make herself known. Your own boys, I'd say to him, no place to go, no home left. She came to you....
w	I went down on my knees.
M	She went down on her knees. What she had never done ever before: down on her knees, and told you that she would have to beg from door to door the rest of her life, she who had been queen of the harvest, who had made the grains come out of the ground and.... What else, what else?
w	I could have spent my life healing the scars in others if he had not taken me from my hearth and my father.
M	She begged you not to do this to her, to give her one more chance, just one more chance.
w	Give me one chance, one more chance, don't I deserve a few weeks to prove that I can change? Look at me. I'm on my knees. And he said: That's what knees are for, that's what a mouth is for. To his wife, the mother of his children: It's about time you learnt some humility.
M	Yes. That's what he said.

W Yes. He asked me: Where are your mumbo-jumbo magic spells now? Where are your false snakes? He told me to find someone else, there are lots of men who'd like a piece of you. You're still a good fuck, he said. Do you want to have one last roll in bed before my wedding? No? Then go back, back, back to your father, he said, I'm sure he's planning a nice warm welcome after you hacked your brother into pieces and threw him on the waters. And then he said, my husband said: It's for your own good that I'm marrying. Come and meet her, my new bride. I'm sure you'll really like her. I'm sure you're going to be good friends. You could teach her some tricks in bed, you know, how to arch up that stiff pelvis of hers, give her some lessons. (Pause.)

M And that's when you decided to fool him.

W When he said I was going to be a good friend of his new wife. He gave me the idea.

M You made him think you had repented. Changed.

W He never really knew me.

M You still love him.

W No.

M If you could only admit that you have kept on loving him…

W I don't love him.

M …then you might forgive him. Or even ask his forgiveness.

W But would you believe me? If I said—today, right now—say I'm sorry, if I truly, deeply, repented, if I told you with tears in my eyes, kneeling down, would you believe me? How would you know it was true?

M We have ways. We have tests.

W What sort of tests?

M Words are never enough. Not if we want to send you back, if we want you to start over again pure, clean of your past. Purged.

W	If I repent, that is.
M	Everybody ends up doing it.
W	Everybody?
M	Almost everybody.
W	Have you ever thought—there's no solution to this one? To someone like me? There just isn't. No happy end to this one. Have you ever come up against a case where the only solution would be to eliminate, obliterate, I mean, finish that person off forever? Write her off. Write him off. No possible redemption.
M	We don't write anybody off. Not anybody. Not men, not women thousands of times worse than you.
W	Are there many of them?
M	Room after room after room. Like grains of sand at the bottom of an endless sea. Room after room, full, filling up fast, spilling over with women like you, men like him. Down there, things are getting—worse. Why should we give you special treatment?
W	Because I am special. He certainly thought so. Ask him. Ask whoever's assigned to him. Doing the same thing to him in the next room.
M	You like that? That he should be going through something just like this?
W	No. I told you. I've been thinking that maybe that's his business. His task. So full of tasks, mission, quests. And now he's facing the most difficult of all: to forgive me. And I've been thinking, maybe I can beat him to it. I can forgive him before he forgives me. What you said: not to dig two graves.
M	And you are not just saying this to try and fool me like you fooled him? Like you fooled your father and your brother and everybody else? Even your children?
W	You said that you had other tests. Try me.

M Are you telling me you're ready?

W Have I ever said this to you before?

M That doesn't mean you're ready.

W Try me. . . . Are you scared?

M I don't want to fail.

W That makes two of us. I don't want you to fail either.

M You think it's still a game. But if you try and cheat, they'll withdraw me from your case, they will, they'll take you away from me.

W Because the trust will have been broken, yes, yes, you told me all that. Would I risk losing you if. . . . You are scared of them.

M No. I just don't think you've come far enough yet. You're tired, are just looking for an easy way out.

W Would you say that to him? If he stood in front of you now and he said he'd had enough, enough, wanted to say how sorry he was, would you just dismiss him? Or would you give him a chance? The truth.

M I'd give him a chance.

W Because he's a man. Because you trust men to keep their word. But because I'm a woman. . . .

M You're not going to get away with this. You're going to ruin this for both of us. You don't know how rough this can be.

W Oh, I'm quaking already. You really frighten me.

M I'm warning you.

W For my own good?

M Yes. I do have your good in mind. That's what I'm supposed to do.

W My own good. Don't you think I should decide what's good for me? Don't you think—

M All right, all right. I know this is madness, I know you're not. . . . Listen. Carefully. This is not going to work unless. . . . You have to obey me. Do exactly what I ask.

w Isn't that what I'm supposed to have learned from you?
 To be a good little girl so I can go back and enjoy life again?

m What do you miss most?

w The sex. What do you miss most?

m I'm not allowed to speak about that.

w Then it's bound to be sex.

m You're not ready for this. I told you you weren't....

w All right, all right. No more jokes. Look. Here I am.
 Obedient and ready.

m You realize that now they will be watching, now it will all
 be recorded, official. If you fail me, they'll pull me off your
 case, I'll never come back. Someone else will, but—not me.
 You understand? Good. Now. First of all, you have to act as if
 I were your man.

w Is this another game?

m No. I am him. Can you do that? See me as him?

w You don't look at all like him, not a bit, but yes, I can do that. If
 that's what you need.

m No. This is what you need. You need to make believe I am him.
 And you have to talk about our children.

w Our children?

m Our children. I'm him. Remember?
 (The MAN switches on the camera.)
 Now what I want to know, woman, is what was the worst part?
 That's what I need you to tell me. What you've always refused
 to talk about. When you saw the first drop of blood, knew you
 couldn't go back on what you...? Was that the—

w No. That wasn't the worst part.

m Tell me.

w This is very hard.

M Maybe it was something he said, the eldest one. What did he say to you, the eldest one, your firstborn? He was first, right? Did I guess right?

W Yes.

M Why?

W He was stronger than his little brother. It would have been— difficult to catch him, he would have run away, if he saw me, the eldest—if he had seen me....

M Seen you what?

W Doing what I.... Doing that.

M Not doing. Say it. Say it.

W Killing.

M No. Say it.

W Murdering.

M Good. Say it again.

W If my first born had seen me murdering his little brother, it would have been more difficult to do the same thing to—

M Say it. Use the words.

W More difficult for me to murder him afterwards.
 (The MAN is horrified but remains calm and in control.)

M So you calculated. You were not insane. Your husband didn't drive you mad as you keep saying. You were fully aware. You had been planning that possibility since the children were born.

W Since they were born. Before they were born. Since then. Maybe before we were born. Before anybody was born.
 (As the WOMAN speaks, the lights begin to go down. As soon as we are in darkness, we hear the voice of the MAN, surprisingly different, grunting, cheerful, counting. He will continue to count up to any number which allows the transition to happen.)

SINGING AGAINST
THE HANDMAID'S

MICHAEL WALLING

THE TIDE:
TALE IN TORONTO

Poul Ruders's opera, based on Margaret Atwood's novel *The Handmaid's Tale*, begins with a newsreel-style film of the events leading up to the establishment of the Republic of Gilead. The dates in the film suggest this will happen in the near future.

31st August 2004. I'm sitting in a Toronto edit suite, doctoring the film to make it work here and now. It's partly a matter of shifting the dates a year or two forward—but not just that. In the original footage, created for the 2000 Copenhagen production, the Twin Towers of the World Trade Center are clearly present. At the Danish performances, the audience used to laugh at this film of an attack on the US. Not any more. David, our editor, clicks his mouse and, like a virtual bin Laden, solemnly removes the Twin Towers from the New York skyline.

The audience are welcomed as conference delegates studying "Iran and Gilead: Two Early Twenty-First Century Theocratic States." Offred's audio-cassettes are taken out of cold storage by Professor Piexoto.

In the novel, Piexoto appears only in an ironic denouement. Having him frame the action of the opera like this underlines the theatricality by casting the audience: they become actively, democratically present, which isn't something people are very used to these days. Our theater is near Lake Ontario, on the other side of which America is in the thick of a supposedly democratic election. I doubt whether the Greek inventors of the term would have recognized this version of democracy. Bush's America is based on a system of advertisement and consumption, in which the electorate is rendered passive by the huge expense involved in the acquisition of any sort of voice. Real democracy requires the continual exchange of voices in the public

space: the reinvention of media as commodities is the antithesis of this. For the Greeks, who invented both democracy and theater, the voice is the key to everything. For them, theater, music, and politics were all part of the same process of public discourse: Book 8 of Aristotle's *Politics* is a book about music. This opera is about the urgency of finding our way back to that

The set is revealed: a gymnasium. Offred and Moira are stripped of their modern clothes, and dressed as Handmaids.

The gymnasium comes straight from the novel—the very first line is "We slept in what had once been the gymnasium." But it's more than that: it's a high, clear, open, white space throwing the events into sharp relief. "Gymnasium" is a Greek word meaning "the place of nakedness." Theater is also a place of nakedness. Nakedness in this scene, where two characters are stripped of individual identity and reinvented in another. Nakedness later, when Offred makes love to Nick. Nakedness in the sense of being exposed as the vulnerable and beautiful animals we are.

Since we've been rehearsing, the gymnasium has taken on an added resonance with the massacre of the schoolchildren in the gymnasium in Chechnya. So this cold, clinical world is also a metaphor for the death of children. That feels horribly appropriate: in the opera a baby is "put down" because she doesn't meet Gilead's standards of physical perfection, and Offred's recurring nightmare is of her five-year-old daughter being torn from her. Ruders's most moving music is associated with this little girl: filled with these sounds, this gymnasium becomes a space for mourning.

Aunt Lydia intones the commandments of Gilead:
"Thou shalt not commit abortion."
"Thou shalt not commit gender treachery."

As so often is the case, what the public art of theater can teach us about the present moment relates to the language through which political ideas are expressed. Like Gilead, the administration of George W. Bush is characterized by a manipulation of biblical language and a reductive moralizing. Gilead's strategy is to take the known structures of religious language, and to subsume them into its own political agenda—giving that agenda the ring of doctrinal certainty. In Gilead's Beatitudes, the meek inherit not the earth but the Republic of Gilead itself; and the (non-dissenting) "silent" are "blessed…for they shall hear God." Gilead's Commandments line up "abortion" and "gender treachery" as crimes, which can be "committed," like murder and theft. This is exactly the theological sleight of hand employed by Bush in many of his public speeches. The 2003 State of the Union address used the words of Lewis E. Jones's 1899 revivalist hymn "There Is Power in the Blood," which is as rooted in the Bible-Belt psyche as the Beatitudes and Commandments are in other Christian cultures. "There is power, wonder-working power," says the hymn, "in the precious blood of the Lamb." Bush spoke of the "power—wonder-working power—in the goodness and idealism and faith of the American people." That the deliberate equation of the American people with Christ as innocent victim was unspoken made it all the more telling and all the more insidious.

The hymn continues, "Would you a victory over evil win?" By defining any enemy he chooses to see as part of an "axis of evil," Bush externalizes and objectifies the moral struggles that more sophisticated theologians locate in a psychological, internal space (a process similar

to what has happened to the idea of *jihad* in Islamist discourse). It is characteristic of the religious right to locate "evil" in a demonized "other," a diabolical monster that may be named the Soviet Union, Osama bin Laden or Saddam Hussein. Following 9/11, TV evangelists Jerry Falwell and Pat Robertson blamed the attacks on abortion rights advocates, feminists, gays, lesbians, and the liberal interest group People for the American Way: God had withdrawn his protection. "God continues to lift the curtain and allow the enemies of America to give us probably what we deserve," said Falwell. Their demons are the very people who are strung up on Gilead's hanging wall—itself, like Falwell's "curtain," a symbol of a closed and protected theocratic state.

The Handmaids wear long shapeless dresses, wimples, and gloves. Virtually the whole body is covered.

When Margaret Atwood wrote *The Handmaid's Tale*, her inspiration for these costumes was the *hijab* (veil) worn by women in post-revolutionary Iran. The even more extreme covering of the female body by the *burqa*, which has come to symbolize the Taliban regime in Afghanistan, inevitably resonates when we look at these costumes. It's strange that imagery drawn from the cultures that the Bush administration constructs as its opposite should seem so powerfully to symbolize aspects of the administration's own response to religion and gender.

That it can do so suggests just how similar are the reactionary theologies of Bush's America and radical Islamism. Each of these movements represents a reaction against the liberalism of the West: a sense that the liberal ideologies stemming from the 1960s have created a decadent society, devoid of spiritual values and a sense of

moral worth, which has been steadily exported across the globe. The influential Islamist theorist Sayyid Qutb developed his ideology in response to a visit to the United States, where he perceived postwar liberalization, and especially feminism, as a dangerous anarchy, a breakdown in moral law. Qutb's response was to politicize his version of Islam: for him, the moral decay evident under democracy was set against the imposition of the law of God as revealed in the *Shari'a*. For Qutb, then, the *jihad* ceased to be either an internal struggle for spiritual truth or even a defensive struggle to protect Islamic territory. It became justifiable to wage war against non-Islamic governments. Such regimes were perceived as representing the condition of *jahiliya* (the state of ignorance before the time of the Prophet), a theological moment transformed into a political moment.

The theological justification for the neoconservatism of the Bush administration is similarly rooted in the rejection of the liberal consensus. Liberalism, as the argument first laid down by the Chicago Platonist Leo Strauss runs, has failed to create a good society, but has led instead to an increase in crime, poverty, depression, and mental illness; a "moral decay" characterized by homosexuality, feminism, and abortion. In rejecting the liberal morality of postwar America, neoconservatism reasserts "traditional values." In Bush's own case, the process of this rejection is biographically embodied: after his playboy youth, at the age of forty he was "saved" by Billy Graham, and has gone on to espouse the "born again" theology of Dr. Tony Evans, the founder of the Promise Keepers movement. In a startling parallel with Islamism, this movement pictures the seizure of earthly power by the "people of God" as the only means by which the world can be rescued from moral decay. Hence Bush's stance: "We will export death and violence to the four corners of the earth in defense of this great nation." Although Qutb and Evans present their positions as

traditional, the reality is that they are both radical new responses to the perceived threat of moral breakdown.

This bizarre symbiosis between American political Christianity and Islamism explains something of the two movements' almost erotic fascination with one another. They imagine themselves as opposites, but they have been formed in the same way. As with Offred and the Commander, there is enmity and attraction in equal measure.

Serena Joy, a former TV evangelist married to the Commander, tells Offred that he is "my husband. Till death us do part. That is one of the things we fought for."

Serena Joy's political domestication is central to the opera. It is also central to the neoconservative project in Bush's US: much of which is concerned with overturning feminism, getting women back into the home, and emphasizing the "traditional family" as the basis of the "American way." This is why the focus of so much Republican rhetoric is on thwarting abortion and gay rights.

Offred remembers her life in the Time Before; making love to Luke while Serena Joy sang "Amazing Grace" on the television.

"Amazing Grace" is the anthem of the Christian right in America: Bush's cabinet, led by Condoleezza Rice, sang it the weekend after 9/11. Its theology is rooted in a binary discourse of good and evil, lost and found: simple language that is readily politicized. Because this theology is rooted in a conviction that the individual's free choice to accept the proffered salvation is a once and for all guarantee of "chosen" status, it leads to a markedly unreflective faith. There is no room for doubt or questioning, no sense of any internal spiritual

or moral drama. There is simply the belief in a righteous "us" pitted against an evil "them." It is, therefore, a theology that introduces the possibility of global warfare.

The global nature of this war has created the new universal subject: the suspect. In this paranoid atmosphere, suspicion is everywhere, so that even names and identity are themselves the object of suspicion. Deprived of their names, renamed so that they exist solely in relation to the Commanders, the Handmaids are deprived of their identities, and so of their worth. They become depersonalized. The anonymous clothing and ritualized way of life warrant comparison with the depersonalizing of detainees in Abu Ghraib and Guantanamo Bay, and of women in Taliban Afghanistan.

The result of this un-naming is that naming, the use—the game—of language, becomes central to Offred's interior process of resistance. Forbidden to read or write, she stares in wonder at the Commander's books, and relishes the taste of words like "booze" and "zygote," which add spice to their illicit Scrabble. Unable to express emotion publicly, she constantly seeks to name her feelings for herself: "What I feel / Is despair / Like famine." Such an action of naming becomes deeply subversive in a world where women are un-named, without identities.

The Particution: a political prisoner is kicked to death.

Ruders makes an astonishing quotation of Bach's "Passion" chorale to accompany a scene of hideous brutality. It could, of course, be argued that this is a very cynical moment, that the hymn is intended by the men of Gilead to give theological justification to judicial murder. But, as we rehearse, I find this jarring and distorted chorale has the entirely opposite effect on me. It seems to assert the Christlike dignity of the

unknown suspect who has fought totalitarianism and is now being destroyed. It serves as a reminder of another kind of faith to set against the fascistic horrors portrayed in the opera, horrors that are increasingly present on this continent. This would be a faith based on forgiveness rather than retribution, on humility rather than assertiveness, on love rather than hatred. This other meaning of Christianity makes the "Christian" basis of the Bush regime look very hollow indeed.

The end of the opera: Offred is taken captive by the Eyes of God.

I never know quite how I feel about the ending of the opera. Offred is apparently captured, but her lover Nick reassures her that this is the Mayday resistance; and the fact that the tapes were made suggests that she did indeed escape to a "new life." It feels very like another version of Christian myth: Piexoto calls it "the tale of her Passion," and there is an ambiguous variation on the theme of death and resurrection here at the end. Maybe that is inherent in this form called opera, which began with Monteverdi's treatment of Orpheus: a myth of death and resurrection if ever there was one. Maybe it runs even deeper—maybe these archetypal narratives are so deeply ingrained in our culture that we end up constantly rewriting them in different forms. Maybe Margaret Atwood did it on purpose: I don't pluck up the courage to ask her.

What concerns me about our narrative revisiting of these archetypes is that it might compound rather than rebut the dangerous theologies that dominate contemporary political discourse. Neoconservative Christianity is deeply apocalyptic in tone—there's much talk of the Rapture, and of final battles between "good" and "evil." It's because of this eschatological emphasis in American theology that

the politics of the right have become so insistent on the need for immediate action: "You know not the hour." I find myself feeling wary of any narrative that concludes with Judgment.

This is particularly the case when, as here, there is an element of Resurrection attached. The Second Coming is a known pillar of apocalyptic Christian theology: it is also, in another form, central to Shi'a radicalism. In the Shi'ite tradition, each Imam (or leader) in the line of the Prophet's cousin and son-in-law Ali was in turn secretly murdered for political reasons. The Twelfth Imam, Muhammad al Muntazar (the Awaited One), simply disappeared. In Shi'ite theology, this "Hidden Imam" will return at the end of time as the Messiah or al-Mahdi, to bring peace and justice to a world torn apart by corruption and warfare. This figure is hugely powerful in Shi'a psychology: Ayatollah Khomeini drew much of his charisma from permitting his image to be subtly aligned with that of the Hidden Imam.

I don't believe the thesis behind Huntington's *Clash of Civilizations*: if anything, there is strife between Christian America and radical Islamism because of what they have in common, rather than where they differ. If we are genuinely to subvert the mythological underpinnings that support the dangerous politics of the apocalypse, perhaps we should be looking for new paradigms with which we can sabotage rather than reinforce their narrative structures. This calls for the sort of theater that Grotowski was seeking in work like *Apocalypsis cum Figuris*: a fundamental psychological assault on the basic paradigms of Judaeo-Christian-Islamic culture. Whether that is even possible within public speech, be that theater, opera or politics as we know them today, I'm not sure.

99 PIECES OF *AMAN*

ALIA TOOR

Al Alim: The All-knowing; he who is all-knowing.
Ya Alim: He who repeats the name will find his heart becoming luminous, revealing divine light.

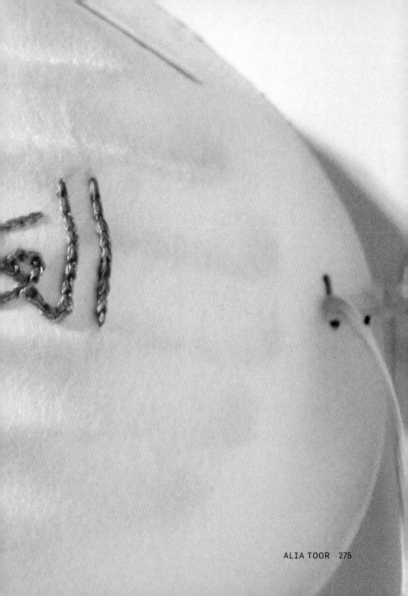

Al Azim: The Great One; he who is magnificent.
Ya Azim: Those who repeat this Name many times will be respected.

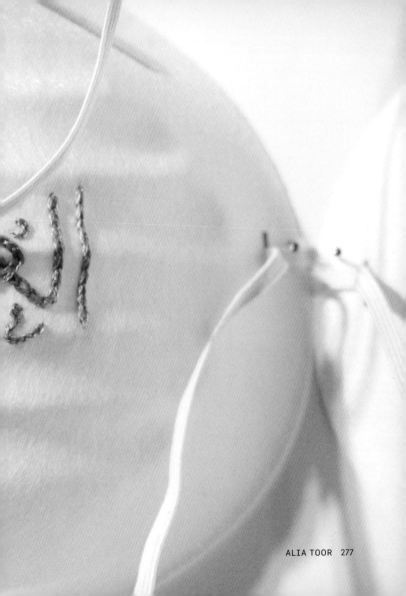

Al Shakur: The Appreciative; he who is grateful and gives rewards for deeds done for him.
Ya Shakur: He who has a heavy heart and repeats this Name forty-one times, breathes into
a glass of water then washes himself with this water, will feel his heart lighten,
and he will be able to maintain himself.

ALIA TOOR 279

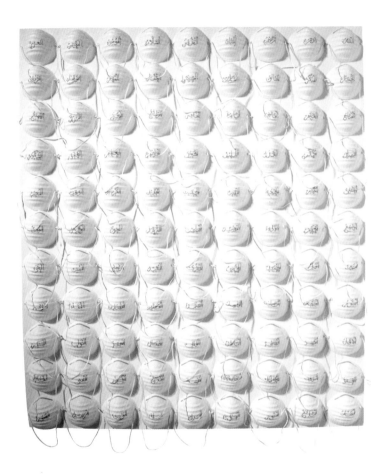

MEALTIME

DIANA FITZGERALD BRYDEN

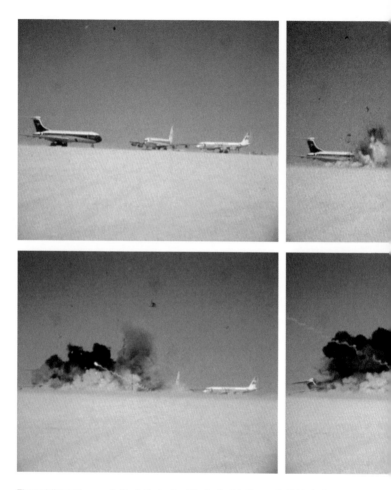

Three airliners blown up in Black September hijack attack in Dawson's Field, Jordan.
(ITN, 13 September 1970)

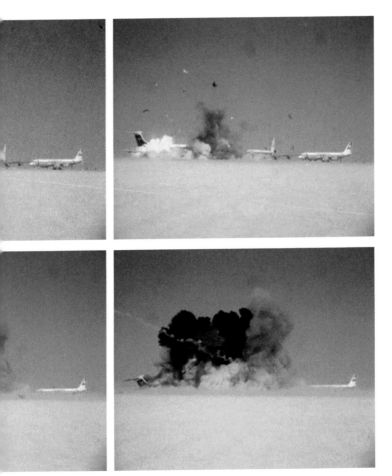

Has the Leopard...

What will she look like? Lydia Devlin and Mouna Ammari, strangers to each other, are both wondering this. They're not the only ones. Due to the dangers of the profession, few armed revolutionaries make it to middle age, and those who do—well, time, like politics, is not always kind. Former heroes and heroines lose their sex appeal. Visionary governments turn corrupt and are tossed out by the people who clamored for their instigation. No one saw Che get fat, lose his hair, compromise his principles. His followers and detractors do that for him. They're the ones who must live in time while his beauty replicates itself endlessly on posters and coffee mugs.

The audience is primed for Rafa's charisma. The excitement in the room has psychosomatic manifestations: people twitch, cough, whisper like concert patrons trapped in their seats during a quiet movement. Some fan themselves, though the lecture hall is not hot. With premonitory awareness the crowd begins to hush just before the moderator and panelists file in and prepare to take their seats. Bodies incline towards the stage. *Is that her?*

Altitude Sickness

September 4, 1970, and the passengers on El Al flight 071 (Tel Aviv to London) have more than usual cause to applaud their captain and crew on a safe landing. As the plane taxis to a full stop a young woman near its tail end is crying from the pain in her head. A gun butt broke the skin near her temple, inches away from that most fragile spot where the blow might have killed her. Lying face down, her features distorted by pain and fury, she's still beautiful, which it could be argued is an immaterial fact, but given the circumstances, not at all. For one thing, her distinctive beauty compelled her to suffer plastic surgery in order to board 071 without being recognized. Her altered,

if undiminished, looks will play their part in exciting the interest of the press, the sympathy of the public. They'll make her jailers more solicitous. Combined with her considerable charisma they've pleased more lovers than might be expected for a young woman, not yet twenty-two, who's had other things on her mind.

Rafa the beautiful is sprawled in the aisle, face mashed into the carpet, forehead bleeding. Her arms and legs have been restrained, first by passengers determined not to let her up, now by impromptu handcuffs (neckties and rope). Like some high-stress version of a party game, the grenade she dropped in the scuffle—pin still in place—rolled forward, was pocketed by Melissa, a stewardess, who passed it like a hot potato to Josh, the El Al security man whose gun butt clocked Rafa on the head. Rafa tried to shout a name—"Pablo!"— but Josh's hand covered her mouth, his palm slimy with her own snot and spit. She gagged, trying to breathe, to get out more sound. It wouldn't have mattered anyway; Pablo was dead, as it turned out. Shot by the business end of the gun that stunned Rafa. She hardly knew him, barely has his last name straight, which will be rendered differently in various news reports later. They'd only met twice before the hijacking, but he was her one ally on the plane. There can be little doubt that almost everyone else—children, businessmen, mothers, teachers on sabbatical—would be happy to have seen her die along with him.

While Rafa lies incapacitated her more successful comrades are supervising the landing of four planes on an airstrip in Jordan. Terrified passengers from several points of origin have been informed that their fates now depend on the resourcefulness of their governments. Over the next few hours they will swelter inside the stopped planes, keeping their eyes on the hands of the men watching over them. Soon fluids will be rationed, toilets will overflow; the planes

will begin to stink. Hijackers and passengers alike will start mouth-breathing, dream of surviving to inhale fresh air again. Doors to the planes—an armed hijacker at each one—will be opened to allow some of that precious air to circulate. Passengers surreptitiously dry-swallow heart pills and Valium, afraid that those who reveal an infirmity will be selected, Darwinian-style, as the first to die if it comes to that. A strange bond will develop between even these passengers and their captors, as the hours become a day, then two days, then three.

The travelers inside Rafa's plane were lucky. While cruising at 30,000 feet their air circulated freely, if a little muddier each time as the machinery worked to process more smoke than usual—a frenzy of cigarette-lighting after the aborted attack—and the plane maintained its course to London. When they hit rough air, Rafa rolled awkwardly, bruising her shoulder. Pablo's body is in the hold, kept from spoiling by the subzero temperatures there. Once the plane has rolled to a full stop, four men step on board and order the passengers to stay seated until Rafa has been safely removed. They unleash her and snap on real cuffs, taking her into custody, accompanied for the sake of decorum by a female officer who will supervise the strip search. Pablo is sent to the morgue, sharing an ambulance with a coroner and a police officer. Other ambulances are waiting for the passengers, whose delayed responses to shock and tension will hit now that the pressure's off. Rafa will spend the next few hours in the company of British Intelligence, then she's transferred to Holloway, where she will later be interviewed under guard by a handful of journalists, among them Phil Devlin, a British journalist of Irish descent. Phone conversations have already been initiated between various governments and their representatives, including the Jordanian embassy just down the street from Phil's house.

Past Tense

The Devlins lived beyond their means, smack in the middle of London's embassy district. Three days after the hijacking, Phil's daughter Lydia and her friend Caroline were walking home from school with Caroline's nanny, Joan, when they found their usual route blocked by barricades. Even stranger, the police carried guns. Once before, Lydia had seen gun-toting cops: extras in a James Bond film on location at the Italian embassy, exciting, but palpably unreal. These men were different: flat-caps, not the Dixon of Dock Green patrolmen with their domed helmets and bruising but relatively innocent truncheons—though there were some of those too, arms folded, lining the fence in front of the Jordanian embassy. A faint roar came from inside the building. It rolled closer and then further away with the wind, vocal tides. As Lydia learned later from the television, the sound came from the lungs of about fifty young men shouting slogans, buttressed by the steady buzz coming from half that number again of reporters. The men, a BBC announcer informed her, were student demonstrators, most of them from Jordan or Lebanon, who were occupying the embassy. They were protesting the expulsion of Palestinians from Jordan after Arafat's defeat there. And insisting on the release of Rafa Ahmed.

"Who's Rafa Ahmed?" Lydia asked Phil.

"She's one of the hijackers." A *woman*?

"Why did she do it?" Lydia's question couldn't begin to convey all that she meant by it, such as how could a woman, any woman, be so fearless? What could drive her to risk her life, to threaten the lives of strangers? What kind of person was she?

Phil answered her literally. "The usual. Freedom. Land." He pulled her onto his knee and she lolled against him, pleased to be the focus of his attention.

"Freedom for who?"

"Terrorists," Elise said crisply, without putting down her paper. The ice in her glass cracked and Lydia jumped. Smoke from Elise's cigarette made a ragged question mark in the air.

Phil ignored her. "I'm a good Irish Catholic, Lydia. I understand the obsession with territory. And violence." And he looked back at the television, where Jenny Richardson, a popular actress and friend of theirs, was shown chained to the railing opposite the embassy in solidarity with the protesters. She held a banner: Free All Prisoners of Conscience. Another phrase, Right of Return, was scrawled in red across the front of her white T-shirt. Depending on your point of view Jenny was an apologist for terrorists (Elise, *The Daily Mirror*) or a supporter of oppressed refugees (Jenny, Phil). Phil said Jenny was a nitwit, but he admired her bravado, and, Elise had observed more than once, her tits, which she bared on stage and television often and with enthusiasm. At the moment they were covered and heaving in front of a transfixed cameraman as she wrestled with two police officers. Elise gave a snort and raised her paper in front of her face.

A few days after the demonstration, Phil interviewed Rafa. Not really an interview, by his usual standards. More a heavily supervised zoo visit designed to allow a handful of journalists and photographers to document the fact that Rafa was unharmed and under the compassionate supervision of a couple of the more photogenic female wardens. Rafa left the country almost immediately afterwards, and within twenty-four hours seven Palestinian militants had been released from various jails across Europe. The hostages in Jordan were freed in exchange for these concessions. There were two casualties from the hijackings: Pablo whatever-his-last-name-was and Ed Hollis, an American engineer and diabetic who went into insulin shock, exacerbated by the prolonged stress of being terrified and confined in

100 degree heat for more than three days. Hollis died in a hospital after being taken to Amman with the other passengers. A spokesperson for the hijackers expressed regret for his death.

Identity Crisis

Names. Devlin. Ahmed. Palestine. Only the rarest and most rooted have a solid name—a name of pure inheritance handed down intact— by which they recognize themselves and are recognized by others. Quite apart from marriage, most of the world's people can follow the thread backwards and forwards from a mutated name, a personal history of migration or exile, surprises and digressions, or deliberate camouflage. Take Rafa Ahmed's co-hijacker. Last name Marino, said one interview; Moreno, reported another news source. Pablo, whoever he was (if Pablo was even his name, and not a disposable element of the hijacker's tool-kit), was gone now, one of the ranks whose personal statistics feature briefly in news reports then evaporate outside their sensational moment.

Take Phil Devlin, an Irish Catholic married to a Jew. Following his abrupt death in 1973, Phil and the survivors—Yves (photographer) and Ian (fellow journo)—were named in news reports; Phil's fellow casualty, his driver Basman, a father of four, was not.

Take Beirut's politicians, clerics, and fighters. The spelling of their names in news reports, books, and communiqués depends on the author's origin, religion, or instinct. Al- becomes El-, Faranjiyyeh becomes Franjieh. Lebanese names are a serious business, announcing Muslim or Christian, Druze, Phalange, Murabitoun, French-educated or English, just for starters, and sometimes confounding all expected interpretations. Misread at a checkpoint by a stoned, distracted teen-ager, as in the case of Mouna's cousin, a name can get your lights put out once and for all.

When Lebanese citizens migrate, like Jews (Phil Devlin's father-in-law, Max, for instance) they may adapt their names or be rechristened entirely. Amos Muzyad Jahoob (or Amos Jacobs, depending on the source) becomes—top-o'-the-mornin' to ye—Danny Thomas. And so it goes: -berg and -stein are sheared away for maximum comfort and efficiency, El- and Al- set adrift to soothe suspicious minds. Families divide and multiply, dissolve or reconstitute—can any of us say she knows her true name?

Rafa Ahmed: there's a name and a half. Mouna Ammari sits at her kitchen table, transfixed by the first in a series of photographs. Rafa's glossy face is ripe with a bitter satisfaction that makes her gleam. *Fuck, she's beautiful.* In spite of the plastic surgery she had to disguise her notorious face. She was in her twenties at the time, just older than Mouna now. Here are photos of her being dragged away by El Al security; and here, photos of her triumphant return home from prison. Mouna was a child then—*so ugly, such a chicken too*—constantly afraid, unable to imagine being that beautiful or brave. Her response to Rafa, even then, was part sexual, and later, as a gawky girl, she was both aroused and comforted by the thought of Rafa's courage. *How could she be that brave and fierce? I'd have wet my pants.* She turns the page to pictures of the burning planes on the tarmac in Jordan. Then she reads details of the negotiations over the European hostages; Rafa's colleagues insisting on the release of seven of their comrades, plus Rafa, in exchange. It's clear now that a bargain was struck almost from the beginning, back-door diplomacy. Phil Devlin knew all of it, including Hussein's bizarre request to Golda Meir (denied by Hussein, by Meir, by Britain, by the US, by anyone in authority who could spit the words out). He knew more than that. He knew Rafa, up close.

Mouna's apartment is quiet, save for the tail-end of street sounds.

Car-horns, voices, someone's tires grinding snow. (The noisy drunks down the street have dispersed, kissed and made up, gone in from the cold to drink some more.) She still keeps an ear half-cocked for explosions, but there are none of those here.

She sits with the lights off, resting her eyes and thinking about home, about her little sister, about those who've stayed behind. Uninvited, a memory fills the gap. That's the problem. Create a vacuum and it demands to be filled—and by what, you don't get to choose: Mouna and Sara Halil walking home from school. Usually Mouna's cousin Farid escorted them, but that day he wasn't there, she can't remember why. She and Sara were hurrying home, talking non-stop as usual. They flinched unconsciously at the sound of gunfire, streets away, but without interrupting their narrative, which was no doubt about the social games of girls too important in the school hierarchy to associate with them. They passed one of the bombed-out buildings; glanced at it as they hurried by, saw shadows moving through the gutted space, quickly, from the interior to the shattered windows on the main floor. A young man with a gun smiled at them.

"Girls, come here!" He beckoned with his free hand. They stopped, frozen.

"Don't be afraid. Come. We just want to talk to you." He was wearing bell-bottoms and a tight T-shirt: disco handsome. They edged closer. Inside, a cheap chandelier hung from the ceiling, half-detached, faux-crystal coated with plaster dust. It swayed while they stood there. A cardboard hostess, wearing the Air France tricolor, waved at them. *Bonjour! Comment ça va?* A shredded poster showed scraps of the Eiffel Tower. Another man with a gun was kneeling, fiddling with his weapon, cleaning or reloading. A third man stepped forward. He wasn't wearing a shirt. Smoking a cigarette—no, a different smell: a joint. They were stoned. The shirtless guy smiled, mindlessly rubbing

his left nipple while he looked at Sara, his gun slung over a bare shoulder. "Come and play with us," he said, echoing his friend. He had a surprisingly light voice. Then he snickered.

"We have to go home," Mouna said.

The first guy, Disco Boy, spoke again.

"You can go, little girl. Your friend wants to stay."

He smiled in what was supposed to be a charming way, but came off as half-cocked, unbalanced. Mouna felt unable to move, transfixed by the chandelier. She was sure she could see it swaying; that it was about to fall, the glass bowl and its imitation crystal loops ready to shatter, adding delicate powder to the crushed mess of rubble on the floor.

She should have stayed alert. Because next thing, Disco Boy had stepped out, grabbed Sara by the wrist, and was pulling her into the building. She screamed and he put his hand over her mouth. Mouna snapped to it—*guess I wasn't such a little chicken after all*—and lunged after them, holding on to Sara's other arm, yelling.

"Let her go!"

"Shut up, bitch." He took his hand away from Sara's mouth and whipped his gun around, thwacking Mouna in the head. She fell down. Held her hand to her face. Wet. She was bleeding. The man cleaning his gun ignored them, the other one, still stroking his own chest, laughed like an idiot. Sara had started to cry. Mouna got up and ran for them again. Sara's shirt was torn open and the man was grabbing her small breasts. She was crying like a baby, gagging, snot running down her face. Mouna smelled sweat (Disco Boy) and piss (Sara). This time she watched the gun—in the moment, though, it didn't occur to her that he might actually shoot—and ran for his stomach, head lowered. She butted it, hard, and he loosened his grip on Sara, who dropped free. They ran for it. Hearing gunfire behind them, they

didn't slow down. They ran and ran until they were at the end of Sara's street, then stopped to inspect the damage. Mouna wiped Sara's face on her own shirttail. Sara's shirt was torn—she would blame it on sports at school—and Mouna's cheek was bleeding. She rubbed it clean. Now there was blood on her white shirt, as well as Sara's snot and tears. "Can you wash your underwear when your mother isn't looking?" Sara shook her head. "Here, give them to me. I'll do it." Sara stepped out of them and Mouna balled them up and stuffed them into her pocket.

Her mother yelled at her when she got home, for being careless and late.

"What is this mess? My god, what's the matter with you? You'll never find a husband at this rate." That night Mouna rinsed out Sara's underwear and put them on the balcony to dry. She retrieved them early in the morning and gave them back before school.

Enough nostalgia. She stretches and yawns. The conference is in four days. She won't get much sleep tonight, but it doesn't hurt to try.

Memory Lane

Lydia Devlin has grasped the reality of her father's death now, of course, but not then, knocked sideways by the sucker punch. Then it was hard to believe there was an irrefutable difference between that day without Phil and the many others that preceded it. Because of his regular absences the change was immediate in some ways, attenuated in others. Away from the epicenter itself, she and her brother found themselves increasingly affected by aftershocks, and it was obvious that there was indeed a rupture between life before—mostly predictable, occasionally tense, inflected by the complex forces that pushed Elise and Phil together and apart and divided them from

their kids—and after, limbo-land, lopsided and out of whack. But in spite of the fact that Lydia could read his obituary in all the papers, including *The Times*, and that her mother was clearly both grieving and angry, she wasn't convinced that Phil wouldn't pop up—*surprise!*—grinning like the Rasputin jack-in-a-box he brought her once from Moscow. One day—soon, maybe—she'd hear the high drawn-out squeal of taxi brakes, the motor of the big black cab chuffing like a Clydesdale while Phil paid his fare, and then he'd shoulder open the door: Holiday Dad, on his way back from another extended assignment, suitcase full of presents and a new batch of tall stories, freshly baked: jeeps and sandstorms and feasts watched over by vigilant gunmen.

The 20/20 hindsight version of his death took time to develop, details culled from gossip overheard, rumors, and later, conversations with Yves, who'd been with him—had rushed yelling into the gorge after him, tripped and fallen on the rocks (bruised his face and broken the lens on one of his cameras)—and from her own furtive combing of microfiche and back issues of London newspapers in more than one library. Straining her eyes over blurred film and scuffed newsprint, she began to develop an impression, half-etched, like a brass rubbing, of the woman Phil was on his way to meet at the border the day that he smoked his last cigarette, drank his last coffee, had his last thought, whatever that was. And finally, of course, there's a more explicit story—with its subtext: *a pox on all yer houses*—in Ted Armitage's book. A story whose telling, even at this distance, has propelled Lydia to Montreal, to see Rafa in the flesh, or as close as she can get.

About the day itself—not the day it happened, but the day they heard, which, due to the multiplication of a slim time difference by inevitable delays and confusion, not to mention political complications, were not one and the same—this is what Lydia can remember: the London house, white with its black door. Checkerboard tiles in

the hallway and kitchen. A burnt-toast smell from breakfast. Elise's face. (She'd heard before them, naturally, some time the previous night, but when exactly Lydia doesn't know and Elise has never said.) It seems likely that she was up all night. Matthew and Lydia were sitting in the breakfast nook when she came in, cigarette hanging loosely from two fingers. Matthew, ever conscientious even at age six, extended an ashtray, which Elise stared at as a plush little concertina of ash collapsed and drifted to the black-and-white tiled floor. After she told them Phil was dead—no way to soft-pedal the sensational details: *hit by a rocket, car blown up*—she left them alone and went to phone Phil's mother, then her own. Lydia and Matthew looked at each other, mirror images of confusion, sitting dumbly on the vinyl bench just inside the yolky umbra of light from the table lamp; radio on, smear of ash on the floor where Elise's heel had pressed as she turned. They could hear her voice echoing loudly in the hallway. Lydia slid off the seat and knelt down, began to wipe the ash with her napkin, just as Matthew started to cry. She squeezed his knee. "Don't cry, Moo." His baby name.

OCD

The conference delegates from Israel and Jordan will hate this inhospitable weather. Mouna opens the kitchen's back door a crack and blows smoke outside. It's too cold to smoke on the porch, even to appease her sister's anxieties, which are piling on top of one another like hoarded newspapers. It takes an hour to get her out of the house for school: the windows and back door, if not carefully locked, will let in thieves; the oven left on will leak gas and blow up the house; an improperly closed tap in the bathroom will flood the apartment. One morning Mouna overslept and woke to find Nasima pacing the kitchen, coat on, clammy with sweat. She couldn't remember if she'd

fed the cat, couldn't bear to risk feeding him twice. A cross of anxiety and OCD, the psychiatrist says. His treatment plan involves helping her "manage" her anxieties like so many office projects, while he tries to attack their root cause: post-traumatic stress, the occupational hazard of those who've fled war zones.

Mouna hears footsteps down the hall and flicks her cigarette out into a snow-filled flowerpot, where it makes a tiny, hissing dent. "Have you seen my keys?" Nasima calls. "I can't remember where I put them." The note of tension in her voice is within normal range today, the average person's frustration over elusive property.

"On the table." Mouna pulls the door shut.

"Thanks." Nasima comes in. "It's cold in here."

"Newsflash, baby girl. It's cold everywhere in this city."

Mouna grabs her bag from the back of a kitchen chair, and propels her sister out without letting her start the loop. "Everything's set."

They're almost at the door when Nasima turns back to check the kitchen window. Mouna steers her outside, shutting the door firmly behind them. She jiggles the key so Nasima can see the lock has engaged and the apartment is secure. When Nasima starts for the bus-stop Mouna points to the car. "I'm driving today."

"The pollution…."

"You may want to freeze your butt off, but I prefer to take advantage of modern technology." She unlocks the car and gestures inside. "Your limo, Mademoiselle."

She incurs more criticism by waiting for the car to warm up.

"Madame Gariépy says it's a myth that you need to let the engine run."

"Madame Gariépy doesn't have a shitbox for a car, perhaps."

She takes pity and pulls out into the street. "OK, Mademoiselle, here we go, ready or not." Nasima is quiet, staring out the window

and listening to the announcer give a deeply pessimistic weekend weather forecast in exhaustive detail.

"Want me to pick you up today?"

"Salma's invited me for tea." She's silent the rest of the ride.

On the way home, Mouna stops at the Italian bakery on Parc to pick up a coffee. She leaves the car running—*forgive me, Nasima*. Takes a sip of her coffee before leaving the bakery. Instant infusion. *God, I hate to get up early. It's unnatural.*

"Mouna!"

It's Marco, from the Center. "Nice outfit." She forgot she's wearing pajama pants under her coat.

"What are you doing up this early?"

"What makes you think I've been to bed?"

He pats her cheek with a warm hand. "Pillow-crease." Holds the door for her. It's started snowing again. *"Merde."*

"Ready for the debate?"

"Is anyone?" The main feature of the conference is a face-off between the Israeli foreign minister and Rafa A., reformed terrorist. The question period has been allocated to various pre-assigned delegates, including Mouna. Questions have been submitted in advance and scanned by the committee to ensure "positive intent." Mouna's is a fairly innocuous one about refugee education statistics, but she'll use it as a lever if she can. They've been warned that the mikes will be turned off if there's trouble, but it's not that hard to project your voice when you have enough incentive. The trick will be to do it fast, before the debate is shut down. She can't be the only one making that calculation.

Sleep Disorders

Lydia wakes in the dark, crouched on her heels in bed as if something

slimy touched her feet. She can't recall what the dream was about, but the fear that came with it takes a while to fade. The hotel room is foreign, its shapes ominous, sweater-monsters to a small child with the bedtime heebie-jeebies. She gets out of bed and plugs in the electric kettle. Waiting for it to boil her self-confidence bottoms out. There's no lonelier time than pre-dawn to assess your own wisdom. Why is she in Montreal? Even if she could get close enough to Rafa to ask private questions, what would she say?

Last week she dreamt that Phil was giving the Annual Safety Speech at her primary school at least a year after his own death. Apart from that wrinkle and one or two others, the dream was remarkable for its verisimilitude in detail and atmosphere. In her dream she was unfazed by Officer Phil's identity, as he was by the fact that the policewoman, at first a stranger—one of those faces plucked from the visual archive to provide authenticity in dreamland—became Jenny Richardson and, cracking dream-code logic, took off her police jacket and delivered her part of the lecture topless. Officer Phil didn't miss a beat. When he got to the part about Suspicious Packages, Lydia was transported to Toronto, the St. Clair West subway stop. An abandoned Adidas bag sat next to a rubbish bin. Which was the dangerous object? Bag or bin, bin or bag? *Boom!* Too late.

Conference organizers have asserted that all necessary measures are being taken to keep this event violence-free. With her tea unsipped on the night-table beside the bed, Lydia lies half-dozing. She can see Rafa's face, that iconic photograph, now making the rounds again, an engraved touchstone in her memory vault: *kaffiyeh* almost a bridal veil, flirtatious downward gaze, Rafa's smile secretive and rich with some ironic pleasure.

Mouna's nightlife is of a different order. Her Rafa is another kind of dream-girl, bursting through the ceiling of an abandoned building,

her body punching light into the center of the black room. People Mouna can't see are moving through the ruined space; she can hear glass crunch under their feet; laughter. The room changes, suddenly turns bright: an office suite empty of furniture, green carpet lozenged with darker green where filing cabinets and desks blocked the light. No, not carpet, but leaves and trees; roots catch at her ankles, poke through broken windows. She's at the old Hippodrome, picnicking with friends. Horses are running riderless, there are no spoons for the picnic. She's back inside the building, altered again. Pigeons sit on the wires outside, their watery coos thicken the air, getting louder and louder. *Where is she?* Rafa is pulling her arm: "Come on. Follow me." And, with a flash of joy, Mouna takes her hand—warm and strong, throbbing with vitality—but can't keep her grip. She is running behind Rafa—trying to run, but her legs are so heavy, she's a cartoon, she can't keep up. It's dark again. And someone is standing in the dark corner, watching her. Someone calls her name, loudly: "Mouna!" She wakes in a froth of anxiety, sure that she has heard a live voice. The lost promise of Rafa's warm hand brings tears to her eyes. The pigeons outside her window are making a disgruntled ruckus.

...Changed Her Spots?

Metal detectors have been installed in the foyer. Outside: uniforms, horses, microphones, TV cameras. Demonstrators, for and against. One or two wear skull-masks of the kind once associated with anti-nuclear demos, but here they mean something else. Others dress Gaza-style, scarves pulled up to cover their faces. The placards have the usual terse, obdurate messages, in French and English. Honour the Right of Return still a favorite, surviving the years when Lydia had no idea what all the fuss was about. When the Devlin and Ammari families, like Beirut, were still intact.

Separately cresting a wave of protesters, Lydia and Mouna are bumped inside huge wooden doors, shouldering their way down a long corridor to an improvised checkpoint where each is scanned and screened, warned not to use a flash camera or otherwise disrupt the proceedings. While Mouna is opening her bag for a policeman, Lydia is dumping her coffee into the plastic-lined bin already half-full with cardboard and Styrofoam cups. Splashed black plastic, steam drifting up from the slop of liquids pooling. The clean-up job will be a messy chore. Those with pre-assigned seats, Mouna included, are allowed in first. Lydia waits her turn. Every time the main door opens there's a swell of noise, protesters yelling slogans, taunting the police as they jostle each other and those in elbow-distance. Anyone important has been ushered in safely via private entrance, a half hour or more earlier.

At first the din inside the lecture hall is almost as loud, though less heated, than outside. Apart from the students and delegates there's the usual media hierarchy: TV journalists and dailies at the top, monthlies, political rags, and student newspapers lower down (or further back). At the bottom are those members of the general public who could wangle clearance. On stage there's a long table, miked, and a podium for the individual speakers.

This is Rafa's first overseas appearance in ten years. What has she done, who has she been, in the intervening period? "A Jordanian housewife," one newspaper said, but that's the least of it. She's a politician now, among other things, one of Arafat's advisors. Voices start to fall silent as a handful of people walk onto the stage. When the last one—a woman—enters, there's a collective murmur, almost a sigh, from the audience. Here she is, in the flesh. Here, in one of the bland, over-lit rooms where journalists and their subjects, students and mentors, politicians and critics, regularly confront each other.

Lydia is closer than she expected, close enough to imagine that she smells the tainted alloy of nicotine and perfume on Rafa's skin. That face, deeply charismatic, still sphinx-like, even more so with some added flesh. Still beautiful, too, her head uncovered now, a crisp matron's haircut, a cigarette in her hand. She's a chain smoker, like Mouna.

Almost as soon as the questions begin the organizers realize their mistake.

"Would you still die for the Palestinian cause?" one of the students yells, breaching protocol. A journalist later describes the look Rafa gives her interrogator. Dismissive, flat. Brutal.

"Of course."

"Would you kill?"

At her answer, its ensuing uproar, the moderator gives the signal to switch off the mikes.

BROTHER SUSPECT

JEANNE RANDOLPH

Of course the United Airlines Boeing 737 was carrying enough fuel to reach Los Angeles International Airport. LAX was our destination. I was flying with a phobia. My carry-on included a comforting fetish (my 1954 Oxford University Press reprint of *Four Tales* by Joseph Conrad, dust jacket in very good condition), a damp clean facecloth in a baggie (for safe breathing should the cabin air thicken with polyester flames), and a flask of Wild Turkey® bourbon. I was scared stiff. When the plane lifted heavenward my stomach sank. I swilled down some bourbon. The flight attendant was still buckled into a contraption that looked like an amalgam of an electric chair and a Tilt-A-Whirl fun seat. Her head was bowed. I knew she was scared to death. The pilot had warned we would encounter turbulence before reaching our flight avenue at 35,000 feet.

Too stiff to flex my spine, I left my Conrad stowed under the seat in front of me. I fumbled for the magazine in the pouch with the throw-up bag and safety card. *SkyWest* magazine dropped into my lap and I began leafing through each trembling page. Within seconds I had leafed and leafed all the way to the final article, an article about bin Laden.

Not *that* bin Laden; his brother, who is launching a new perfume. He wants to bring a divine aroma into the world. The article also mentioned that when he travels he adjusts the spelling of his name. And because he "looks like just another guy" anyone sitting next to him would "accept him as just another passenger."

My head in the clouds, the name "bin Laden" turned into a symbol, and I relaxed into my preferred personal narcotic: psychoanalytic theory. I began toying with the notion of the name "bin Laden" as a symptom; a symptom of the fracture line along which the human psyche "splits" in defense against gross anxiety. In 1946 Melanie Klein had psychoanalyzed the splitting of psyches. She had witnessed patients' sadism and grief at such cross-purposes that their souls would

literally break in half. Klein described the "relations of the patient to the analyst split in such a way that the analyst remains the good (or bad) figure while somebody else becomes the opposite figure."

Might bin Laden the *parfumeur* be desperate to enact the "good figure" of the family name? One brother fills the air with the stench of hate, the other wants to revive us with jasmine smelling salts. One turns the family name into a name from Hell, the other adjusts some vowels to become another stranger on a plane.

Most often the human unconscious is said to be more like a Rottweiler, *homo hominis lupus*. "Man is a wolf to man," said Freud. But what if, instead of irreconcilable sadism and grief, splitting might also sever extraordinary tenderness from vulnerability? What if, at the moment of trauma, there was a surge of *caritas* instead of grief; not sadism, but *vulnerability* projected into the nearby world? The unconscious like a mama kangaroo? That's crazy talk.

Still, I speculated, Joseph Conrad's tale "The Secret Sharer" could propose just that: a discombobulated psyche breaking in two, one dimension pure tenderness, the other pure vulnerability. In "The Secret Sharer" a stowaway has lost everything except his vulnerability. His protector, the captain of the ship, is consumed by tenderness for him.

"The Secret Sharer" was within my grasp, one of the *Four Tales* at my feet. Curiosity was my muscle-relaxant. Letting *SkyWest* slide down my leg, I pulled the book up into my lap. The tale of the Secret Sharer is recounted by a newly appointed English captain on a ship homebound from the Gulf of Siam. The captain recounts how he had pulled a man alive out of the Gulf; in his own cabin the captain had secluded and protected this fugitive, and then maneuvered the ship so the fugitive could swim safely ashore. In accomplishing this, the captain had risked the ship and the lives of his crew.

The captain is not otherwise particularly nice. He's quite grumpy and judgmental, constantly reminding himself how he feels like "a stranger," before as well as after he fishes the obvious stranger out of the Gulf. The young stowaway hardly moves, and dares not speak, excepting a few whispered exchanges with the captain every midnight. There are incidents on board that tax the captain's ingenuity and forbearance in keeping the stowaway secret, the worst of which is a search by the stowaway's own captain and crew looking for him, the murderer, they say, of their ship's second mate.

The captain calls his precious stowaway "my double, my second self, my other self, my mirror reflection," and is terribly self-conscious, as if the ship "had a double captain."

With literary hindsight, one might interpret the captain's quarters, where the two "were side by side talking in our secret way," as a utopia for two ideal psyches. Even so, the story indicts the pettiness of rote attention to hierarchy. This tale is a brilliant artist's reparation for all the splitting in the world that has turned out so badly. A story bobbing in the foreground implies its background, to use Adorno's words, "as that which keeps [utopian subjectivity] silent, the image of a world that refuses peace."

The relationship between captain and stowaway offers an upside-down version of suspicion, a messed-up hierarchy of authority and suspect. This is a story of identification with the suspect, a reverse (someone with power in complete empathy with his hostage) of Stockholm syndrome. The captain recognizes his own vulnerability in the plight of the suspect, not exactly a dominant theme in US popular culture. With gratitude, the suspect acknowledges what they both long for, which paradoxically the man in power, the captain himself, did not really have: "… a great satisfaction to have got somebody to understand.… It's very wonderful." "The Secret Sharer" might

be a story that challenges psychoanalytic theory (splitting always a symptom to be cured). In these times it could be interpreted as a story that challenges official US culture, its imagination and therefore its ethos having gone off the deep end.

To identify with the suspect would be to recognize the stranger within ourselves, a stranger who tries to hold fast through the squalor of consumerism. To identify with the suspect would mean succumbing to a grief that consumerism cannot console. Introspection, listening, self-restraint, these are not, alas, just personal traits, though as personal traits these may be latent in the kangaroo unconscious, waiting for their opportunity. These traits ebb or flow according to their value in the active mythos of a nation, of its government, of its artists, of its philosophers and educators—and, to be trusted, these traits must be palpable to the economic stowaways of the earth. Individuals can look into their own hearts and find light or darkness; individuals can impinge on the plans of their government—they must. Beyond that, we witness a split, enacted as military and economic institutions, which is as deep and powerful as the Gulf of Siam.

WORKS CITED

Theodor Adorno (1958)
Noten zur Literatur
Frankfurt: Suhrkamp

Joseph Conrad (1954)
The Secret Sharer
Four Tales
London: Oxford University Press

Heinrich Meng and
Ernst L. Freud, eds. (1963)
Psychoanalysis and Faith: The Letters of Sigmund Freud and Oskar Pfister
New York: Basic Books

THINGS COLLAPSE

CAMILLA GIBB

It is uninhabited, they say, save for a lighthouse keeper and the ghost of a nun. They say it is poisoned. They are the people on the opposing shore: men with tobacco-stained teeth, fingers glistening with fish scales, fish guts like umbilical cords heaped at their feet, men who will not be seduced by the beauty of the island shore before them. They won't even fish within a hundred feet of that shore—eat one of them fish and your innards will burn and blister, they say.

But surely the fish swim back and forth across this channel, I reply.

No sir, them fish there e'nt swimmers, they stay close to the shore, just like women, no worries there.

But fish didn't catch it, animals didn't catch it, it was a people disease.

And just where do you think a disease goes after the sick have all died, son? The poison is in the soil, from the blood, and in the plants that grow from that soil, and in the bones of the animals that eat them plants; it even in the wooden posts of those rotting buildings rooted there.

They will not, will absolutely not, offer me passage over the Dragon's Mouth Strait. For any price. I will sit on this beach and keep watch for the lighthouse keeper. I will scour the horizon for the man who scours the horizon. I will wait an eternity if I have to. My only other option is to wait for the ghost of a nun.

On the eve of Carnival, the revelers arrive, doped-up and drunk and keen to get naked. They are too oblivious to be deterred by the rumors of this place, the need to carry on the party drives them here to this solemn beach where no one will interfere while they grunt and mash their bodies into each other until daybreak, when the sun will force

them to stand and brush the sand from between their buttocks and make their way home.

The lighthouse keeper sees the remnants: a few patches of color, clothes discarded and forgotten on the beach. He sees everything on this thin boomerang of an island: the crenellated reef of the north shore, the sandy crescent between two rocky promontories of the south, and the remnants of the buildings hidden in the indefatigable jungle just a few hundred feet from this shore—the red roofs, corrugated tin, tilted steeple, the overgrown paths in-between.

The only other visitors are curious Americans, couples who, through the familiarity and the years, have come to look like siblings, hardy and affluent siblings wearing white shorts and pastel-colored polo shirts that show off cinnamon-colored tans. They stand firmly rooted on the gleaming decks of yachts, then drop anchor and paddle or swim to shore. They embrace and kiss because they think they have chanced upon some secret discovery, because they think they are alone.

The more curious among them will make their way in search of the buildings they are sure they saw from the water, buildings obscured now by the verdurous jungle wall before them. They'll find a path, a few broken branches, the remains of a rotting step, shriek with excitement, take their spouse by the calloused hand. They'll part brush and hear *chacachaca*, the chatter of monkeys in the trees above, and wind their way through moss-covered trunks until they find themselves before a liana-wrapped building, its shutters askew, paint peeling, windows broken, its staircase sloping and damp slippery green.

Whichever of the buildings it is—the nuns' quarters, the doctor's house, the barracks, the hospital, the church, or one of the houses of the separated—the strangers will be struck by the evidence inside:

papers scattered on a floor, medicine bottles lined up on a counter, a pot sitting on a stove, clothes hanging on a hook, evidence that suggests whoever once lived here vacated in a hurry.

Later that night, over whiskey in tumblers on their gleaming deck, man and wife will use words like "eerie" and "haunted" in their written logs and online blogs and they will wonder aloud if anyone has ever made a documentary about the place, flirting briefly with the idea of making one themselves before coming to their slightly drunken senses, like every other American on a big white boat who has touched the shore before.

No one ever stays more than a few hours. Only the lighthouse keeper: he who sees everything along this ten-mile strip of land; he who has not touched the shore of the mainland in twenty-five years.

———

People called it the Saturn flu, Columbus's disease, names that suggested it lived far away and belonged to someone else, but amongst themselves, they took the name the locals on the adjacent shore had given it: sayin' bye-bye, the separating sickness. They were the separated, the separate, the bye-byed, the sick, where yesterday they had been the ordinary, worrying about interest rates and global warming and the relative merits of lo-cal versus lo-carb.

Kir was among those who had been ordinary. For six years he'd been an actor, a struggling actor until he got the job as the voice of Billy the Beluga. He was married to Liz and their son was nearly a year old then, but they still hadn't landed on a name. No worries, Liz assured her husband, there are plenty of cultures where boys choose their own names.

She was a doctoral student in anthropology. It came in handy whenever they wanted to break the rules—she'd find some precedent

elsewhere and vindicate the unorthodoxies of their parenting or sexual lives. Not that the latter was so unconventional. They just had the "celebrity fuck" rule. There was one celebrity you could have sex with and if you just happened to meet said celebrity one day, you'd get a pass. But just the once.

Liz chose a very old and distinguished French anthropologist, and sure enough he came and gave a guest lecture in her department and she seduced him over wine in paper cups and tooth-picked cubes of cheese. They did the nasty in the forensic anthropology lab. She came home reeking of formaldehyde and Kir was madder than hell. He had, after all, chosen Marilyn Monroe.

Later, separated from his wife, he worried that she might have seen that Lévi-Straussian wannabe again. He even worried that the reason he was now separated, separate, was because of her involvement with the professor; that he'd infected her with the residue of some ethnographic adventure.

But everyone was speculating then; no one had answers. No one knew whether it was sexually transmitted or could even say whether it was bacterial or viral. What made some people susceptible and not others. Why the severity varied so greatly. Whether it would kill them. Why the tongue turned blue.

Kir had woken up one morning, his jaw slack and his tongue so fat he could barely contain it in his mouth. He gargled with salt water. He sucked on ice. He stared at his blue tongue in the mirror, looking for cankers, some sign of irritation. He couldn't go to work: his Billy the Beluga voice was woolen, stuffed thick. So he sat on the rug and played with his son with no name. He made macaroni and cheese, but found he couldn't chew because his tongue was in the way. He drank a beer for lunch, instead. And then another. And then his earlobes grew hot and started to swell.

The next day he went to a clinic and sat in an orange plastic chair feeling hot and old. He wore a woolen hat that covered his ears, even though it was June, and concealed his mouth behind a book.

The doctor put a thermometer in his mouth and mapped his entire torso with her stethoscope. She pressed her fingers into his lymph glands and checked his blood pressure. She grimaced a little, drew blood, told him to take Extra Strength Tylenol and come back at the end of the week if things hadn't improved. She'd call him if the tests turned up anything.

Kir called the only person he knew in medicine, Liz's youngest brother Peter, who was training to be a plastic surgeon. There is a procedure, Peter told Kir, if the uh, you know... tongue thing stays permanent.

Do you think it's elephantiasis of the head, or something? Kir asked.

I doubt that, said Peter.

It's fucking ugly, said Kir. Even the baby's keeping his distance. Liz can't even bring herself to look at me.

Whatever it is, it'll probably just run its course, Peter said. Give it a few more days.

The results all came back negative and Kir's earlobes did stop tingling, his tongue did subside, but because Liz appeared so relieved, he couldn't confide that he didn't have much sensation. He was eating solid food again, but all he could taste was blood. And the heat had now moved to his fingers. He was acutely aware of the slight tremor of the fork as it passed through the space between his plate and his mouth, though Liz was kind enough not to draw attention to it.

The separating sickness had begun.

My father died when I was baby, died of an illness which also later died, a brief-lived epidemic at the beginning of the millennium. My mother named it only once. Fatigued, marking papers, sick of my incessant questioning, she blurted out Saturn flu, but then immediately recanted, telling me this wasn't news for public consumption, that I best forget it and stick with the story that my father had died of a heart attack or better still, an aneurysm.

But lying is bad, I'd said.

This isn't lying. It's called revisionism. One day you'll understand the difference.

I was old enough to know that Saturn flu was a bad thing that had happened to bad people because tatty-satty was a common taunt in the schoolyard, even in our lefty, crunchy granola school where we were taught to negotiate with others and explore our feelings and we each had our own drum.

It was only later that I heard people say it was caused by having sex with dead chickens or syphilitic corpses, or eating the shit of crystal meth addicts. When I was eighteen, my Uncle Pete, a plastic surgeon, said: There were wild rumors those days. It was some kind of virus, but no one knows where it came from, or for that matter, where it went, but that's the way of humankind, isn't it, to turn an illness into a moral thing, this at the same time Botox was all the rage, everyone begging to be injected with toxins, infected with botulism—it was a fucked up time. Still is, thank God, he said laughing, or I'd be out of a job.

They say the infected died in quarantined hospital wards, their bodies disposed of in incinerators. That there were no survivors. That there are no graves. I've asked my mother: Did you visit him in hospital? She says no, no one could, the law prohibited it. As I got older and got wise to (or cynical about) love, I began to suspect that

this had nothing to do with laws, and more to do with loved ones becoming unloved. It must happen when people suspect you of fucking corpses or eating the shit of drug addicts, no matter how much sense and reason and science tell you there is no basis for such allegations. They didn't perform autopsies, there was no preservation or analysis of DNA, all that remains is the stigma, the mildewed stench that surrounds the relatives and descendants of the sick, which forces them to live out their lives in grimy, forgotten corners.

In the last couple of years, a small lobby group has formed, demanding the right to proper funerals, seeking state compensation and support for educational programs to correct public misconceptions. My mother keeps her distance, insisting on aneurysm as the cause of my father's death. Somehow, five years after he died, the year she was up for tenure at Radcliffe, she even managed to have a death certificate drawn up that said as much.

But who am I to criticize? Who is to say what would have happened without the lies she called revisionism? Just as she might not have graduated, been granted tenure, had another date in her life, I might not have had violin lessons, played soccer, gotten a scholarship to McGill, studied art, become, albeit briefly, a teacher. Revisionism has served us both. To a point.

———————

Max inherited the lighthouse keeper's post from his father—a man whose face was as pockmarked and barnacled as the coral Max used to collect from the reef when he was a boy, chipping if off bit by bit with a fish-scaling knife to sell to British tourists. Now Max rebuilds the reef in his mind. He looks out now, casting his vision like a protective net.

As a boy, Max would visit his father on Sundays after church. His father didn't return to the mainland anymore because his mother

wanted nothing to do with him. She'd forgiven (not quite forgiven, more ignored, elided, tolerated, whatever place it is women go to erase such visions and carry on) the indiscretions with the first two washerwomen—pants around his ankles, heaving himself against women bent over buckets of soapy brown water, his mouth unable to hold its expression of panic as he verged on the precipice of white explosion and then jumped—but the third, the third was a vision impossible to erase. She discovered her husband holding on to one end of a sheet, the washerwoman twisting the other end. She collapsed onto the ground. Her husband was no longer a man.

She had heard that love could do such things, turning a man against his nature, and while she might have fantasized as a girl about a man turning small in her presence, in the lovelessness of her marriage she'd become convinced that such fantasy was vanity and delusion. But then poof: proof; a vision of submission that incited such fierce envy she came after him with the meat cleaver.

He left for the island, his anatomy scarred but still functional, never to return home again.

The boy, she knew, needed a father, even a pockmarked, weak ugly bastard like the man she'd maimed, so every Sunday after church, she put Max in the back of her brother's fishing boat and Uncle Jack drove his nephew to the shore.

They ate a lunch of fish and rice—his father who had been so emasculated by love now forced to cook his own food for a lifetime—and his father interpreted the water and the life afloat on it, giving Max, without his realizing it, the eyes of a lighthouse keeper, eyes he could not know he would one day need. For when the sick began arriving on the island, suddenly there was no passage back.

Who are they? he asked his father of the multitudes who arrived in the dark.

Perhaps the whales have returned, his father muttered.

A century ago, the island had been a whaling station, until the whales got wise to it and changed their migratory route. This killed the local economy, and people had years of suffering until the government sold the country's soul and the British established African palm plantations on the mainland and people became fat again and the word export was on everyone's lips.

But no one forgot about the lean years, and they pointed to the island as a reminder. Those who had lived through the starvation told their grandchildren stories, said the place was cursed, said its ghosts would steal the money straight from a man's pocket. People admired the keeper's job as a humbling act of self-sacrifice, but believed whoever occupied such a position in such a haunted place must be more than a little bit strange.

At sundown that Sunday, the boy's Uncle Jack did not arrive to pick him up. Huh, said the boy's father and made him up a nest of a bed beside his own. The boy asked his father for a bedtime story and his father looked a bit confused, asked him if he was a bit old for that sort of thing, but then relented, shuffling through the papers on his desk.

I got nothing much but my log, he said.

The boy nodded and the man sighed and sat down and began reading the first of several entries from the heavy leather-bound book. And this is how Master Max's apprenticeship began. Inadvertently. In the absence of any other bedtime stories.

When Jean-Pierre and I split up, I spent days doing nothing and seeing no one, eating cereal for dinner and wearing thrice-worn socks, moping about and wondering if I was going to die, quite literally, of a

heart not so much broken as squeezed white of all blood. Jean-Pierre had picked up one of my students at the club one night. He brought him back to our apartment and they snorted a little coke and soon, against my better judgment, we all got naked. Within a day I was out of a job, out of a future, out of my mind. I'm not innocent in all this, but I'm not, unlike Jean-Pierre, morally bankrupt.

For some reason, I called my mother. As usual she didn't register the flatness in my voice, preferred the sound of her own, nattered on inanely about the tyranny of people in her department and asked me when I was coming back for a visit.

Good, she said. You can help me pack. I wanted to tell you—do you remember Ragner? No? Linguistics prof. I introduced you to him at a Christmas party two years ago. Him and his wife. Ex-wife now, she said, laughing. You're going to think it's pretty ridiculous at my age, but we're hooking up.

Hooking up? Mom, no one says that anymore. Ask your linguistics prof.

So, when can I expect you back? The closing date is the first of July. In plenty of time to help you pack.

Max spent the morning after the strangers arrived worrying about school, wondering where his Uncle Jack was, and worrying that his mother must be worrying about her only son.

His father put him to work washing windows. Wiping them down with vinegar and water. Max Senior saw his son's sullen expression through the glass, but he didn't know what to do. He tried to radio the mainland, but got nothing but static. Later, he radioed a passing ship and asked the captain if he could do him the favor of passing a message to the harbormaster, whose signal he couldn't seem to locate.

And the captain stammered on his radio, asked him: Haven't you heard?

Negative, said the lighthouse keeper.

They've quarantined the island, said the captain. Off limits, out of bounds.

But why? asked the lighthouse keeper.

Some sickness, the captain said, I don't know more than that.

The keeper looked down to the crescent beach where the people were clumped together in small groups and said: Aye.

———

I think I bear an uncanny resemblance to my father, but my mother refuses to see it. I peeled a picture out of its yellowed, gluey place before stuffing the album in a box she'd already marked "memorabilia." She refuses to tell me much about him and she's hardly sentimental, so when I found a sheaf of letters from him in that very same box, I was more than a little bit surprised. Seventeen letters bound with string. When I saw the dates, my astonishment was surpassed by a crushing wave of despair. In the first of the letters I would have been two. In the last of them, thirteen.

Revisionism, I realized, requires destroying all evidence of the old that could possibly contradict the new. Because if you don't? Contamination. Spillage. Some random discovery will eventually lead you, like me, to sit on a beach for a month staring at water, looking for answers to questions you've barely formed, chief among them, who you are. And you will conclude that you feel like little more than toast: someone buttered in everyone else's lies.

———

There were perhaps close to a hundred of them, though Max Senior

could see the ones in hospital green far outnumbered the ones with guns and gas masks.

You best keep your distance, they told the lighthouse keeper, keep holed up in your house and do your job. And because he was not one for confrontation, he would do as he was told, but perhaps he might ask one question?

Too late for questions, I'm afraid, they said, wagging their heads.

He and his boy watched out of their clean windows for months: watched the boats arrive with tents and lumber and corrugated tin, and the others that disgorged people, the ones in green forming assembly lines, moving like a trail of leaf cutter ants, and the ones with guns and gas masks supervising the scything of jungle and the building of buildings until they had themselves something like a town, with a church and a hospital, barracks and houses, and a road through the jungle connecting one end of the bay with the other.

January 2002

Dear Liz,

I'm sorry it's taken me so long to get a letter to you. I don't even know where I'm writing from—somewhere so hot and humid that the paper I'm writing on is limp, the ink is bleeding, every breath is like inhaling a hit from a bong. I don't know if this is because of the climate or the illness, but it seems to affect us all in the same way.

There are about six hundred of us here, some of whom I met in hospital during quarantine. There were more of us in hospital every day, and it became so crowded that they took away the bed frames and lined up the mattresses so they were all touching on the floor, and soon it was like three people to a mattress, a nightmare of tears

and arguments, and they realized it was out of control and decided they'd have to move us.

They took the hundred or so of the earliest arrivals, including me, and packed us into a refrigerated truck, and then I couldn't fucking believe it, a boat, a big mother fucking boat, but no one would tell us where we were going. *Somewhere safe* they kept saying—and not doctors, but army, fucking fascists, guys with guns and gas masks saying *somewhere safe*, and I'm thinking: safe for who?

And then I get it. We all get it. We're considered a threat to national security, apparently, and do we have any rights? Fuck no, because there's a law that says that the government can curtail civil liberties where there is a perceived threat to national security. But that's a law against terrorists, someone pointed out, and one of the generals says: Ordinarily yes, but it's also a law that can be extended in certain circumstances.

And one of the lawyers among us said: They're right, actually. Technically, maybe, but not morally, I said.

We're fucked, we all agreed.

I'm scared shitless, Liz. Please, please find out where the fuck I am. I've given my watch to the guy who mans the lighthouse here in return for sending this letter by return boat to the mainland. You know, I don't even know what the mainland is called, nobody can fucking tell me, but when you get this letter it's got to have a postmark and a stamp on it, so you'll know, even if I don't, and then you can do something, like hire a lawyer, lobby the DA, the mayor, the president, something, Liz, please, I'm dying here.

I love you and I love our son more than anything and I wish we'd made up our fucking minds and given him a name before all this happened.

Please, please help me Liz.

They were one hundred and fifty in the beginning, seven hundred in a matter of weeks, and then, thanks to the segregation ordinances issued in 2003, and the practice of cruel seizure legalized to enforce the ordinances in 2004, that number eventually swelled to twenty-seven hundred, twenty-seven hundred living in buildings designed for no more than a thousand.

Those who were very sick lived in the hospital; while those who simply had sores but still had sensation in their limbs were housed in separate buildings overseen by the military barracks perched higher up the hill. Every night, the air filled with the gray smoke and bitter smell of burning bodies as half a dozen departures were thrown upon the fire.

Every day, the surviving sick rose to the peal of church bells and chattering monkeys. Their reward for attending morning services with Father Mathers, self-appointed apostle of these lowliest of outcastes, was a bowl of boiled millet and a cup of weak tea. They attended to their duties in pairs as prescribed on the rotating roster: weeding garden plots of vegetables, collecting fruit from the trees, replacing rotten wooden slats, repairing punctured roofs, reeling in nets, scaling fish, cooking over fires, burying the ashes of the dead, and cleaning latrines.

At night, they huddled around fires, playing chess, playing cards, telling stories of other lives when they were accountants and software engineers and interior designers and Pilates instructors and third-grade teachers and growing philosophical, contemplative, then melancholy.

The most melancholy sought out their lovers, slipping away into the dark jungle, having sex that made them feel, for at least a moment, that it was still worth being alive. Babies were born, and those who

were not seized by the army and taken away were hidden under floor-boards and fed through the cracks in-between.

In a matter of a few short years these citizens of nowhere were speaking their own patois, a necessity-derived creole drawn from English, French, and Spanish. A matter of a few short years became ten. On the tenth anniversary of the first to go into exile, all but the sickest in the hospital were corralled into the church for information sessions. The military officers described the cure as "experimental and voluntary," while the doctors explained the procedure, illustrating its trajectory with neurological maps of the brain.

First, the patient would be pumped full of the antidote which would stall the progression of the illness. One's vital forces would also begin to wither as a consequence, until one lapsed into a coma. Once comatose though, the brain would be operated upon, and certain synaptic connections rerouted so that the body and parts of the brain would come back to life.

And what of the rest of the brain? someone asked.

Severed off, incommunicado, it acted as a self-contained entity, housing what remained of the illness. The martyr that died to spare the rest of you.

Kir's work partner Ben, who was sitting beside him on the hard wooden pew, shook his head. The two of them hung back while half the congregation signed up, Kir taking his cue from Ben. In any population, particularly one as desperate as that on the island, you can count upon a good percentage of early adopters. You've got those who so desire results, however elusive, however unproven, however dangerous their side effects, that they will open their mouths long before they open their eyes.

That fancy chart they had up there? Ben said later, nodding at Kir. Meaningless. All that talk about amino acids and synaptic lapses?

Total bullshit.

How do you know all this? Kir asked. Are you a neurosurgeon, or something?

Thoracic, Ben muttered to his shoes.

You're a doctor? Kir gasped. Why the hell weren't you up there, helping out, man?

I'm sick.

But you could still help people.

I had my medical license revoked.

Can I ask why?

Ben cleared his throat, obviously embarrassed, and said he'd rather not.

So what do you think this cure is about, then?

Least cynical answer? They haven't got a clue what they're talking about.

And most cynical? Kir probed.

They know exactly what they're doing.

September 2011

What I can't get out of my head was the look in your eyes the last time I saw you. Like you'd checked out, or something. That's how I see it now, not having heard from you in all the years I've been here, that you must have already cut me out of your life, but we were married, Liz, supposed to weather all sorts of bullshit over decades together, and it was you who insisted on all that traditional "sickness and health" stuff in our vows. So why the certain blankness when you looked at me, why had you already written me off? I don't really know how your conscience can bear it, and I don't know how this happened

exactly, but you've turned me into a person who wants to leave you with *that* thought as the last line I ever write to you rather than my more natural inclination to reassure you that I still love you and always will. And this has to be the worst side effect of any illness.

Kir

I've noticed a certain boat. Once a month or so, it heads out toward the island dragging a dinghy, but then stops about a hundred feet from shore and lingers there a short while before turning round and heading back to the mainland.

The men with the fish guts at their feet tell me not to ask them any more questions, not about that boat, nor any other, so I wait for another month, and I map the boat's trajectory in order to determine exactly where to meet the captain when he returns to shore.

The dinghy tied to his boat is empty, where I'm sure it must have been full when he set out earlier that morning.

E'nt nothing for you there, only trouble, says the captain.

You supply the lighthouse keeper, don't you? I ask him.

What business is it of yours? he grumbles.

My father was on the island, I tell him.

The captain looks at me askance, cocks his head, squints. Nobody talks like that boy, he says. Nobody in their right mind, that is. You tryin' to get yourself killed?

Take me there, I say. Take me there, I say every day for a month.

The cured were slow, disconnected, able to engage in repetitive tasks but no longer interested in chess or cards or conversation or

clandestine encounters with their lovers, and so it was that the cure was no longer "experimental and voluntary" but "proven and effective" and "mandatory."

The small group of doubters drawn out and drawn together by Ben and Kir found a surprising ally in Father Mathers. Rather than advocating the cure in his sermons, he'd begun encouraging reproduction as the antidote, the fulfillment of Christian duty. Though his concerns were principally selfish, he worried that those who had taken the cure seemed not only to have lost all desire to have sex, but, as the doubters were also speculating, the anatomy to do the deed.

One Sunday, as further encouragement, Father Mathers divided the congregation, men on the right, women on the left, and performed one spontaneous mass wedding. An officer visited him in bed that night. Putting a gun to the priest's temple, the masked man threw a heavy manual down on his pillow.

This is the new bible, the officer said. The *only* bible.

And so it was in secret that Father Mathers delivered his final sermon. He had hoped to escape unnoticed, but in the haste of his exit, carrying nothing but a rucksack containing his bible and that ominous, grease-stained manual, he stumbled over a couple roughing it together in the dark jungle behind the church. Two other couples disentangled nearby.

Father Mathers! said a woman, grasping for her clothes.

Brothers and sisters, he addressed the semi-naked. You must call me Father no longer. I can no longer stand before you as your priest because they will force me to speak the words of the military rather than God. What I can tell you is this sickness is not God's doing. And the cure is certainly not the work of God either.

Are you leaving? Kir asked.

Any one of you who wants to try is welcome to accompany me.

And every single one of those lovers, doubters all, said yes, they wanted to try.

———————

The lighthouse keeper cautiously opens the door. Jesus, Mary, and Joseph! he shouts, slapping his hand over his mouth. The ghost of Mr. Kir, he exhales through his fingers.

Not the ghost, the son of, Nick says gently, extending his hand. How is it that this stranger sees the resemblance, where his mother doesn't? You knew my father, Nick says with relief.

The keeper begins to recover and nods slowly. He used to come, like some of them used to come and ask my father: Please Sir, can you send a letter? But he the only one my father will do for. Because he make me laugh as a boy, and I was not a laughing boy. Only when Mr. Kir talk like a whale.

Nick hung his head, and the lighthouse keeper ran back upstairs for a bottle of rum. They sat on a flat rock, drinking warm rum in the middle of the bright morning.

The last time I see him, the lighthouse keeper said, he came in the dark with some friends. They had a holy father with them. And Mr. Kir told all to my papa. And my papa say he can show them to the north shore in the morning, and he give them some string and an ax and say: maybe you can build yourself some raft.

Max had watched from above that morning as five men and two women followed his father down the path to the rocks. He had watched from above that morning as men with gas masks and guns came bounding out of the jungle from behind, raising their rifles, scream upon scream as they shot eight people dead, each body jerking backwards and falling upon the ground. Max, at thirteen years old, had watched in terror from above every morning thereafter, as a war

unfolded in the town. Too many bodies for burning. They threw them in the sea. The sea turned red and the glass of the lighthouse grew dirty, and only a year after everyone was gone did Max feel safe enough to come outside and clean the windows again.

He buried over here, says the lighthouse keeper to the son of Kir. I buried him myself. He points out eight graves marked with white stones. On one he has carved the crude image of a whale.

And I know that one a priest because he carrying his bibles—two bibles, one old, one new. I buried him with his holy books. You see? He points at an x carved into the stone.

Was he sick too, the priest?

No, says Max. Not he, not the army, not my father, not me. This sickness wasn't the spreading kind, despite what people say. Truth is buried right here. I keep listening, waiting so as they'll tell it to me.

I'll wait with you, I say, bending down and tracing the outline of the whale with my finger. Maybe we can dig up the earth to hear them better.

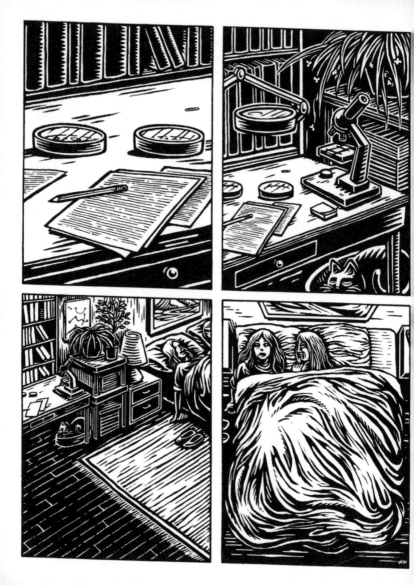

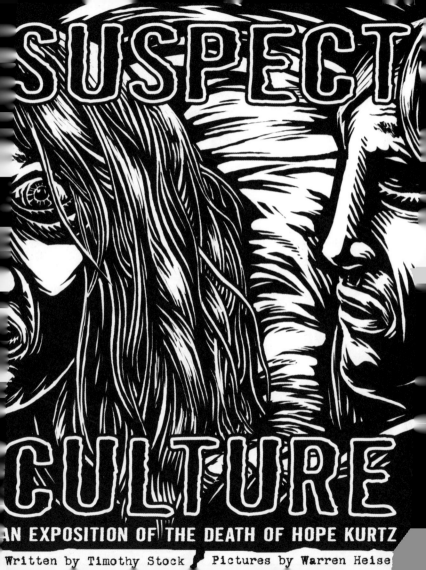

SUSPECT

CULTURE

AN EXPOSITION OF THE DEATH OF HOPE KURTZ

Written by Timothy Stock Pictures by Warren Heise

On May 11th 2004...

Steven Kurtz, of the Critical Art Ensemble

CLICK

"awoke at his Buffalo, N.Y., home to find his wife of 20 years...

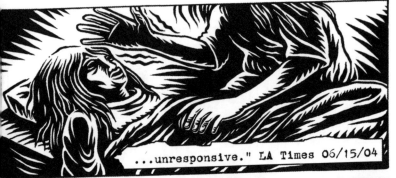

...unresponsive." LA Times 06/15/04

"Kurtz's... nightmare began" LA Times 06/15/04

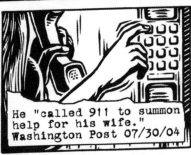

He "called 911 to summon help for his wife." Washington Post 07/30/04

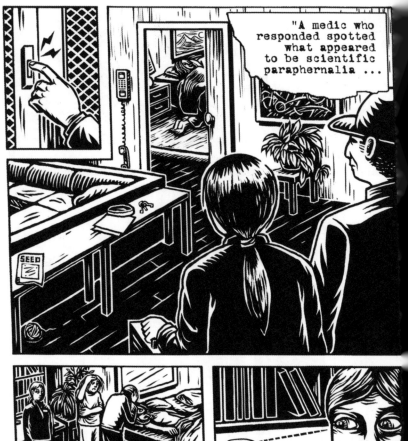

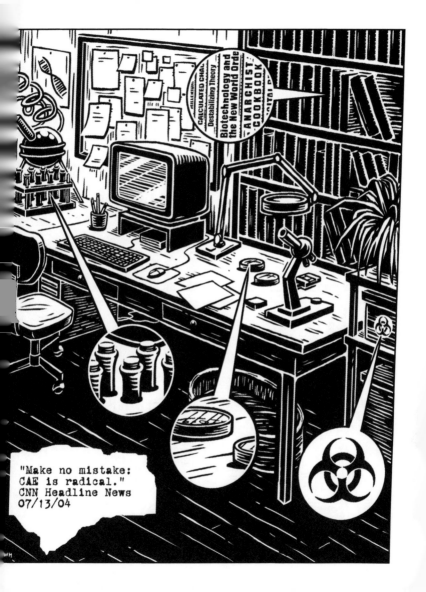

"panicked public
health inspectors ...

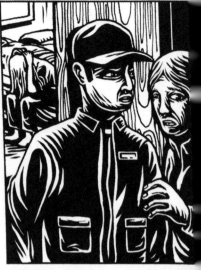

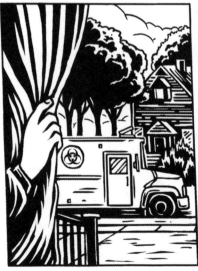

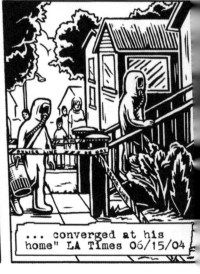

... converged at his
home" LA Times 06/15/04

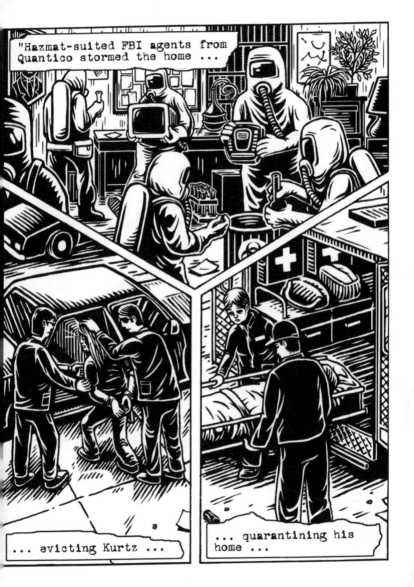

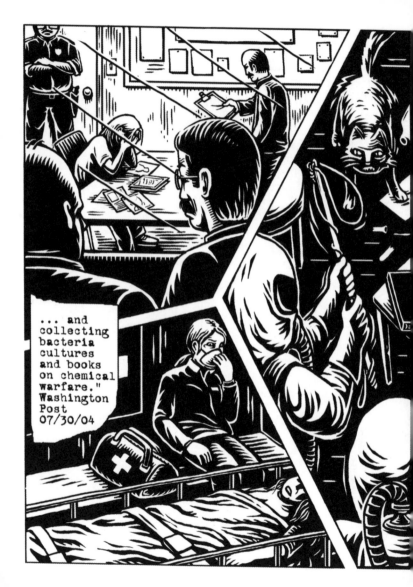

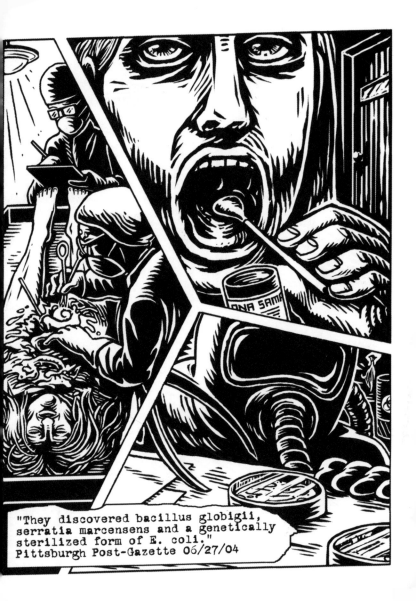

"They discovered bacillus globigii, serratia marcensens and a genetically sterilized form of E. coli."
Pittsburgh Post-Gazette 06/27/04

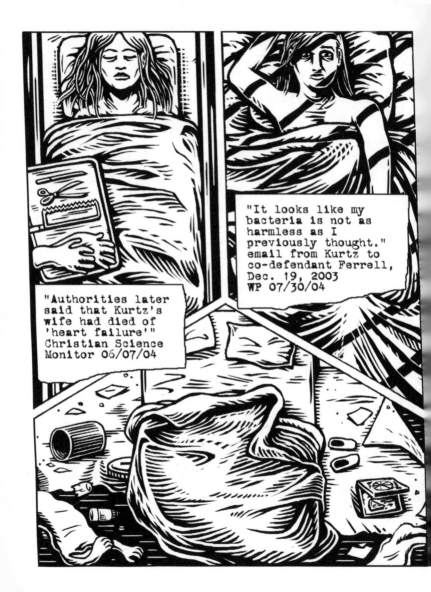

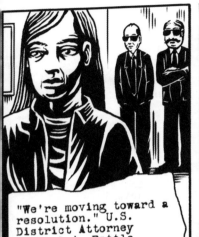

"We're moving toward a resolution." U.S. District Attorney Michael A. Battle, Buffalo News 07/29/04

"I continue to defend any artist's rights to this day" U.S. Attorney William J. Hochul, Washington Post 07/30/04

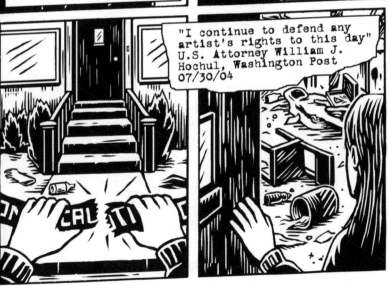

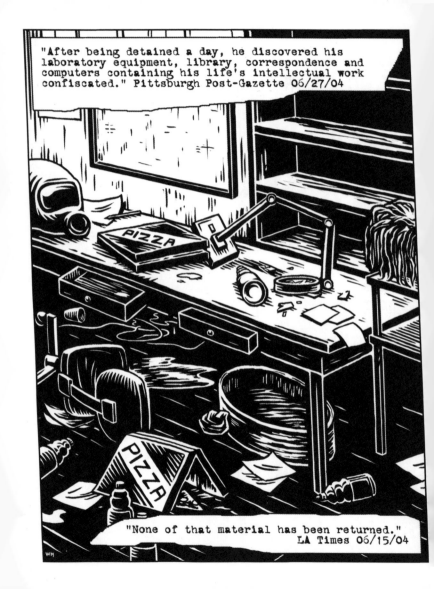

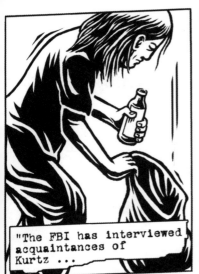

"The FBI has interviewed acquaintances of Kurtz ...

... asking whether Kurtz 'had ever advocated the overthrow of the U.S. government,' ...

... and whether 'he could be a terrorist.'"
Pittsburgh Post-Gazette
06/27/04

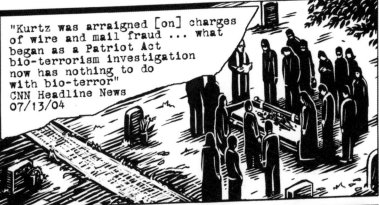

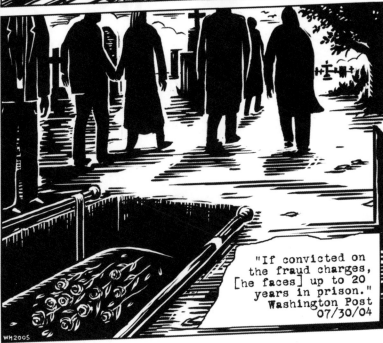

CONTRIBUTORS

Artist **Stephen Andrews** has exhibited his work in Canada, the US, Brazil, Scotland, France, India, and Japan.

George Bragues is program head of media studies at the University of Guelph-Humber.

Diana Fitzgerald Bryden's most recent book of poetry is *Clinic Day*; she is completing her first novel.

Heather Cameron teaches at the Centre for Technology and Society in Berlin and is a research fellow at the Canadian Centre for Policy Research on Science and Technology.

S. D. Chrostowska lives in Toronto, where she is pursuing a PhD in literary criticism.

Simon A. Cole is assistant professor of criminology, law, and society at the University of California, Irvine, and the author of *Suspect Identities*.

Ariel Dorfman is suspicious of everything and everybody, but also extraordinarily hopeful about every human being he meets. He still hasn't figured it out.

Joey Dubuc is the author/illustrator of *Neither Either Nor Or*, and a founding member of Orange/Brown, an artist group.

Kent Enns is a lecturer on the history of philosophy and political theory at the University of Toronto.

George Z. Gasyna recently completed a PhD dissertation on exile literature at the Centre for Comparative Literature, University of Toronto.

Camilla Gibb is the author of three novels: *Mouthing the Words* (City of Toronto Book Award), *The Petty Details of So-and-so's Life*, and *Sweetness in the Belly*.

Jennifer Harris is assistant professor of English at Mount Allison University, specializing in American literature.

Warren Heise draws pictures that appear in popular magazines, on snowboards, and on bathroom walls around the world.

Mark Kingwell is a professor of philosophy at the University of Toronto and a contributing editor of *Harper's Magazine*.

Naomi Klein is the author of *No Logo* and writer/producer of *The Take*, a new documentary on Argentina's occupied factories.

John Knechtel founded *Alphabet City Magazine* in 1991.

Rita Leistner was smuggled into Iraq in April 2003. She is co-author of *Unembedded: Four Independent Photojournalists on the War in Iraq*. She is represented by Redux Pictures, New York.

Gilbert Li is principal of the graphic design firm The Office of Gilbert Li and has been recognized internationally for his work on *Alphabet City Magazine*.

Jeanne Randolph's most recent book is *Why Stoics Box: Essays on Art and Society*.

Patricia Rozema is a filmmaker who finds that reality is poorly structured. Her films (*Mansfield Park*, *I've Heard the Mermaids Singing*, etc.) are her humble attempts to rectify the situation for a few minutes.

Jaspreet Singh's collection—*Seventeen Tomatoes: Tales from Kashmir*—won the 2004 Quebec Writers' Best First Book Prize.

Toronto artist **Cheryl Sourkes** monitors webcams to sample the way the world shows itself off on-line.

Timothy Stock writes serious comic books and comedic philosophy. His PhD thesis on comedy and phenomenology is "You Had to Be There."

Alia Toor is an artist and educator interested in the relationships between media, culture, and education.

Michael Walling is artistic director of *Border Crossings* (UK) and co-directed the COC production of *The Handmaid's Tale*.

Slavoj Žižek is continuing his search for a good terror. His forthcoming book on theology, brain sciences, and politics is *The Parallax View* (MIT Press, 2006).

Suspect was published
with the support of:

ONTARIO ARTS COUNCIL
CONSEIL DES ARTS DE L'ONTARIO

torontoartscouncil
An arm's length body of the City of Toronto

CLARITY

Books on Advertising & Design

Anonymous

DRAKE HOTEL

GLADSTONE
HOTEL